O O 2 **WORLD PRESS PHOTO**

Thames & Hudson

It took the jury of the 45th World Press Photo Contest two weeks of intensive deliberation to arrive at the results published in this book. They had to judge 49,235 entries submitted by 4,171 photographers from 123 countries.

World Press Photo

World Press Photo is an independent non-profit organization, founded in the Netherlands in 1955. Its main aim is to support and promote internationally the work of professional press photographers. Over the years, World Press Photo has evolved into an independent platform for photojournalism and the free exchange of information. The organization operates under the patronage of H.R.H. Prince Bernhard of the Netherlands.

In order to realize its objectives, World Press Photo organizes the world's largest and most prestigious annual press photography contest. The prizewinning photographs are assembled into a traveling exhibition, which is visited by over a million people in 35 countries every year. This yearbook presenting all prizewinning entries is published annually in seven languages. Reflecting the best in the photojournalism of a particular year, the book is both a catalogue for the exhibition and an interesting document in its own right.

Besides managing the extensive exhibition program, the organization closely monitors developments in photojournalism. Educational projects play an increasing role in World Press Photo's annual calendar. Seven times a year seminars open to individual photographers, photo agencies and picture editors are organized in developing countries. The annual Joop Swart Masterclass, held in the Netherlands, is aimed at talented photographers at the start of their careers. They receive practical instruction and are shown how they can enhance their professionalism by some of the most accomplished people in photojournalism.

World Press Photo is sponsored worldwide by Canon, KLM Royal Dutch Airlines and Kodak Professional, a division of Eastman Kodak Company.

World Press Photo of the Year

Erik Refner
Denmark, for Berlingske Tidende

The body of a one-year-old boy who died of dehydration is prepared for burial at Jalozai refugee camp in June. The child's family, originally from North Afghanistan, had sought refuge in Pakistan from political instability and the consequences of drought. The family gave the photographer permission to attend as they washed and wrapped his body in a white funeral shroud, according to Muslim tradition.

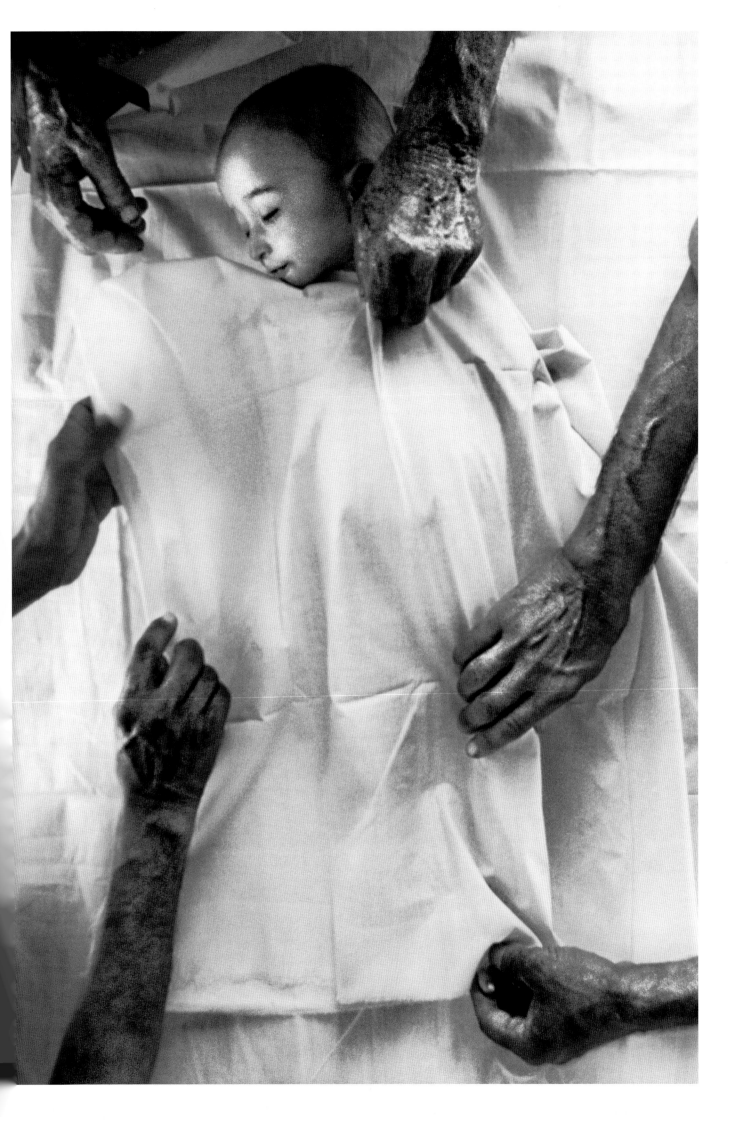

Erik Refner was born in Copenhagen, Denmark, in 1971. In the early 1990s he was a sergeant in the Danish army. After a year as an athlete in Denmark's national pentathlon team he entered the photographic profession as assistant to a fashion photographer. In 1998 he was admitted to the Danish School of Journalism, where he hopes to complete the photojournalism program in the summer of 2002. Swimming, meditation and yoga are some of the things Refner does to relax.

Erik Refner

Erik Refner, the author of the World Press Photo of the Year 2001, answered some questions about his work.

How did you become involved in photography?
I used to be a professional athlete — I was on the Danish national team for the pentathlon. I was already thinking about going into photography when one day, during a visit to a friend who was a fashion photographer, I heard him say that he was looking for an assistant. I took the opportunity to offer my services, and started work the next day. For about 18 months I built up a sound basic knowledge of the technical side of photography. When that had become routine to me, I could concentrate on my subjects.

Was the move to photojournalism a deliberate choice?
I started reading books about photojournalism, and it really got under my skin. I was amazed to see the pictures that could be made without studio facilities, without lights or models, in a "now or never" situation. The challenge appealed to me — I knew that was what I wanted to do.
To be admitted to the Danish School of Journalism in Århus I had to pass a full day's examination, from 7am to 5pm, which included a four-hour photo assignment. Photojournalism had become my goal in life, and for a year I spent a lot of time preparing for the exam. I was able to start my studies at the School of Journalism in September 1998. This summer I hope to finish them, after a two-month project on a subject of my choice.

What makes it feel right for you to be a photojournalist?
First of all, I want to tell stories that reflect my interest in every aspect of society. Secondly, I have a deep personal commitment to the profession — once I'm in the right place I'll go all out to get what I want. And finally, I'm prepared to take on a lot of hard work.

How do you approach your work?
I enjoy working on my own. I do my own research and write my own stories. Thorough research is essential to the way I work. I need to have a clear idea of the background to a story before I start shooting. That's how I know what I'm after — it helps focus my mind. My way of working drains you of energy, but it's also very satisfying.

What sparked your interest in Afghanistan?
At the time, while I was an intern at the *Berlingske Tidende*, there was a lively debate going on in Denmark about how to deal with the refugee problem. I'm very interested in politics, and I discovered that a quarter of the world's refugees come from Afghanistan. Before I asked my editor to finance the story, I spent a month researching it and collecting arguments. After that, I found it easy to persuade him.

In what circumstances did you make the winning picture?
During a previous assignment, on AIDS victims in Cambodia, I had built up a good working relationship with *Médecins Sans Frontières*. I got in touch with them again in Pakistan. They warned me not to go into the refugee camp after dark, so I asked my translator to collect information for me at night.
While I was there, fighting between the Northern Alliance and the Taliban and the worst drought in 30 years forced many Afghans into exile. New refugees started to arrive in the camp, and one morning my translator told me that a family was collecting a funeral shroud and a headstone from *Médecins Sans Frontières* for a baby that had died of dehydration. I went to offer my condolences and received permission from the father to take some pictures while they were preparing the child for burial. It was a very delicate situation. I prayed with them and was very careful not to disturb their grieving.

How has the war on terrorism affected the perception of the work you did in Pakistan?
The world has changed since I was there. Since September 11 the world's attention has been focused on this area, but for me the issues were just as important back in June. At the time the UN couldn't help the refugees, because Pakistan and the international community were not interested in solving their problems. Now all the relief agencies are there, and food and other aid supplies are being distributed.

Any idea what will be your next project?
I'm starting to research a group of social drop-outs who are traveling around Sweden in old American cars. They spend a lot of time partying, listening to rock 'n' roll music and getting drunk. I'd like to live with them for a while. But I also welcome other assignments. I don't want people to think that I'm making extravagant demands now that I have won the World Press Photo award. From May I plan to share a studio with seven other freelance photographers. We work in different disciplines, so we can learn from each other.

Do you expect to stay in photojournalism?
Hard to say — my career has only just started. I love this work. Right now I feel I want to do this for the rest of my life, but there's no knowing what the future holds.

THIS YEAR'S JURY.
First round jury, from left to right:
Roger Hutchings, UK (chair)
Adriaan Monshouwer (secretary)
Kadir van Lohuizen, The Netherlands
Sylvie Rebbot, France
Reza, France
Ana Cecilia Gonzales-Vigil, Peru

Second round jury, from left to right:
Prashant Panjiar, India
Nicole Aeby, Switzerland
Maggie Steber, USA
Jean-François Leroy, France
Herbert Mabuza, South Africa
Roger Hutchings, UK (chairman)
Susan Olle, Australia
Yuri Kozyrev, Russia
Vincent Alabiso, USA

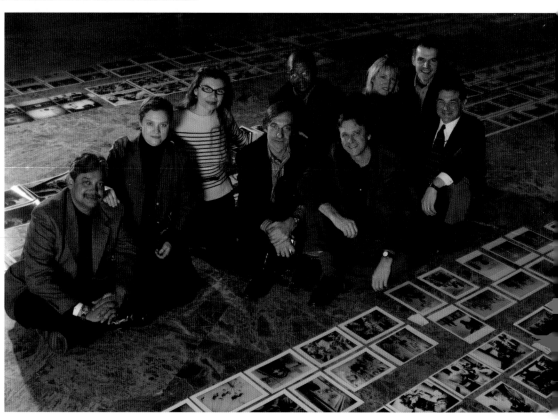

Foreword

This book of prize-winning photographs chosen by the 45th jury of World Press Photo represents only a fragment of the entries submitted for the competition which has become what it is — the world's premier contest for photojournalism— because of the number of talented photographers who participate each year. I would like to acknowledge them at large and thank them for making our job so difficult.

We approached the judging knowing it would be an intense experience, given the magnitude and horror of the terrorist attacks on New York and Washington and the emotional resonance of those events. We had to make difficult choices which are revealed here, in this collection of fine pictures.

The purpose of the contest is to celebrate the best in photography and set a standard which should be inspirational to all photographers. In keeping with the annual trend, more entries were received by World Press Photo than ever; despite the difficulties which have characterized our business for so long, the number of photographers seems to grow. The commitment manifest in the work presented was salutary.
Astonishingly photographers persist against the odds, and now innovations in digital photography are proving to be positive and liberating, enabling us to operate more efficiently by reducing costs, and freeing us from the physical constraints which analogue technology imposed. Revealingly 55% of the entries this year were digital. It needs to be said that the technical quality of the digital pictures varied wildly — too much fluorescent grass and lurid skies in landscapes populated by characters with crimson faces.

In the winning images I was struck by the powerful composition. Of course composition is only a way of emphasizing the meaning of a picture, but the political and social statements and questions posed by some of the pictures are amplified through their design — apparently simple, but reinforcing the message — so that one is left feeling compel-led to stare longer and think harder. It is therefore a triumph of content and composition over style and thus goes against some recent trends which were more stylistic than meaningful. Consequently the chosen pictures testify eloquently to the desperate nature of our times.

There was a consensus within the jury that many of the issues we were scrutinizing are related, interconnected, cause and effect.

Looking back through previous yearbooks I felt a sense of dismay that so many of the crises reported in them are still unsolved problems today. The Middle-East stands out conspicuously, but so does Afghanistan which for the past 24 years has seldom been out of the news: benighted, convulsed by war and invasion, tampered with by meddlesome foreign powers. 1.5 million dead — a country destroyed. Such circumstances led to the emergence of the Taliban and provided a ready home for Al Qaeda. By June last year, 3.6 million Afghans were refugees fleeing a two-year drought and the fanatical Islamic regime.

One day that June a baby died from dehydration — depressingly not a remarkable event in a refugee camp. However, on this occasion there was a photographer to record the moments as the child was prepared for burial. The picture he made reached out to us. It is simple, iconic and symbolic. It comes from a set explaining the plight of the Afghans and it is about something which goes to the root of our current travails. It represents a world of have-nots as opposed to the world of haves which is so resented by some and longed for by others. It points towards matters which need to be addressed and, with the benefit of hindsight, it reproaches us for having ignored Afghanistan since the end of the Cold War. It also reminds us what a photographer is.

The photographer is the scout. One in the vanguard of intelligence gathering but often frustrated by the lack of interest shown in important issues as the news media is dumbed down. In general such people are not sufficiently prized, unlike footballers or B-grade celebrities. We have confused our priorities. Photographers should be recognized for their worth.

ROGER HUTCHINGS
Chairman of the jury
London, February 2002

World Press Photo Children's Award

Aleksander Nordahl
Norway, Dagbladet

A girl smiles at the camera, as her older sisters hide behind a doorway in northern Afghanistan in October. Young women are forbidden to appear unveiled in front of men in Khwaja Bahawudin, an area controlled by the Northern Alliance. Parents decide when a girl is at the age to start wearing a veil.

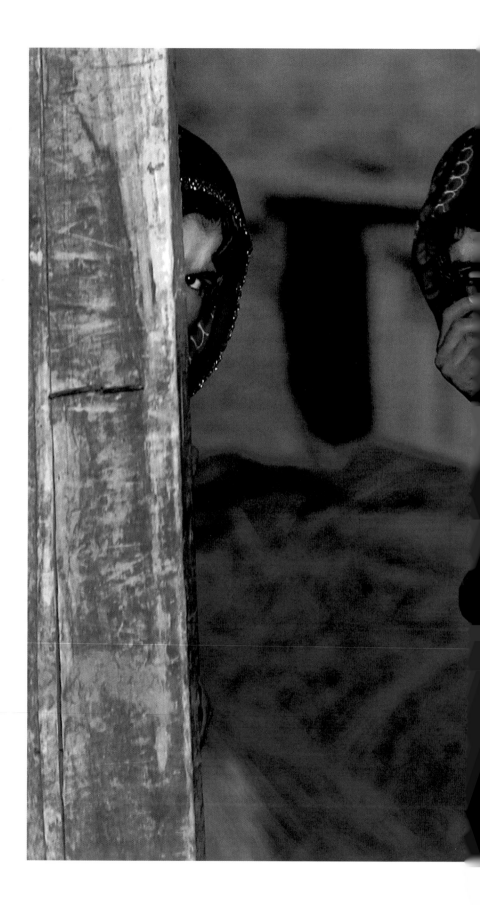

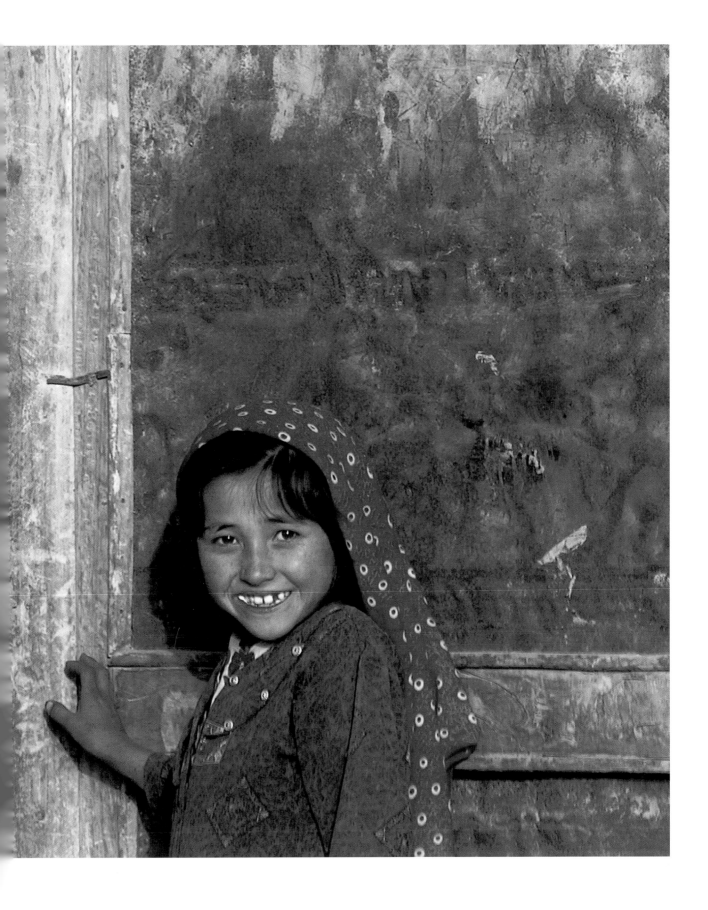

Spot News

Luc Delahaye
France, Magnum Photos for Newsweek

1st Prize Singles

Northern Alliance troops scatter in an ambush by retreating Taliban forces in Afghanistan. The attack came on the afternoon of November 12, as Northern Alliance forces mounted a final offensive to capture the capital Kabul, held by the fundamentalist Taliban since 1996. On the northern front, 25 kilometers from the city, they encountered little resistance until the sudden ambush. Afghanistan's internal clashes intensified in October, following a bombing campaign on Taliban targets led by the US and Britain. Sporadic fighting had continued in the country as the Northern Alliance vowed to overthrow the Taliban regime.

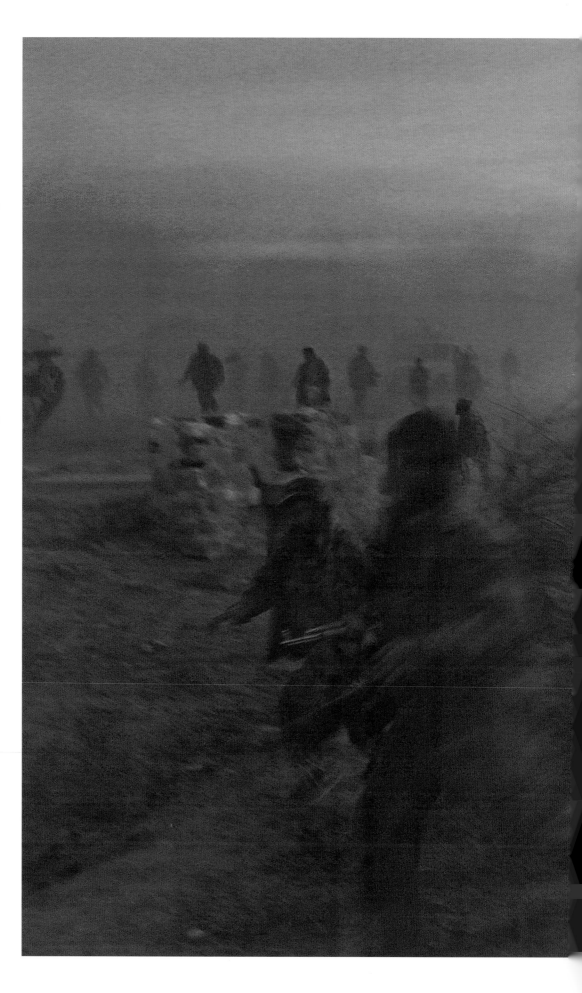

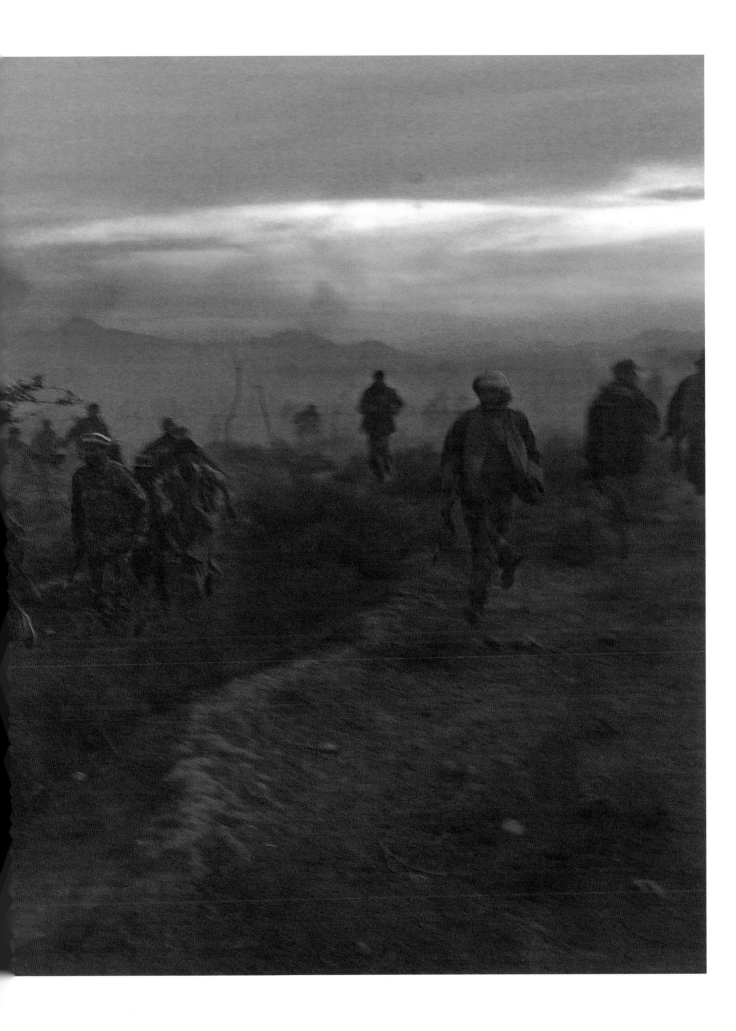

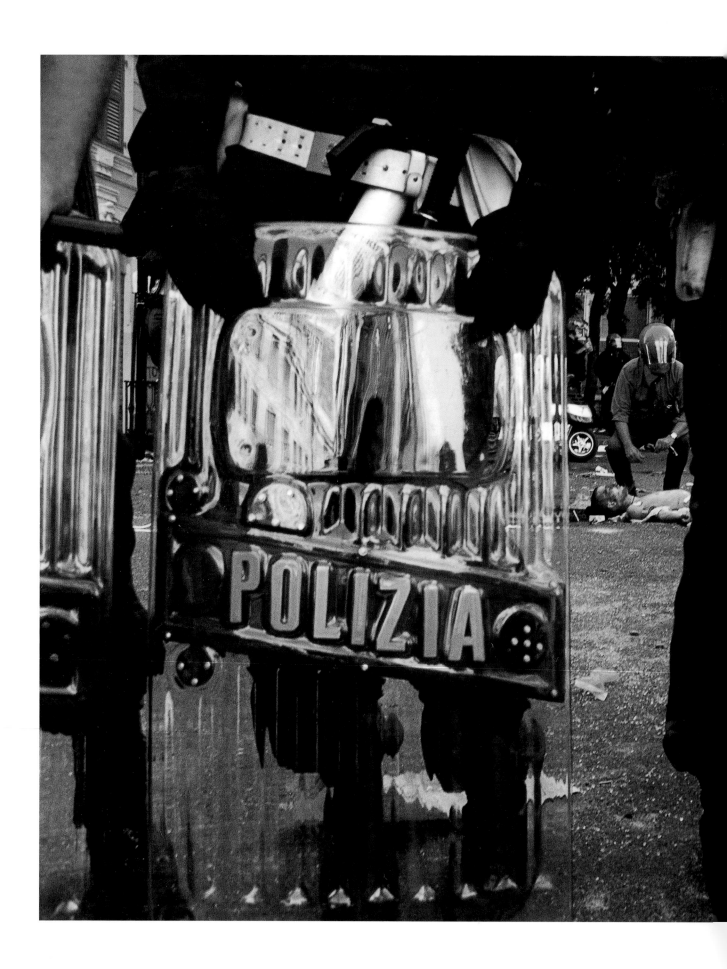

Antoine Serra
France, Corbis Sygma

2nd Prize Singles

The body of Carlo Giuliani, 23, lies in a Genoa street following clashes between Italian police and anti-globalization protesters. At the G8 summit in July, the leaders of eight industrialized nations met behind a four-meter steel barrier to discuss global issues. As the meeting opened, more than 100,000 demonstrators streamed into the city, most holding peaceful protests about the G8 nations' handling of social issues. Street violence escalated, when riot police with shields confronted protesters overturning cars and damaging buildings. Witnesses to Giuliani's death said they heard shots, and saw a police vehicle reverse over him. The Italian Interior Ministry told the press Giuliani was shot twice in the head by a carabinieri police force member, in an act of self-defense.

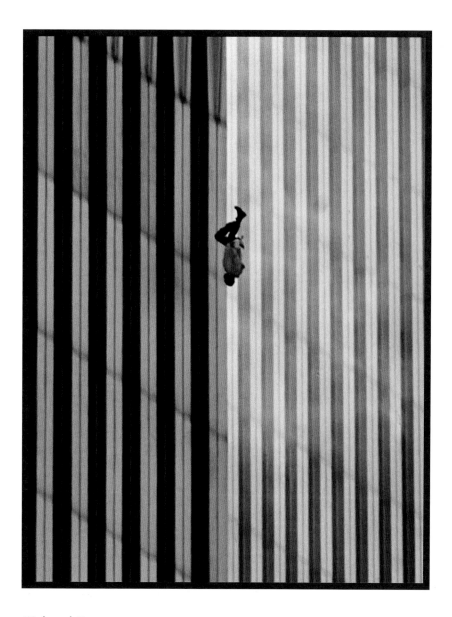

Richard Drew
USA, The Associated Press

3rd Prize Singles

A person falls from the north tower of New York's World
Trade Center on September 11. At 8.45am, the building was
hit by a hijacked Boeing 767 airplane, the first of two attacks
on the center. As explosions sparked fires in the 110-storey
tower, trapped office workers jumped to escape the flames.

David Surowiecki
USA, Getty Images

Honorable mention Singles

Smoke pours from the upper levels of the World Trade Center's
north tower, as those fleeing the fires fall to their death.

Robert Clark
USA, Aurora for Time

1st Prize Stories

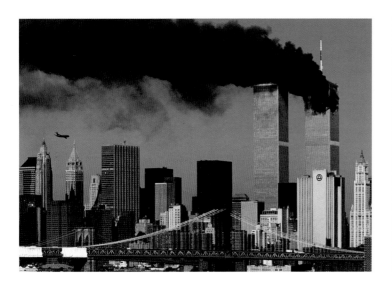 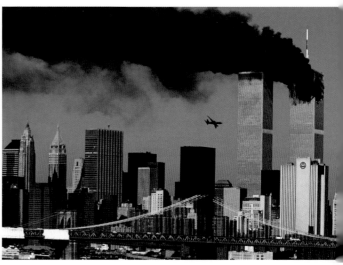

United Airlines Flight 175 approaches the World Trade Center above the Manhattan skyline, crashing into its south tower. The impact of the Boeing 767 ignites an explosive fire, as black smoke continues to stream from the north tower, hit earlier by another hijacked airplane. The September 11 attacks came in the morning, as many of the 40,000 people who worked in the complex arrived at their offices. Two more American airplanes were hijacked the same day; one flew into the Pentagon in Washington, another crashed to the ground in Pennsylvania, killing all on board. US president George W Bush accused members of the Al Qaeda network of carrying out the attack, under the orders of Osama bin Laden.

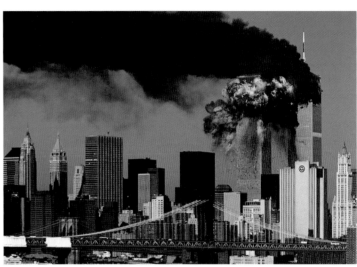

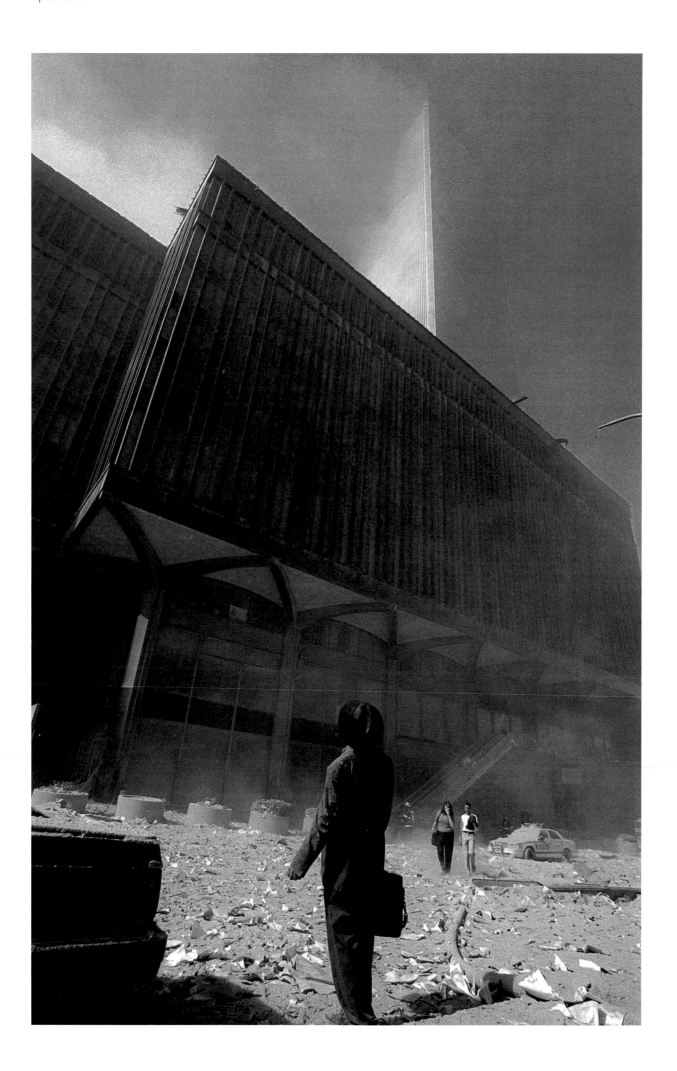

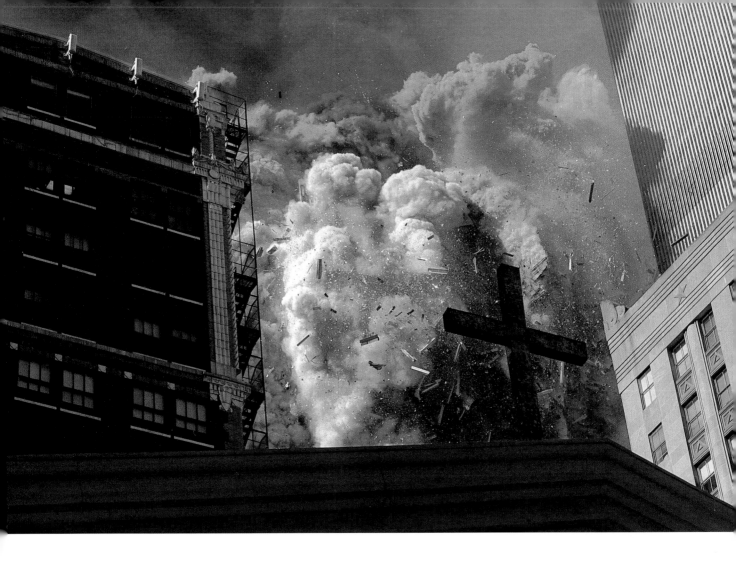

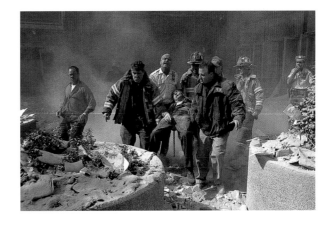

James Nachtwey
USA, VII for Time

2nd Prize Stories

Ash, smoke and shattered glass rained down on lower Manhattan following the destruction of the World Trade Center. For months after the September 11 attacks, rescue workers continued to work in thick dust, clearing the site which came to be known as Ground Zero. The collapse of the twin towers, and buildings below destroyed by falling debris, killed almost 3000 people. Initial estimates of a higher death toll fell as authorities identified who was and was not at the center that morning. The dead included more than 300 New York Fire Department members. This page, above right: New York firemen carry the body of their chaplain, Father Mychal Judge, killed when he went to the aid of those trapped inside the center.

Following pages: A fireman probes the smoking ruins of the World Trade Center's towers. Intense heat from fires, and the airplanes' impact, weakened the huge steel structure of the 110-storey buildings.

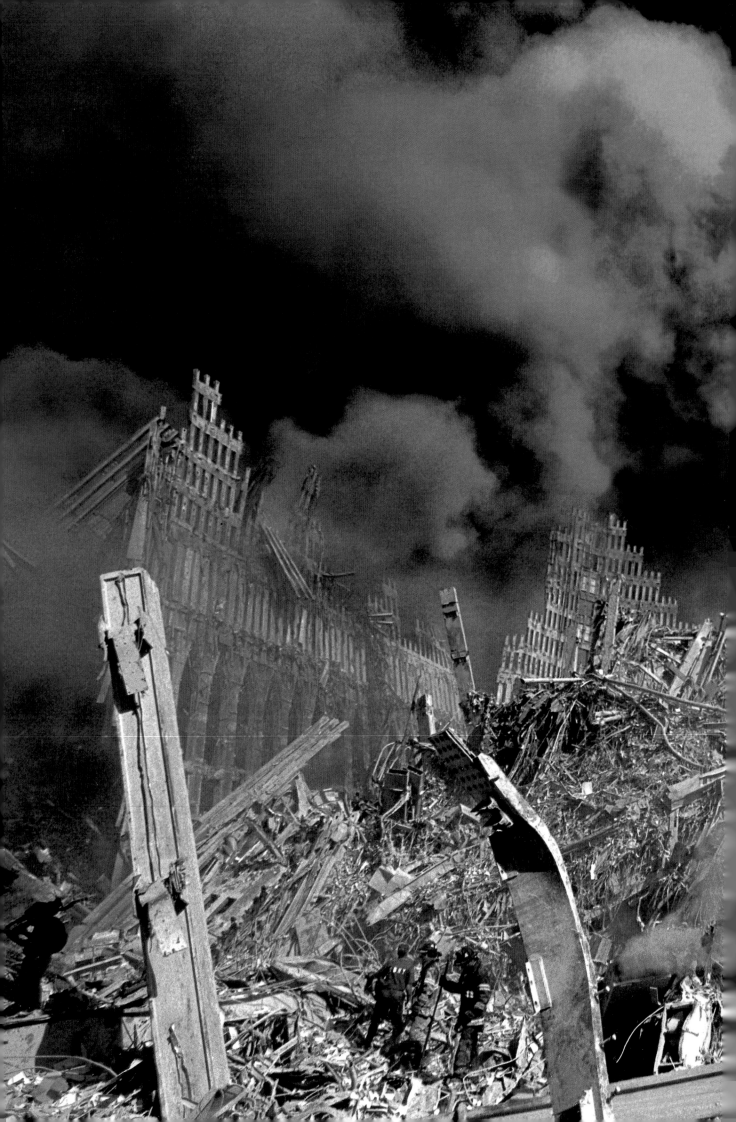

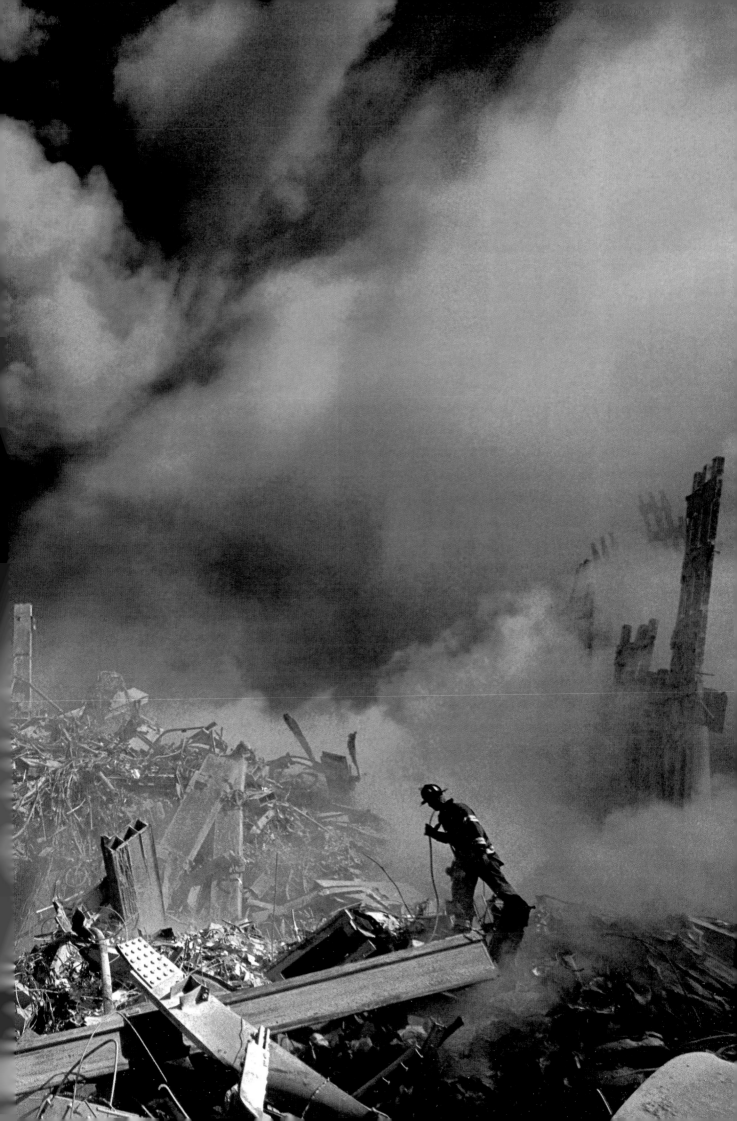

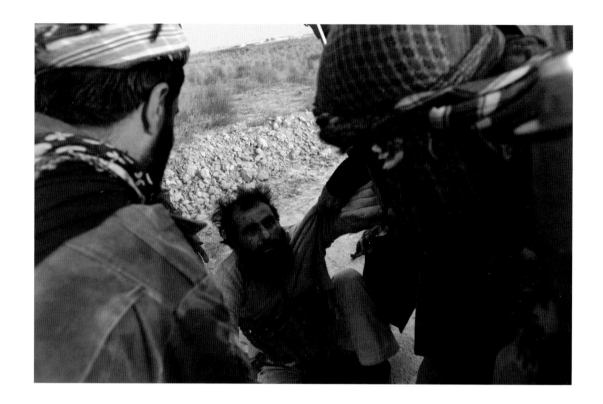

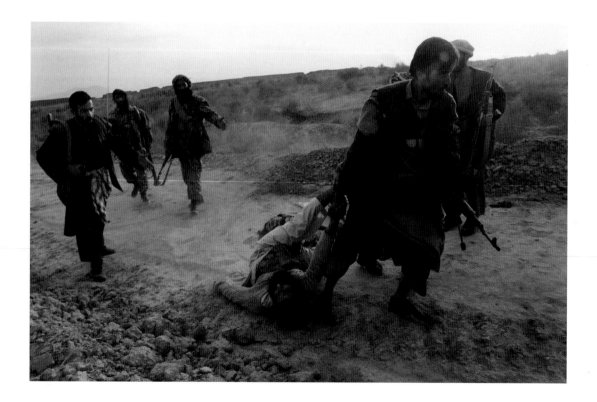

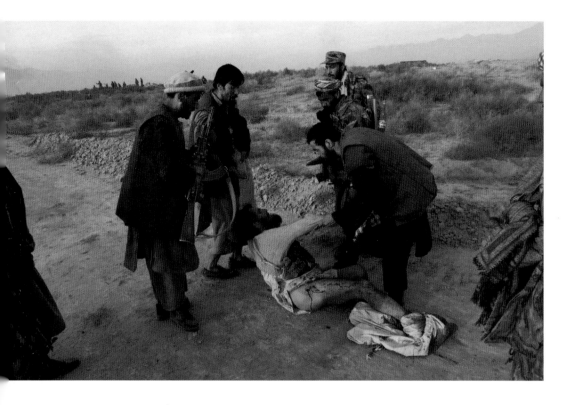

Tyler Hicks
USA, The New York Times/Getty Images

3rd Prize Stories

An injured Taliban soldier pleads for his life after being captured by Northern Alliance soldiers advancing towards Kabul. Dragged along the road, he is killed by three soldiers firing simultaneously into his body. Northern Alliance troops, opposed to the ruling Taliban, took control of Kabul on November 13. The frontline assault followed air strikes on Taliban targets ordered by US president George W Bush. He accused the regime of protecting Osama bin Laden, held responsible by the US for the attacks of September 11.

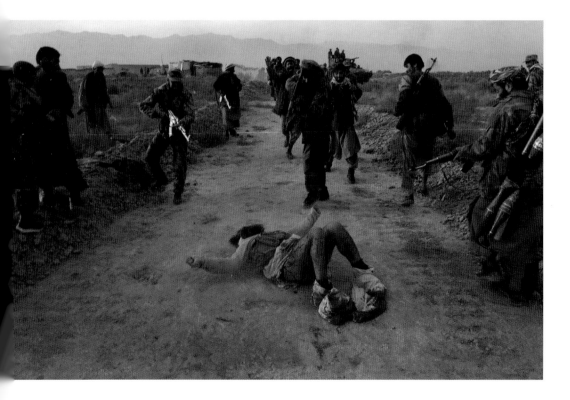

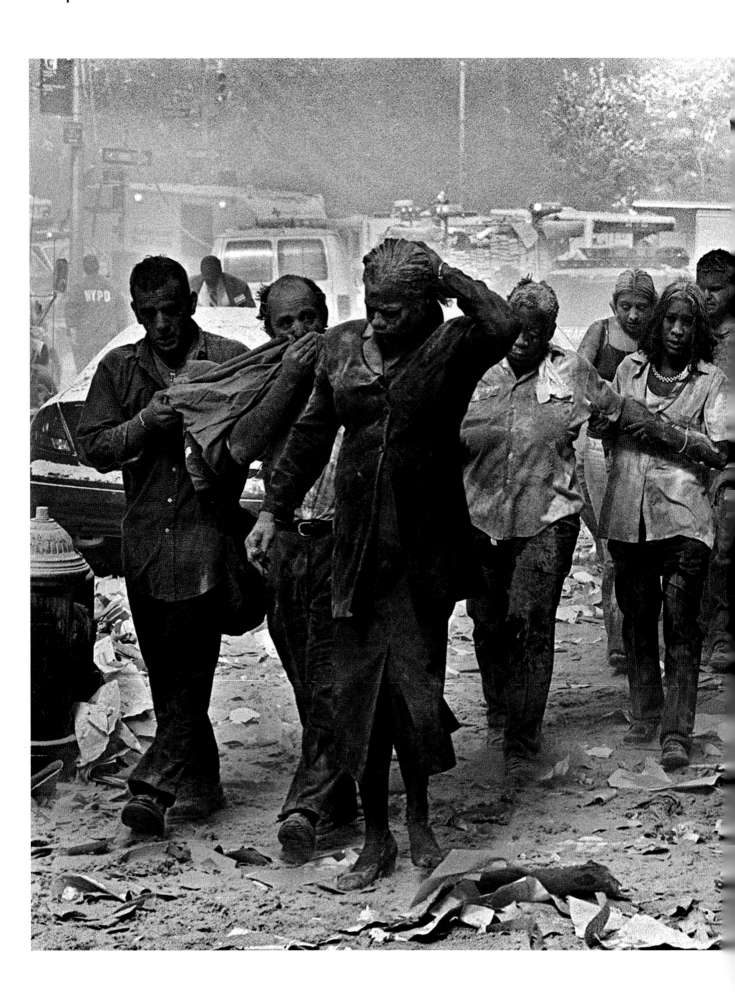

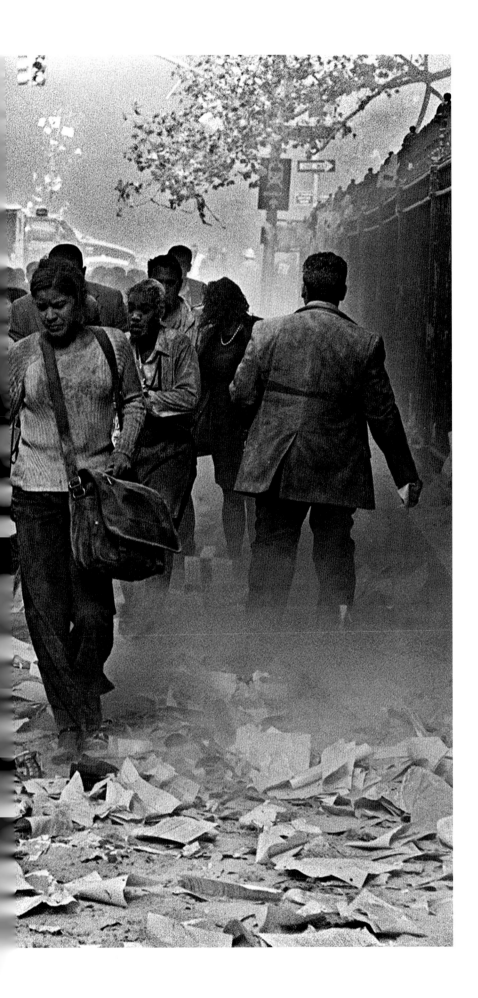

Gulnara Samoilova
USA, The Associated Press

1st Prize Singles

After the World Trade Center's collapse, da-
zed survivors help each other through the
dust and debris covering lower Manhattan.
In a devastating attack, two hijacked air-
planes crashed into the 110-storey twin
towers on September 11, reducing them
to rubble.

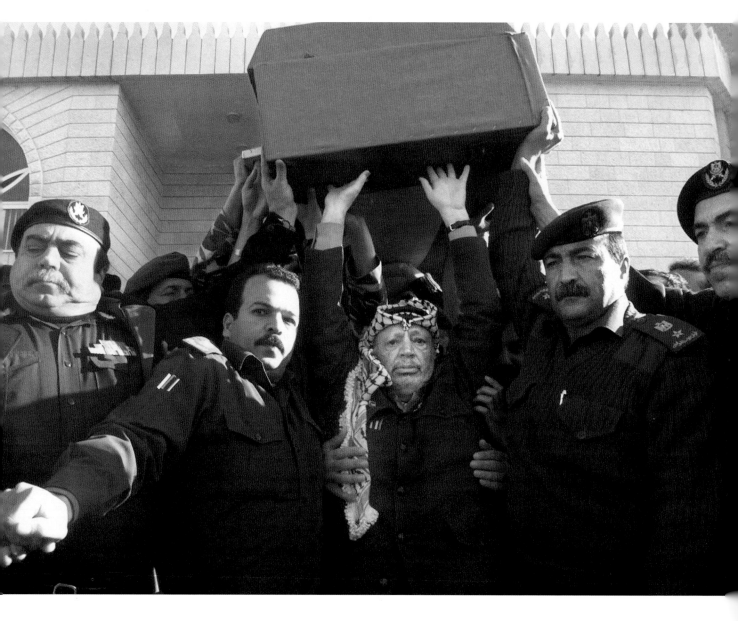

David Guttenfelder
USA, The Associated Press

2nd Prize Singles

Palestinian leader Yasser Arafat helps carry the coffin of Hisham Miki at a funeral service in Gaza City. The director of Palestinian state television, and a friend of Arafat's, Miki was shot by masked gunmen in a restaurant. His death in January came after a three-month wave of violence between Israelis and Palestinians.

Kai Wiedenhöfer
Germany, Lookat Photos

3rd Prize Singles

A fighter mourns Atef
Abiyat, a commander of the
Palestinian Tanzim militia
killed in a car explosion in
Bethlehem in October. As
peace talks continued to
break down, tensions esca-
lated in the region.

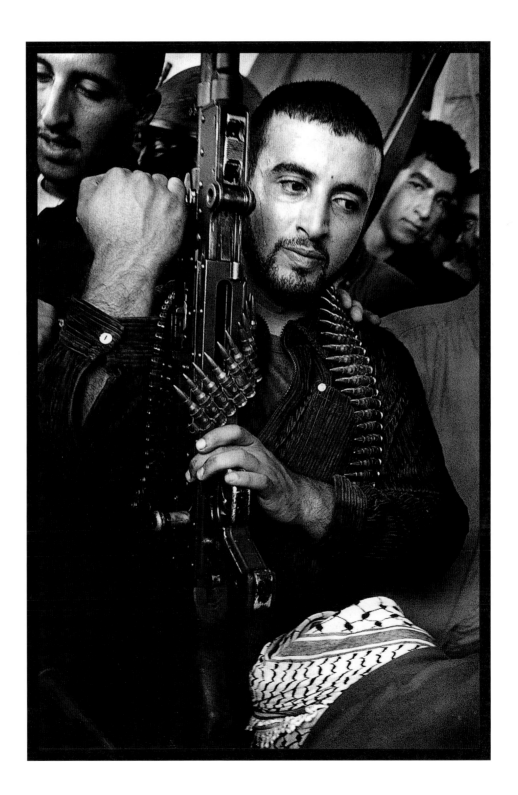

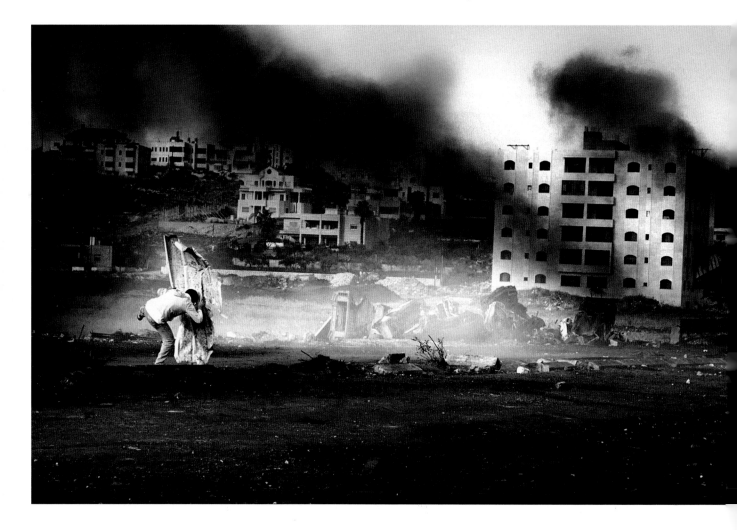

Jan Grarup
Denmark, Rapho for Stern

1st Prize Stories

A generation of Palestinian boys in Ramallah lead split lives, at home with their families, and risking their lives with their friends. The photographer stayed with the boys as they fought, played and rested near the frontline of the Middle East conflict. Top: One of the teenagers, Mohammed, advances towards Israeli soldiers in the City-Inn area. The boys provoke the soldiers by throwing stones. Facing page, top: Mohammed was photographed hours before he was killed by a sniper. Below: Boys at the funeral of a member of Fatah, an armed Palestinian faction. The boys said they shared the organization's goal of an independent Palestine. Following pages: Ahmed and his younger brother at the local swimming club. (story continues)

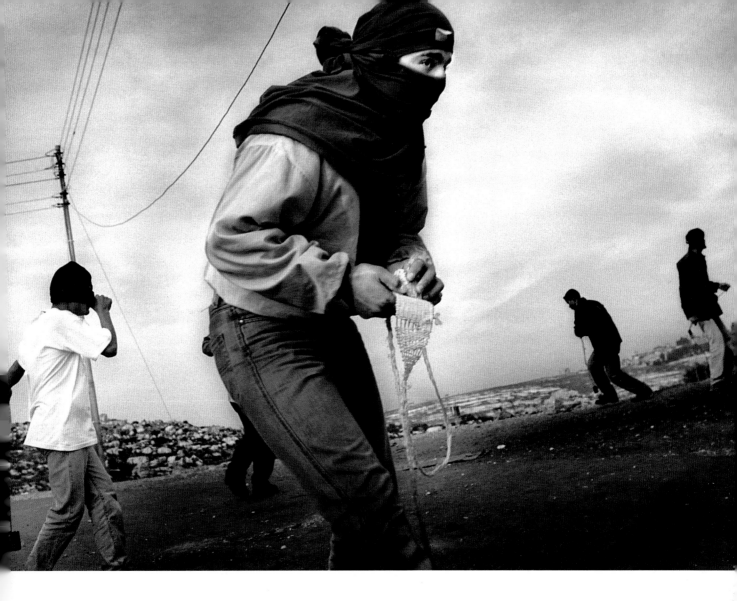
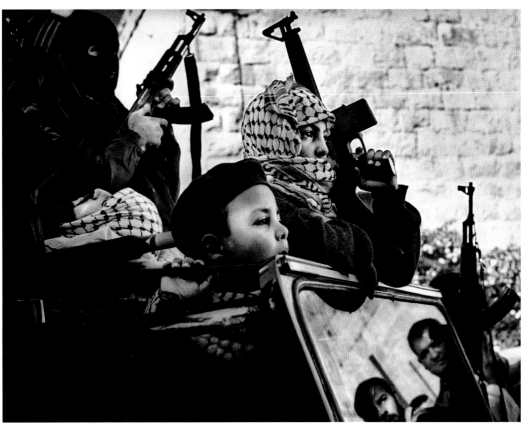

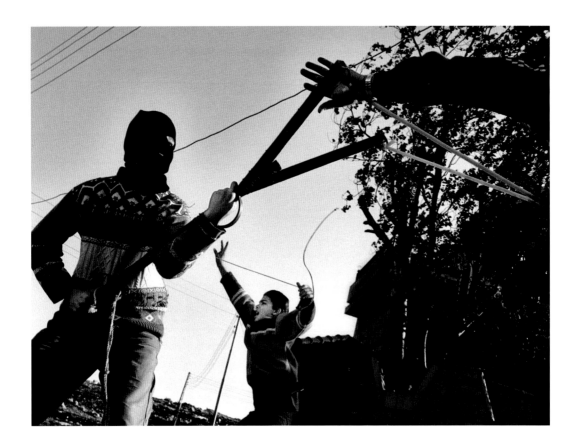

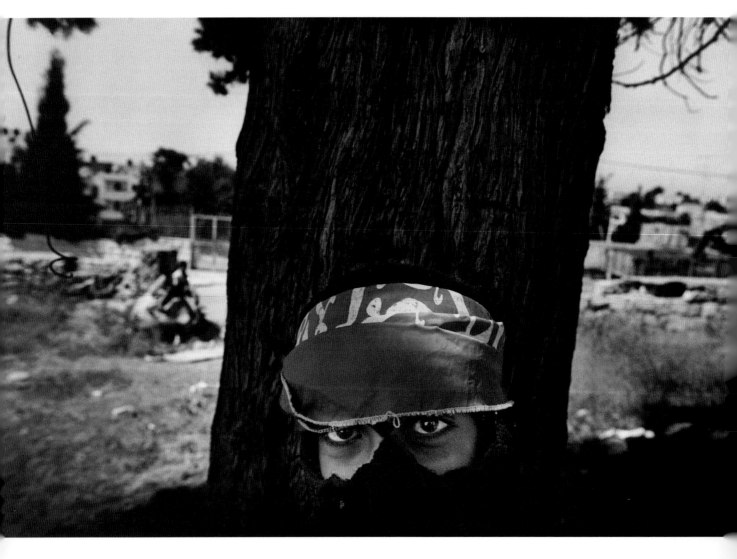

(continued) Masked and hooded, the boys train for combat, learning from their older brothers. Below: Away from the frontline, Ahmed´s passion is flying kites. He plays with them outside his home in the old part of Ramallah.

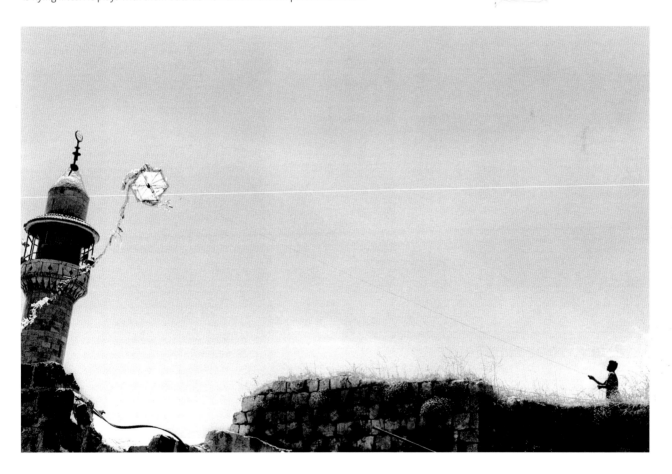

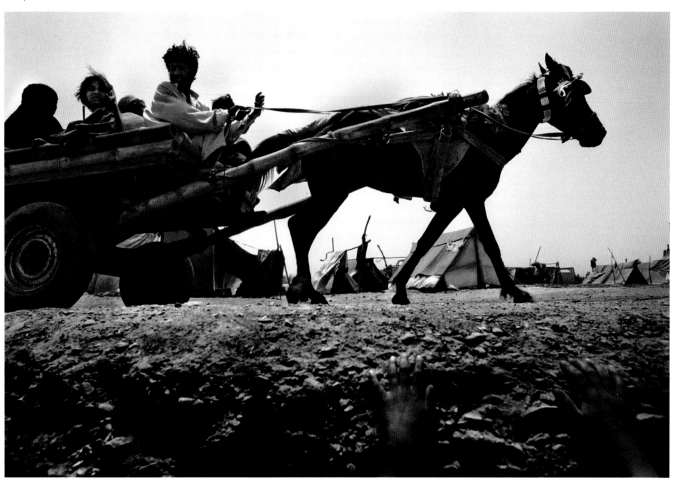

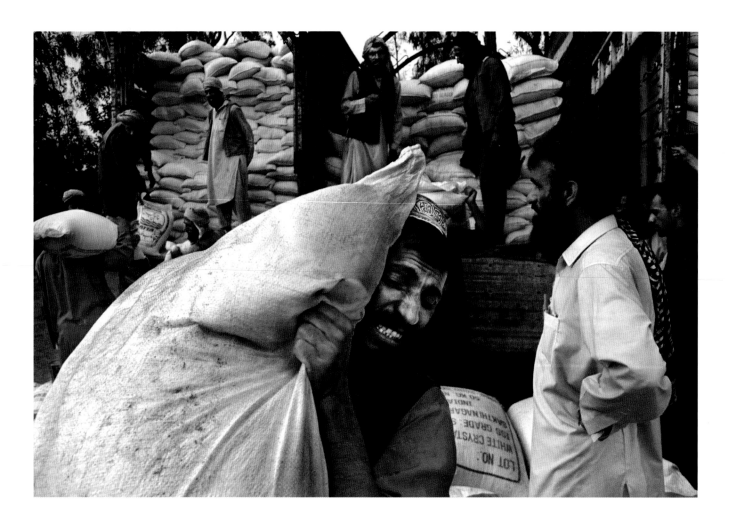

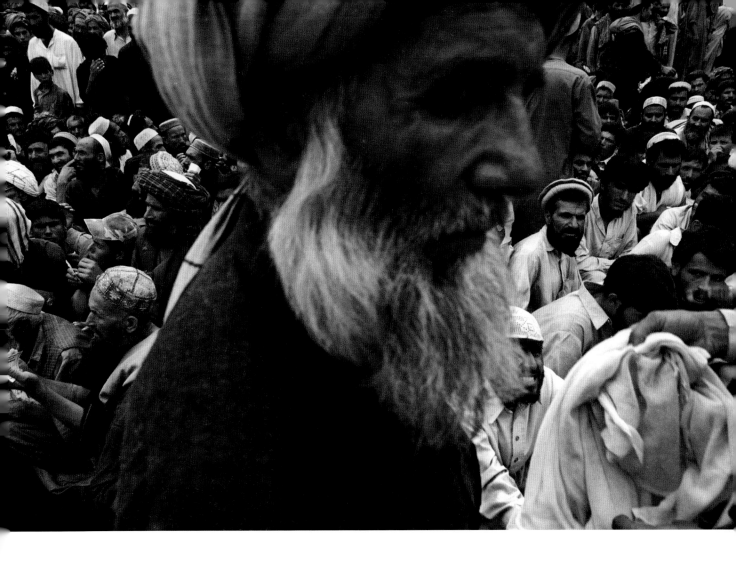

Erik Refner
Denmark, for Berlingske Tidende

2nd Prize Stories

In Pakistan's overcrowded Jalozai camp, 80,000 refugees from Afghanistan endured squalid conditions. Decades of political instability and drought drove millions of people over the border into Pakistan, overwhelming the existing camps. By June, Jalozai could not cope with the numbers, and food and shelter were scarce. Although relief workers tried to provide basic health services, children died from disease or dehydration. Eight months later, the United Nations closed the camp, moving refugees to other areas. Following pages: Near Jalozai, children play in waste water from the city of Peshawar. Summer temperatures reach 50 degrees Celsius.

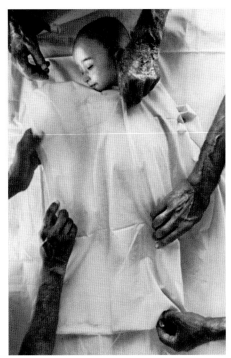

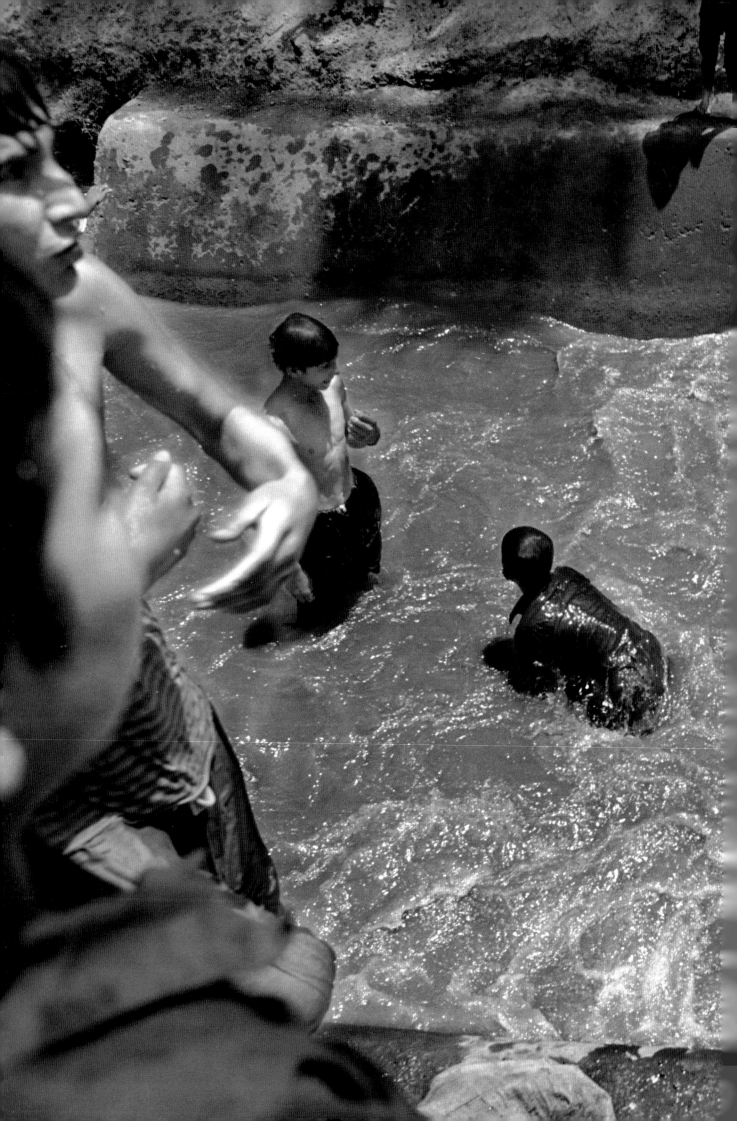

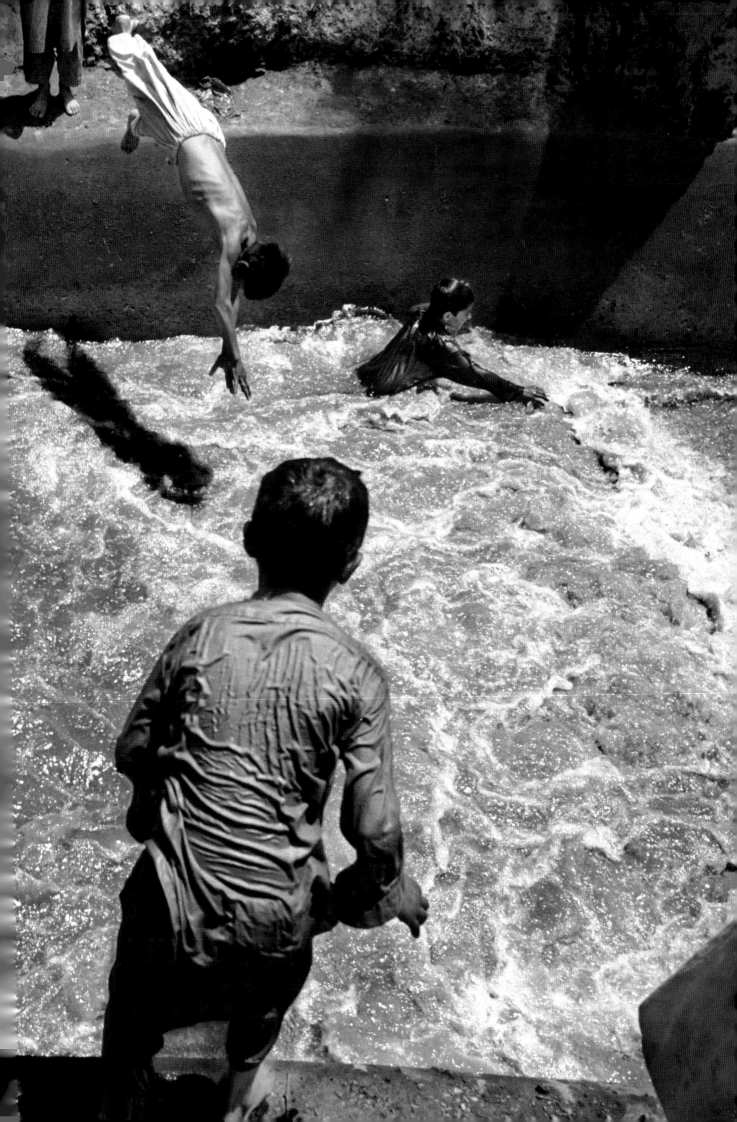

Julien Daniel
France, L'Œil Public

3rd Prize Stories

Broadway became a focal point for those who came to see and photograph the wreckage of New York's World Trade Center. In the weeks after the airplane attacks, the huge site came to be known as Ground Zero. (story continues)

 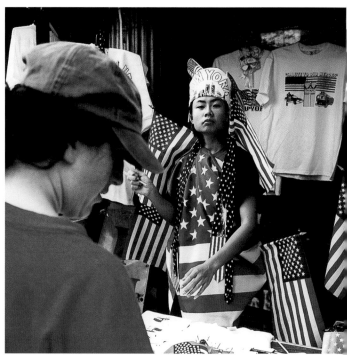

(continued) With New Yorkers and tourists gathering to watch the massive search and clean-up operation, souvenir sellers set up shop nearby.

Portraits

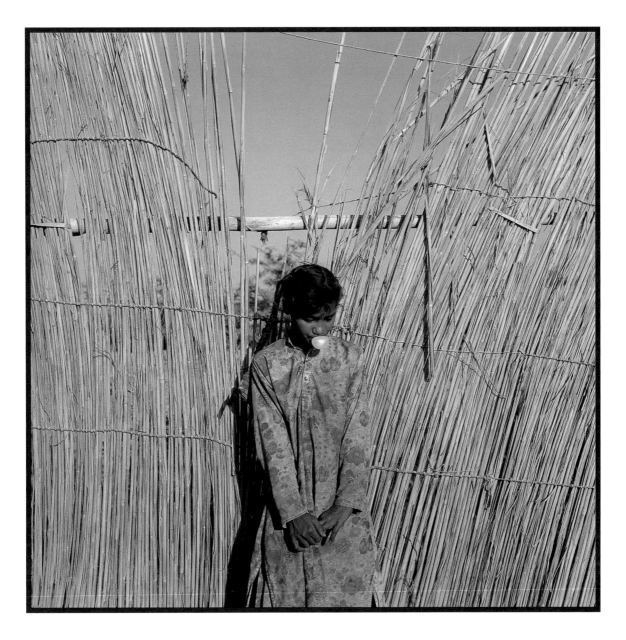

Jodi Bieber
South Africa, Network Photographers
for Learning for Life

1st Prize Singles

In Pakistan, a girl rests after searching for something to sell, to feed her family. She does not go to school as her parents cannot afford for her to stop working. With limited or no education, young women in Pakistan have few chances to break out of a cycle of poverty and hardship. International organizations in the area aim to encourage rural communities to shift their traditional customs, and send their girls to school.

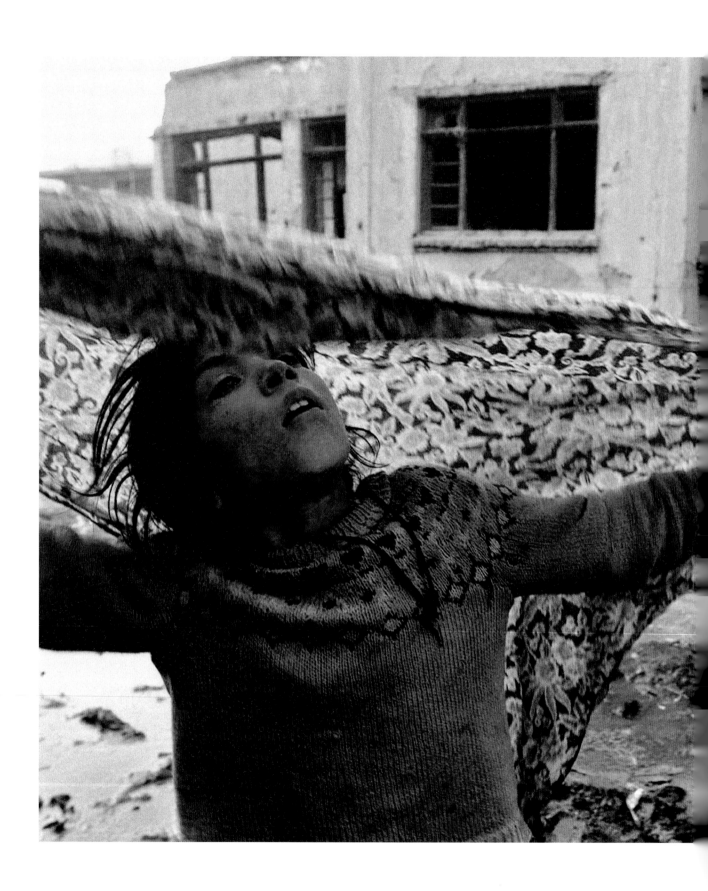

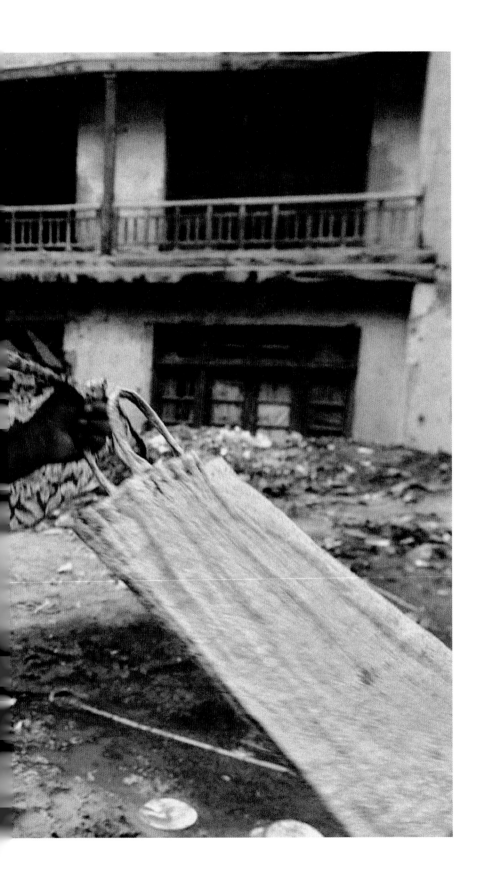

Marco Di Lauro
USA, The Associated Press

2nd Prize Singles

Nine-year-old Maryam covers her-
self with a scarf after leaving the
damaged house where she found
shelter. To survive, she collects
wood and plastic to sell at a market.
In the Afghan capital, Kabul, years
of warfare forced many residents to
flee. With the city in ruins, those
that remained continued a struggle
to survive. In 2001, American air
strikes on Afghanistan weakened
the grip of the ruling Taliban regime,
and by November, opposing
Northern Alliance troops captured
Kabul.

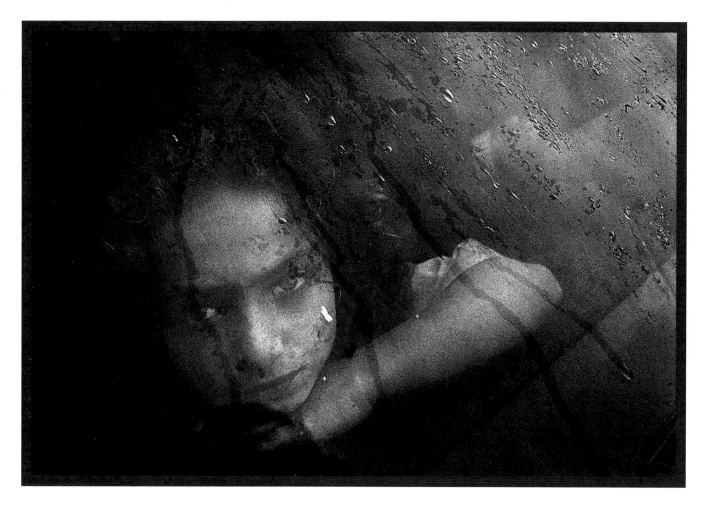

Pietro Di Giambattista
Italy, Graffiti Press

3rd Prize Singles

A Roma girl from Bosnia-Herzegovina leaves an immigrants' camp outside
Rome, in the back seat of a car. In the past decade, the camps have received
an influx of Romas from other parts of Europe, forced from their homes by
warfare and economic hardship.

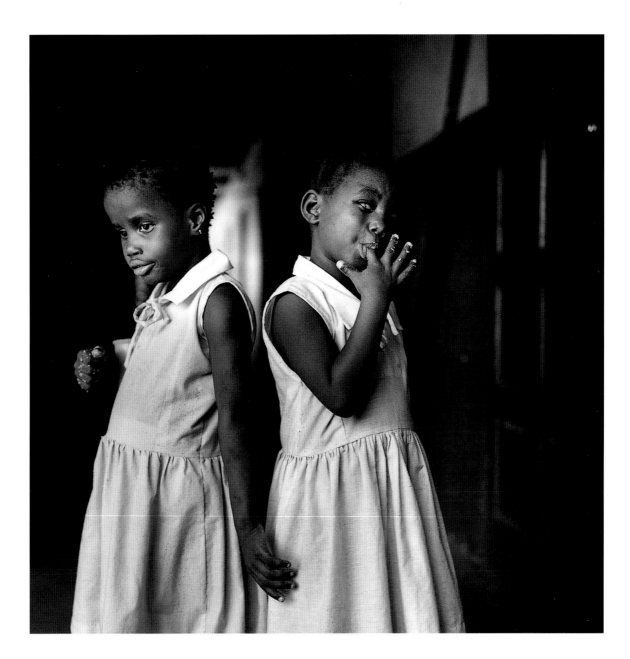

Tim Hetherington
UK, Network Photographers

1st Prize Stories

Milton Margai is the only school for the blind in Sierra Leone. Memunatu Turay and Regina Sesay are two of its 80 pupils, who range in age from four to 18. Located in Freetown, the school has survived the turmoil of an ongoing civil war. Evacuated during a coup in 1998, it was bombed the following year. Some of its pupils were blinded by rebels during the conflict. (story continues)

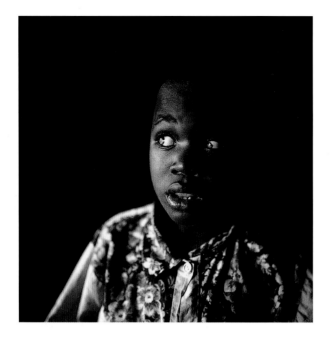
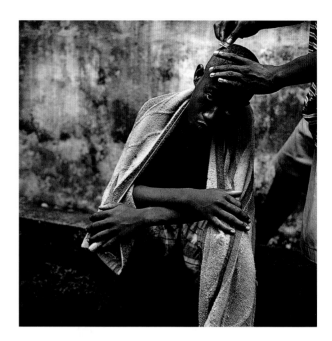
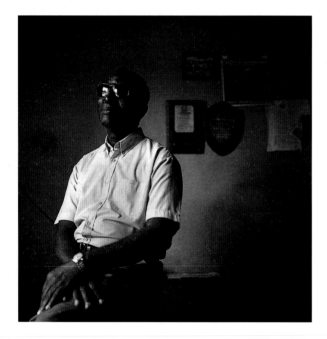
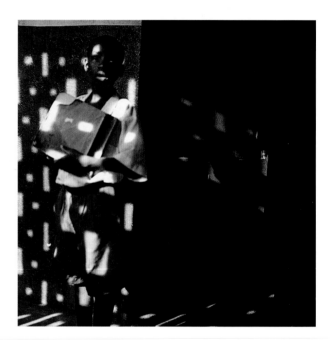

(continued) The school has basic facilities but tries to keep academic standards high. It emphasizes Braille
reading and writing and typing, enabling pupils to go into secondary education, and find jobs.
Above, left: Headmaster Sam Campbell describes blindness as: "a physical nuisance, nothing more."

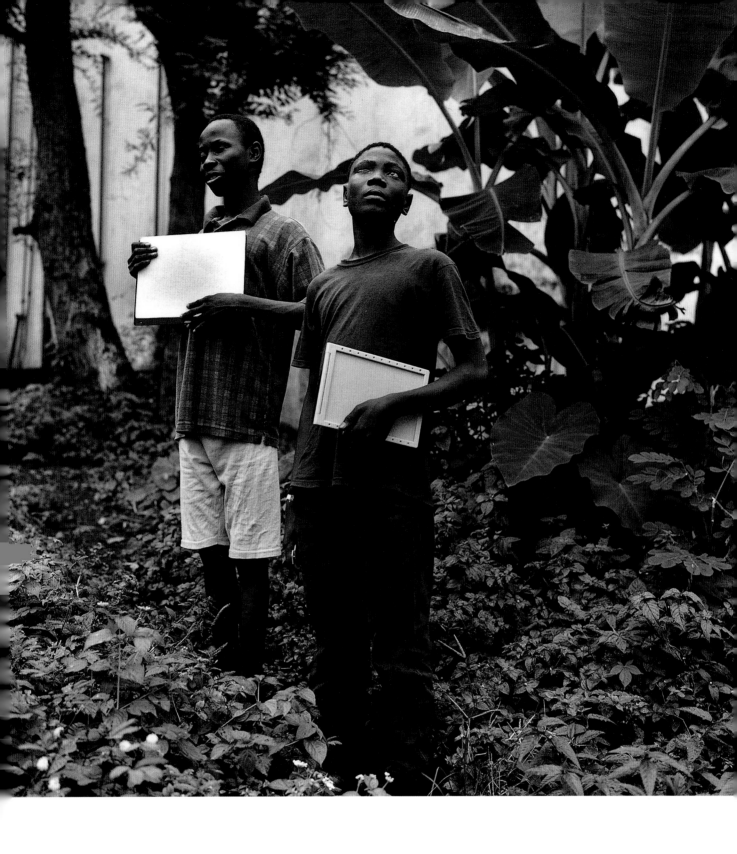

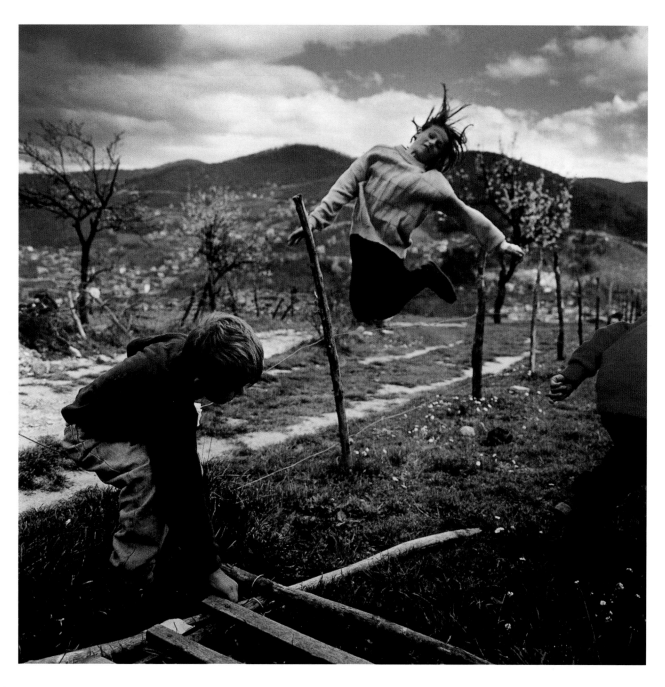

Zijah Gafic
Bosnia-Herzegovina, Agenzia Grazia Neri

2nd Prize Stories

Children play in the suburbs of Gorazde, a city encircled by Serb mili-
tary forces for three years. In the Bosnian civil war of 1992-5, Gorazde
was the last remaining United Nations safe area in eastern Bosnia, yet
it was repeatedly attacked. Since then, the photographer has obser-
ved the war's impact on his family, and others who came to the city
for safety. Facing page, clockwise from top left: Now living in a former
school, a refugee vows she will never return to her home. A boy
watches his parents work in the fields. The family album: the framed
image is the photographer's grandfather, a partisan in the Second
World War who fought Nazi collaborators. Fifty years later, at the first
sign of shelling in Gorazde, he committed suicide. The photographer's
grandmother remains at the family home.

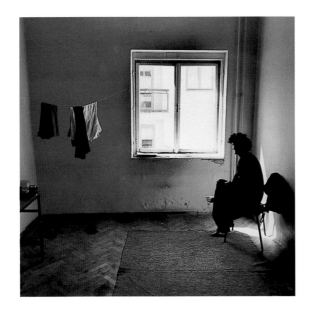

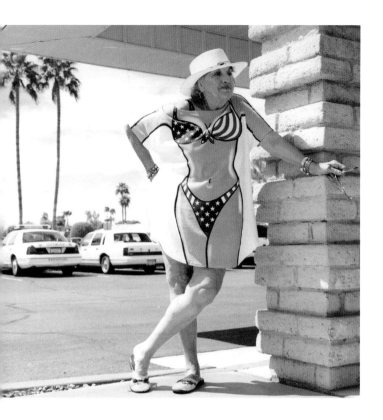 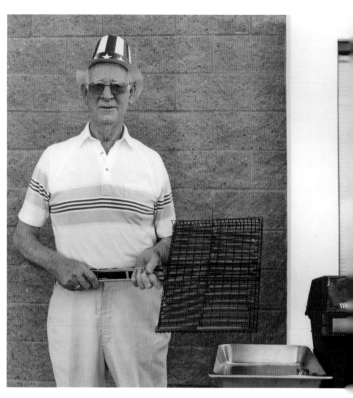

Peter Granser
Austria, photonet-online.de for Stern

3rd Prize Stories

In Sun City, Arizona, 50,000 senior
citizens enjoy a life of leisure in
their own exclusive neighborhood.
With its swimming pools and air-
conditioned homes, the resort is
restricted to those aged over 55.
Founded in 1960, it has its own
churches, theaters, country clubs,
shopping malls, and 200 doctors to
attend to the elderly residents.

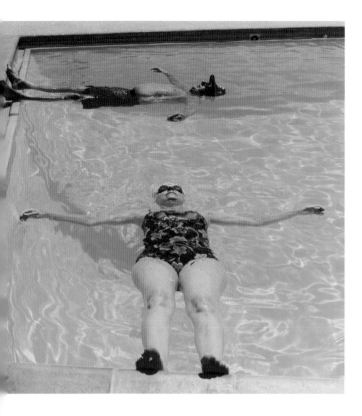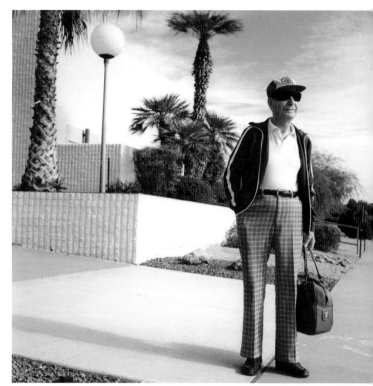

The Arts

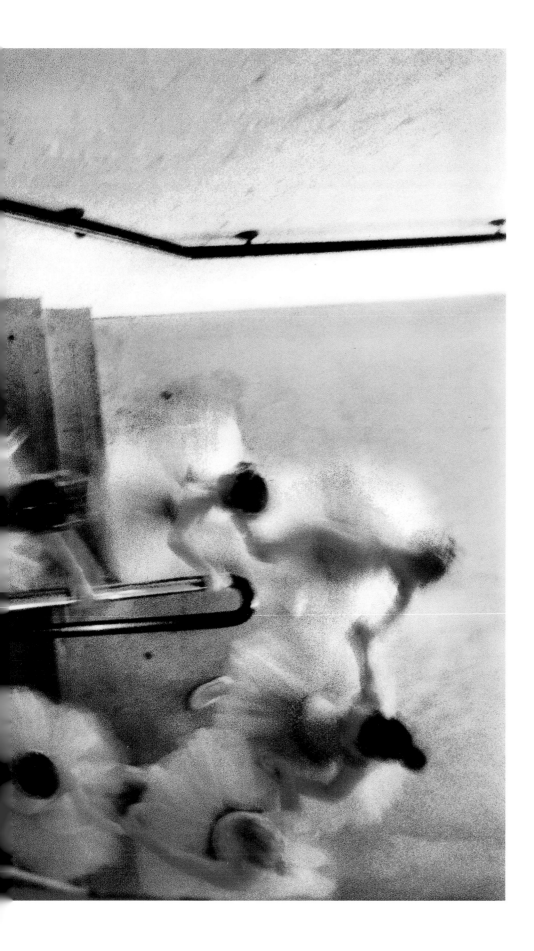

Narelle Autio
Australia, Oculi Photos for
Sydney Morning Herald

1st Prize Singles

Hand in hand, young ballerinas
return to their dressing room
after a performance in
Melbourne, Australia. The dan-
cers, aged from six to eight,
practice every weekend for the
much-anticipated end of year
recital at the Casinia School of
Dance.

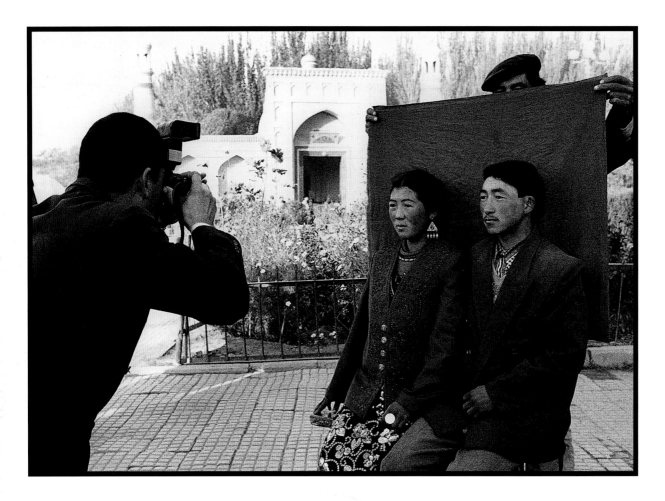

Christian Keenan
UK

2nd Prize Singles

In a popular local custom in Kashgar, The People's Republic of China, young couples like to be photographed at the Id Kah mosque. The Uygur people, who form the majority in the Xinjiang province, follow the Muslim faith. Located in the far west, Kashgar was once a Silk Road oasis, and its mosque is the nation's largest.

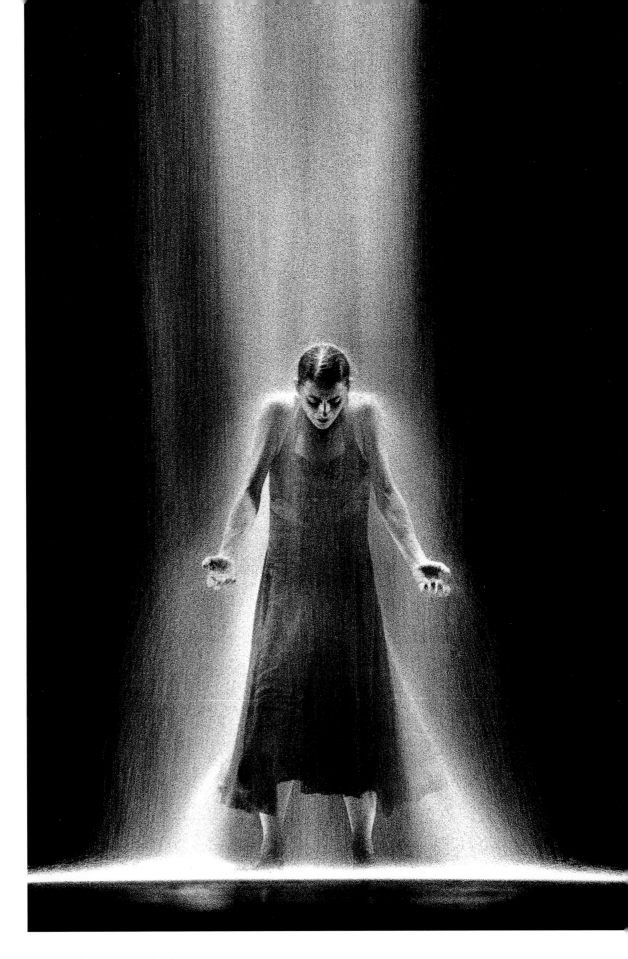

Fernando Marcos Ibañez
Spain, for Compañía Nacional de Danza

3rd Prize Singles

Bathed in light, Emmanuelle Bronein rehearses "White Darkness" at Madrid's Teatro de la Zarzuela in Spain.
The dance piece, choreographed by Nacho Duato, was presented by Compañía Nacional de Danza.

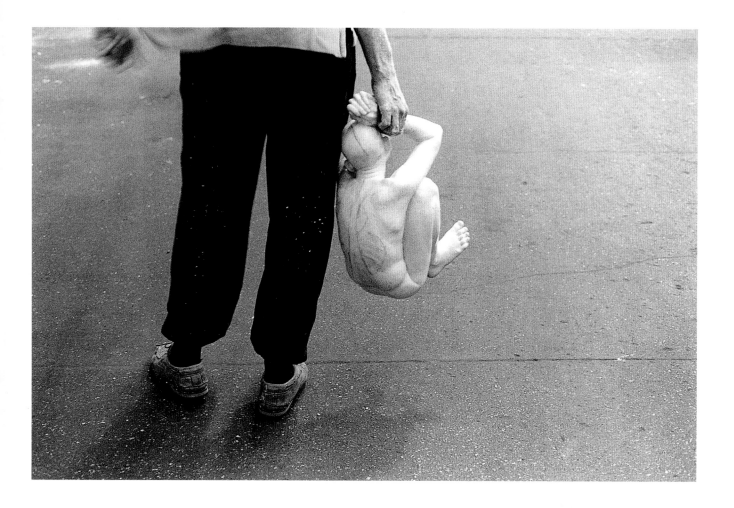

Gautier Deblonde
France, for Anthony d'Offay Gallery/Libération

1st Prize Stories

Ron Mueck's "Boy" grew from small model to huge sculpture in the space of nine months. Originally made for the Millennium Dome in London, it was transported in pieces to the 2001 Venice Biennale. The work began as a 38 centimeter plaster maquette. Right: Mueck gradually increased the scale, working with large polystyrene blocks sliced into horizontal sections. The eyes were cast in a football, and hair made with fishing line. (story continues)

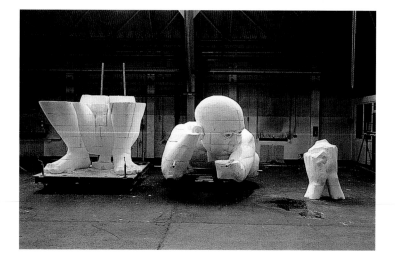

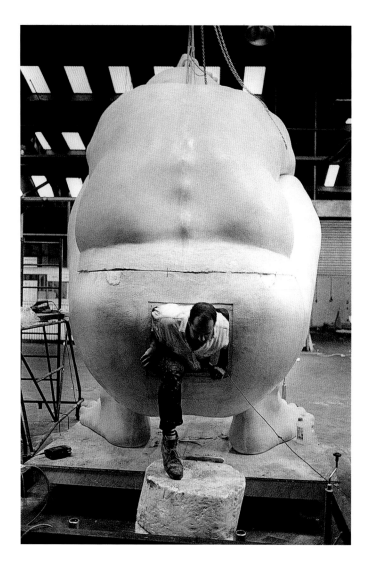 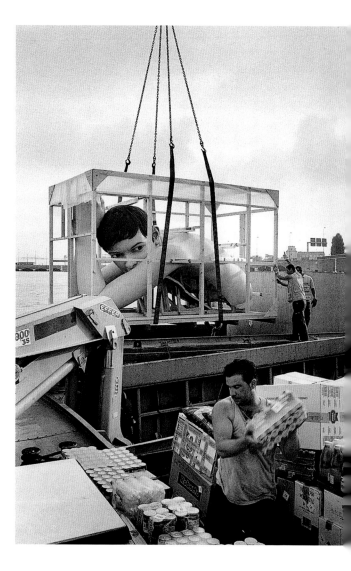

(continued) Mueck brings the boy to life by evoking bones, muscles and limbs. Top, left: A resin used to paint inside each section gave it a flesh tone. Right: Now five meters high, the completed figure is ready to travel, a crouching boy with a wary gaze. Biennale organizers installed it at the entrance to Venice's vast Corderie building.

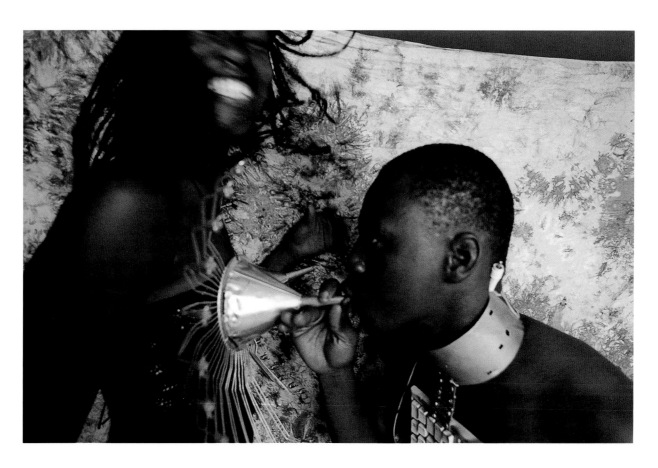

Shobha
Italy, Agenzia Contrasto/Focus

2nd Prize Stories

An explosion of ideas has made Dakar Africa's fashion capital. About 30 ambitious
young designers develop their own personal styles outside the world's better-known
fashion centers. Top: Fashion students find inspiration in unusual items, creating a
bustier top out of a funnel. (story continues)

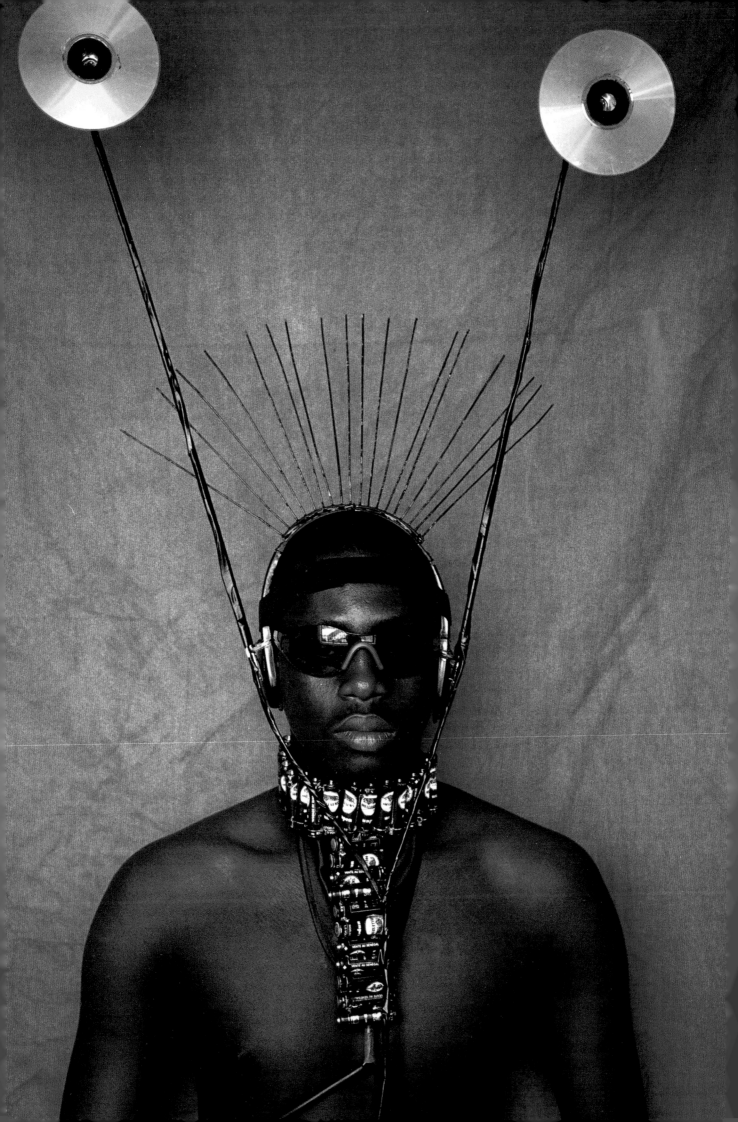

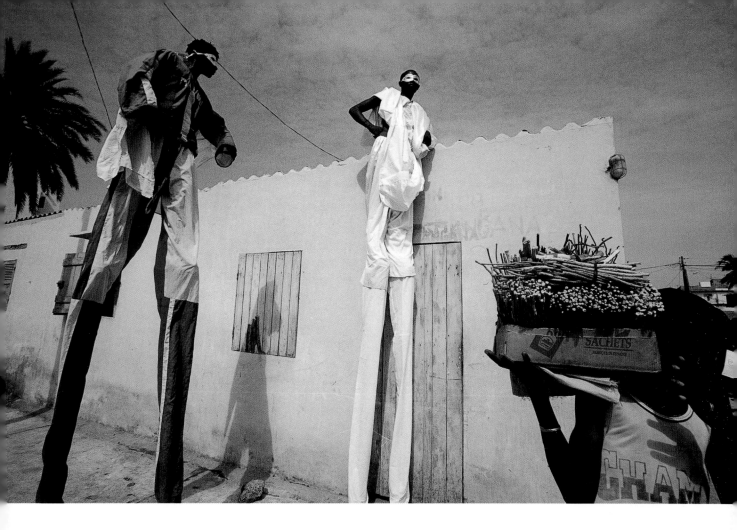

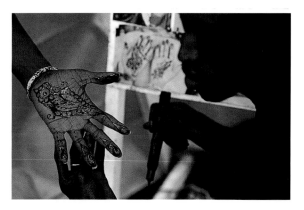

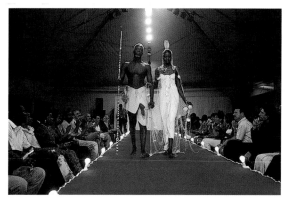

(continued) An annual international fashion week takes place at the same time as the Dakar Carnival, leading to some unexpected sights. Top: stilt walkers take fashion to new heights in the old town. Above left: The women of Senegal decorate themselves with henna tattoos during celebrations. Above right: A bridal gown with a fishnet for a veil. Facing page: A battery necklace and CD antennae make original accessories for a model.

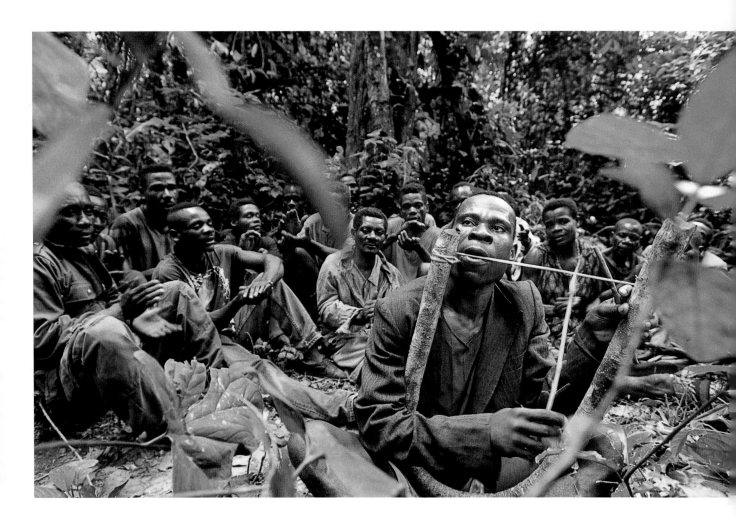

Harald Schmitt
Germany, Stern

3rd Prize Stories

In the Central African Republic, Aka pygmies create musical instruments out of
their environment. String instruments, flutes and drums are made from tree
branches and vines in the dense jungle where musicians gather to play. Facing
page, below right: Carrying their wooden instruments, the musicians arrive at
Berlin Airport, having been invited to perform at the Berlin Philharmonic.

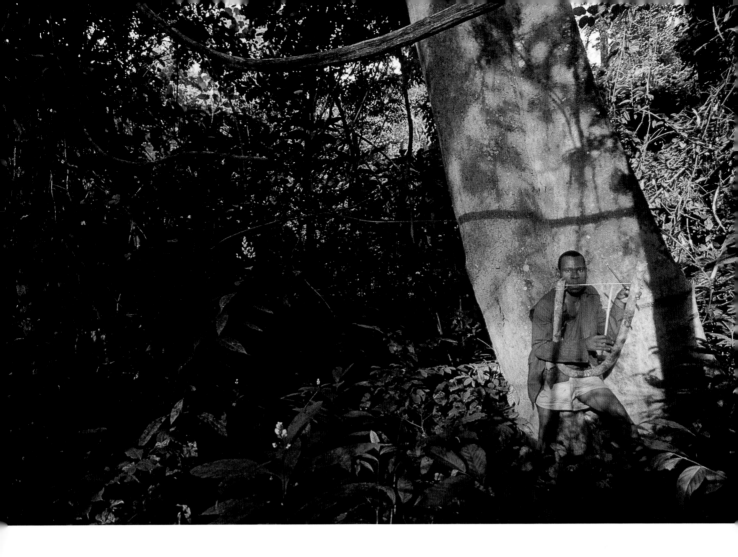

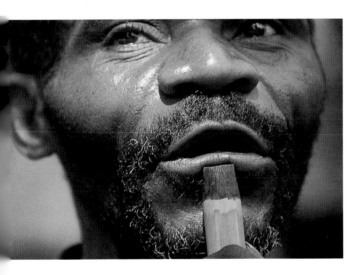

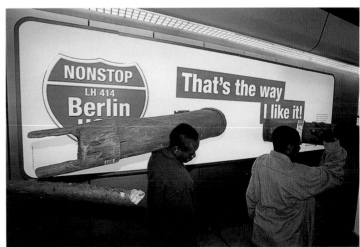

Sports

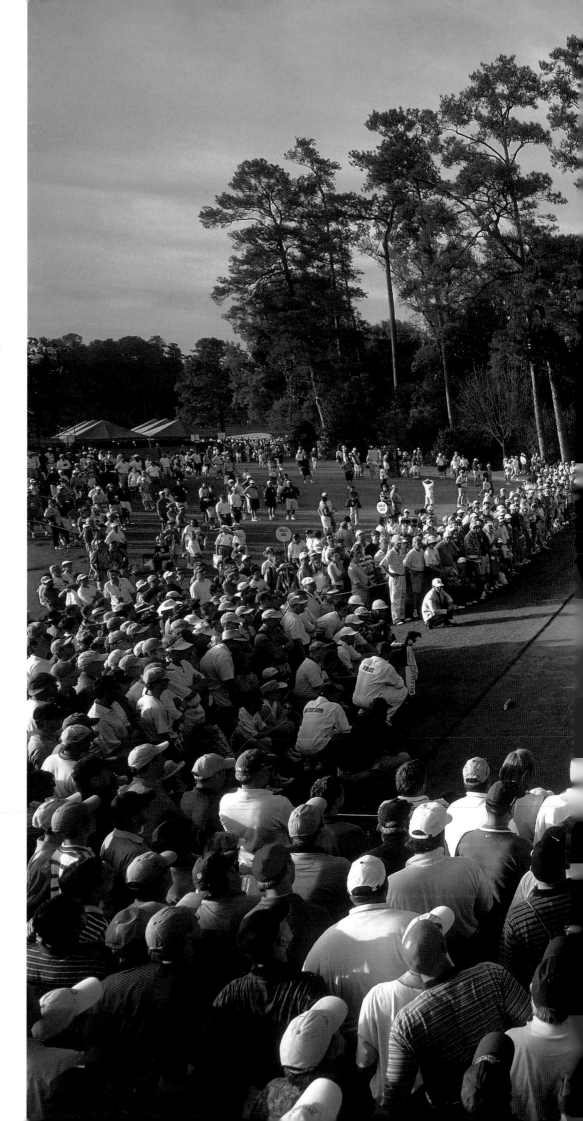

Fred Vuich
USA, Sports Illustrated

1st Prize Singles

Tiger Woods tees off on the 18th hole, at the Masters tournament in Georgia, USA. The American played the final hole under par, on his way to winning the event for a second time. Ranked number one in 2001, he also became the first golfer to hold all four of the major professional titles simultaneously.

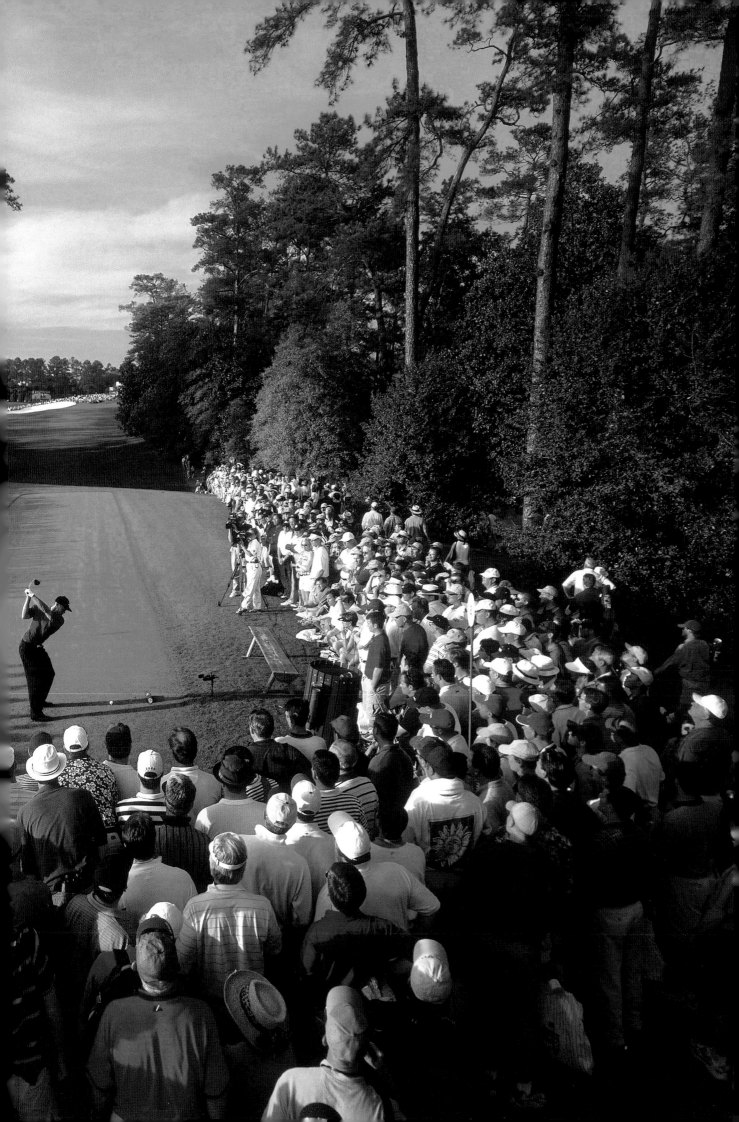

Carlos Puma
USA, The Press-Enterprise

2nd Prize Singles

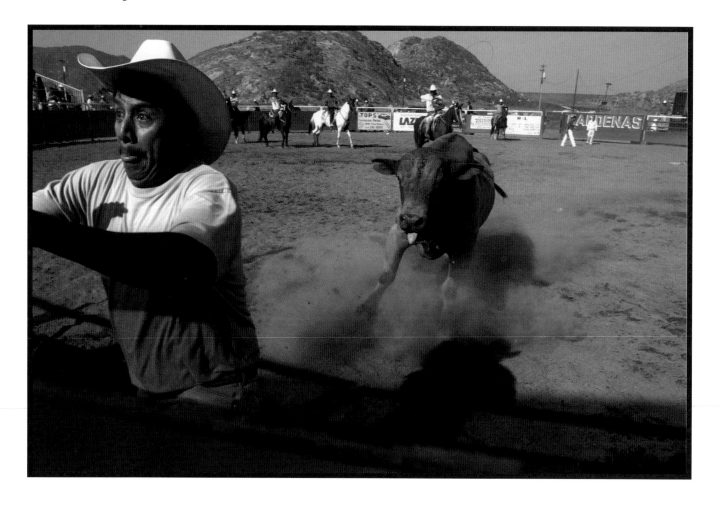

Juan Carlos Valdez runs for the fence at a *jaripeo*, a Mexican ro-
deo, in California, USA. A popular event deriving from Northern
Mexico, the jaripeo is a test of courage and skill for the men
who ride the bucking bulls. At the Lake Perris Fairgrounds ro-
deo, Valdez's job was to distract the beast when it threw off ri-
ders. Events took a dangerous turn, but he narrowly escaped
the charging bull.

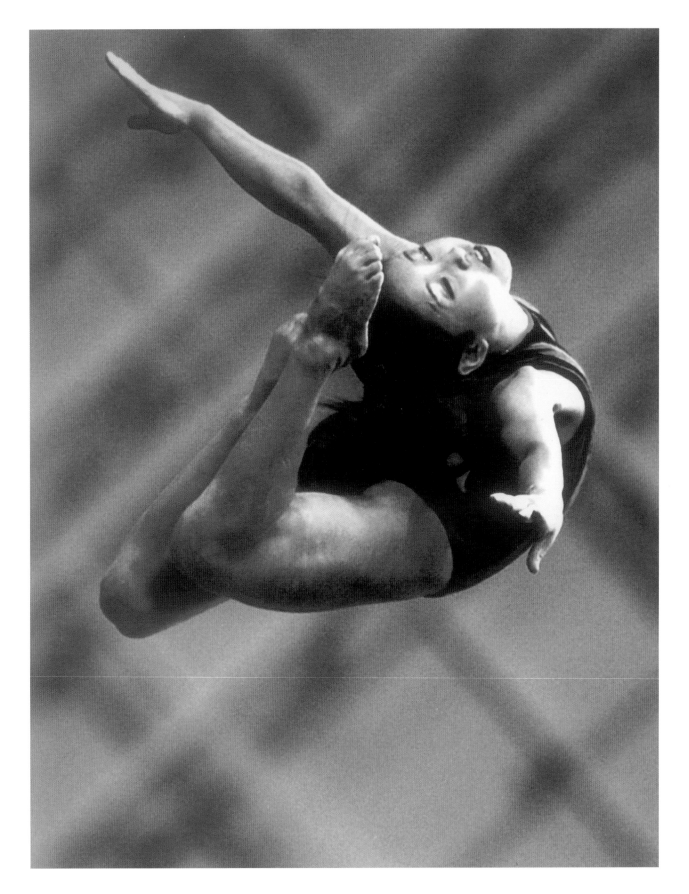

Jia Guorong
People's Republic of China, China News Service

3rd Prize Singles

Chinese gymnasts practice from an early age to compete in world championships. Competition is fierce, and the physical effort arduous. In Guangzhou province, a young competitor embarks on a long process, to defeat first her provincial rivals, and later those at the top of their field, to win national selection.

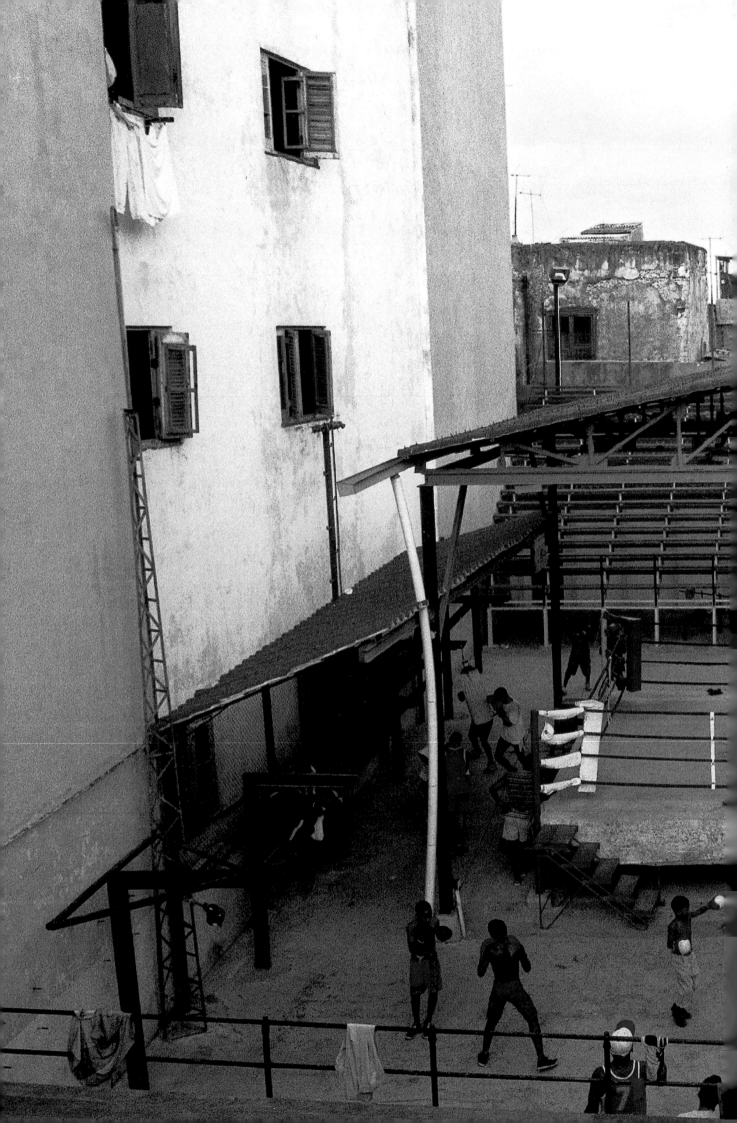

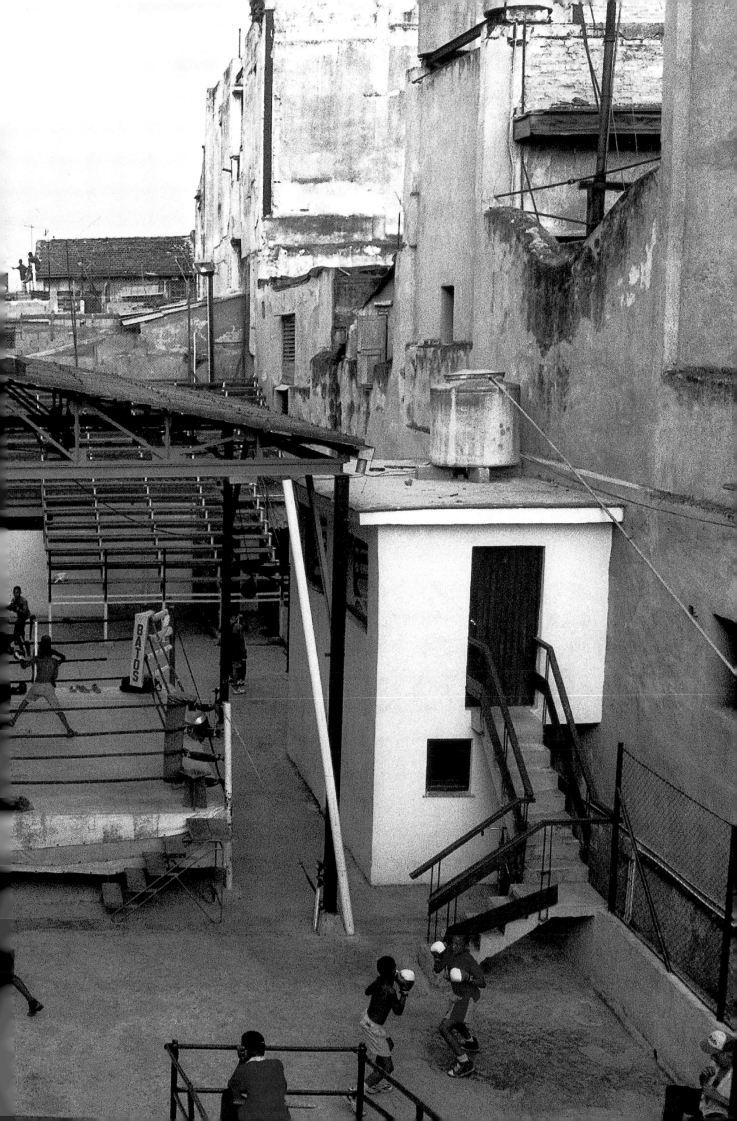

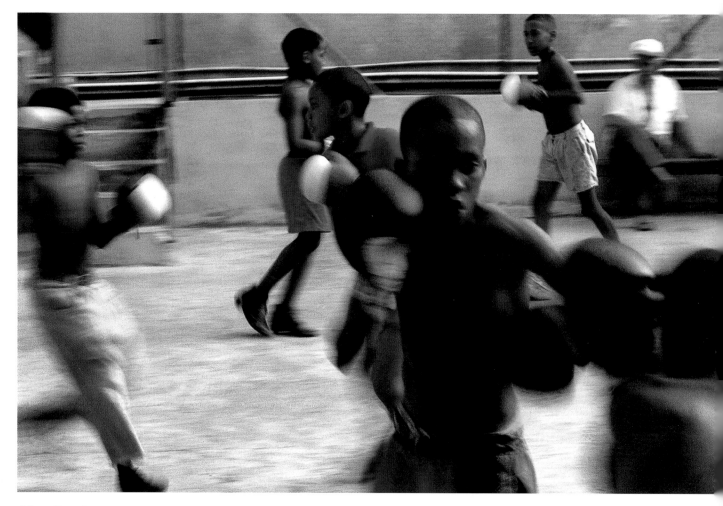

Alex Garcia
USA, Chicago Tribune

1st Prize Stories

Previous spread and these pages: Cuban boys train at the Rafael Trejo boxing gym, wedged between buildings in old Havana. Top: Bouts continue under the eyes of coaches who watch for those with particular promise. Hundreds of such gyms in Cuba nurture young athletes' skills. Facing page, top: Michel Sarria Menendez pauses for breath after successfully advancing in a regional tournament. Coaches expect his hard work could earn him a coveted place in Cuba's Olympic team. Below: A boxer bounces off the wall in training. The boys use whatever facilities are available to hone their skills.

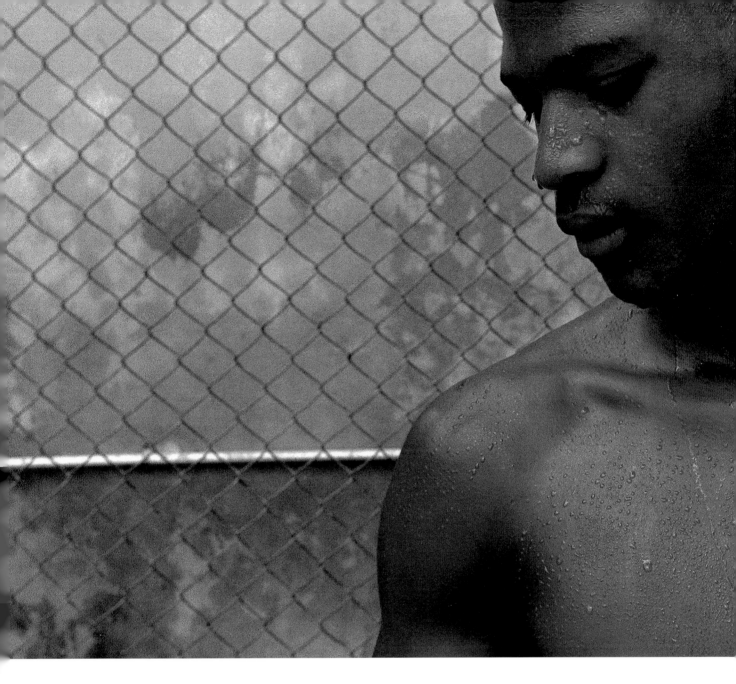

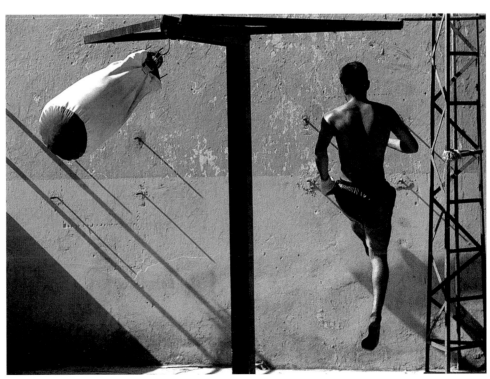

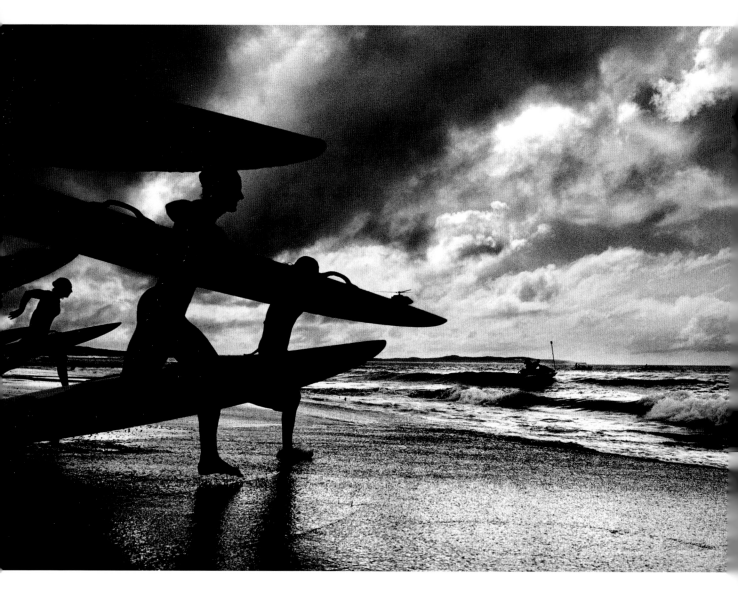

Craig Golding
Australia, Sydney Morning Herald

2nd Prize Stories

At beaches along Australia's coastline, surf lifesavers participate in tough physical competitions to develop their skills. Surf Lifesaving Australia is one of the world's largest volunteer organizations, with more than 100,000 members. From September to April, lifesavers complete a required number of hours on patrol, before competing on the sand and in the sea. Top: The start of the open women's board event at a Sydney club carnival. Facing page, top: Competitors in the women's five-person rescue and resuscitation event feed out a belt line to their team members performing the rescue. Below: Passing the baton at the New South Wales state championships. (story continues)

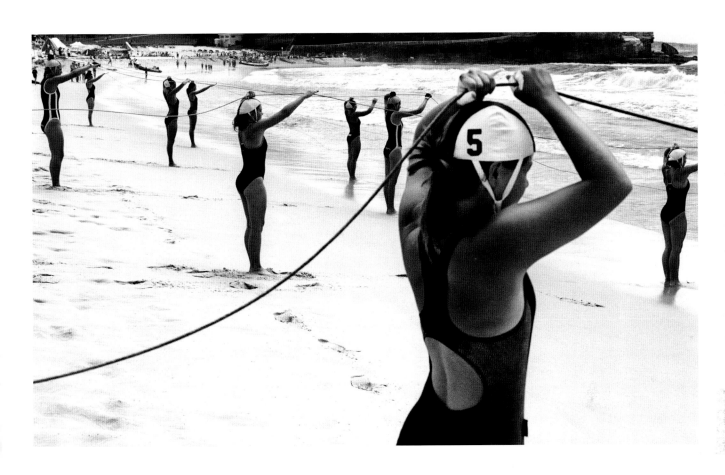

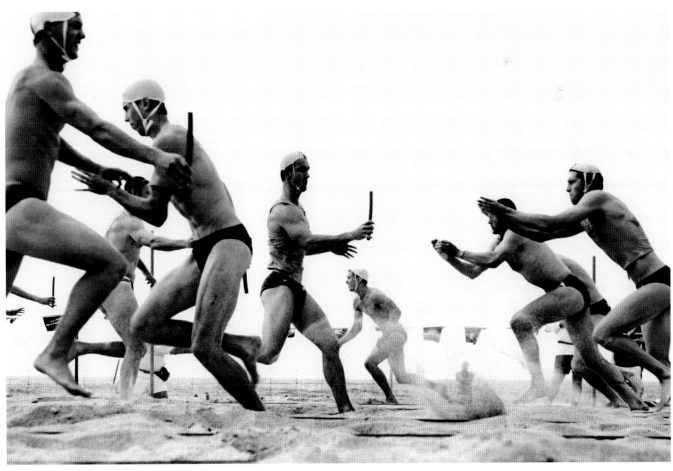

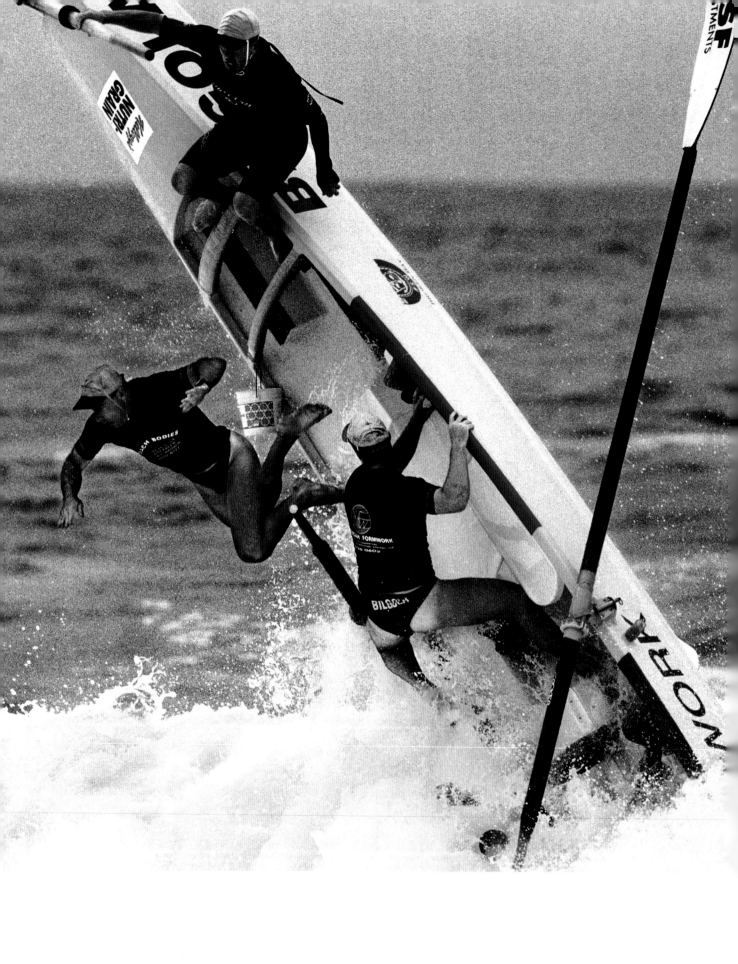

(continued) Facing page: At Maroubra beach, the Bilgola Reserve crew falls from its boat, swamped by waves. This page: A competitor stretches, preparing himself for the men's surf race at the Australian championships in Queensland.

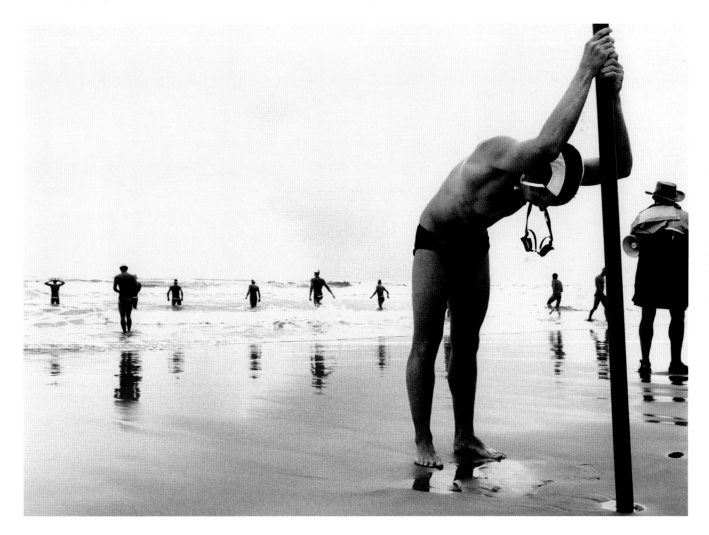

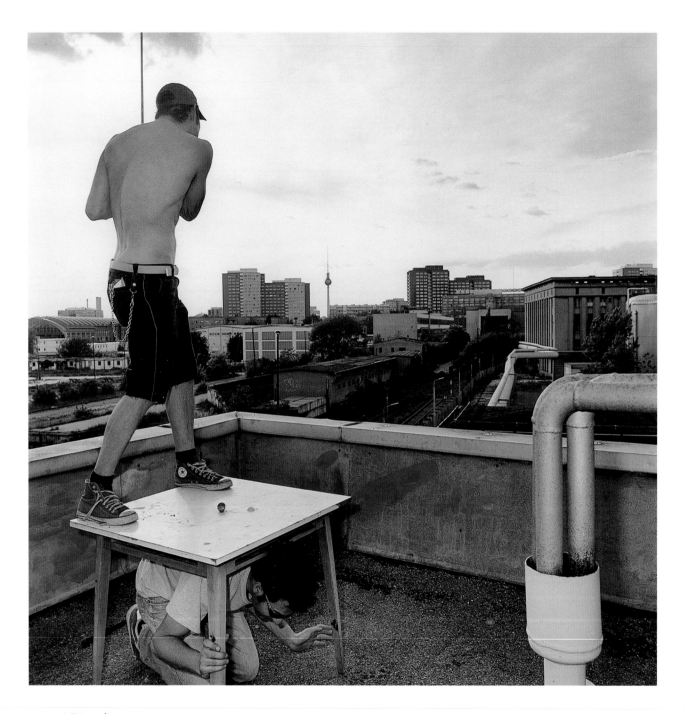

Jens Rötzsch
Germany, Ostkreuz

3rd Prize Stories

Turbo golfers in Berlin avoid conventional greens, in favor of rooftops, garbage containers or construction sites. Named after a Swedish punk band, Turbo Negro, the movement claims members all over Europe. (story continues)

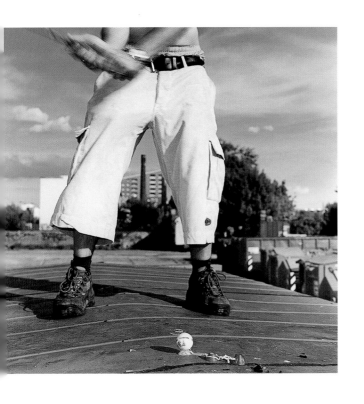
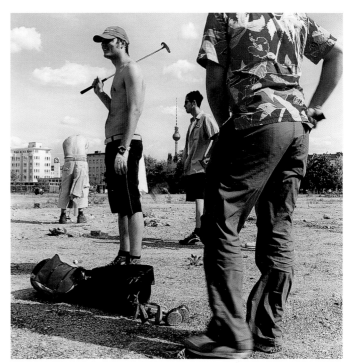

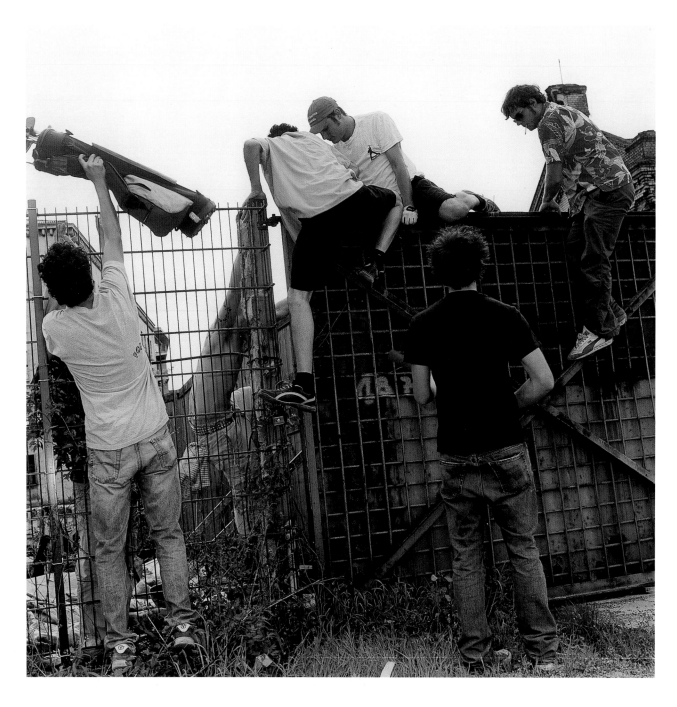

(continued) Turbo golfers find places to tee off on the city's fringe. Their uniforms (jeans and baggy pants), and the loud music they play, keep them out of traditional golf clubs.

Nature and the Environment

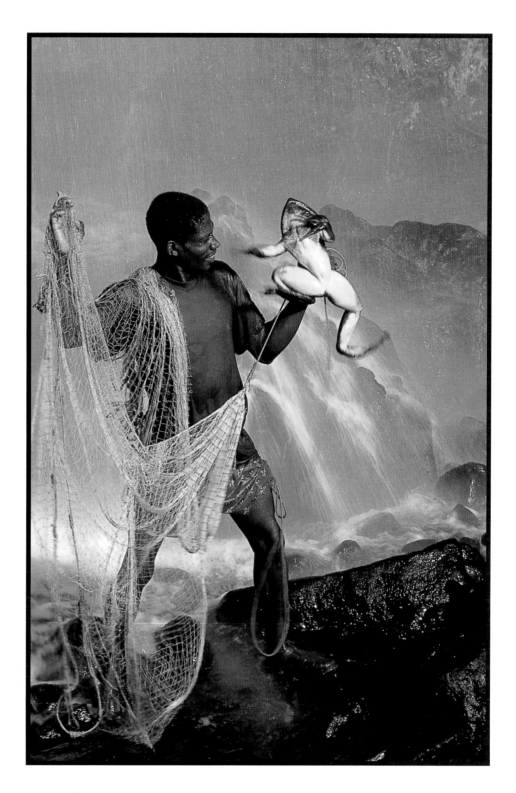

Geneviève Renson
France

1st Prize Singles

Beneath cascading water in Cameroon, a boy catches a rare Goliath frog. Reaching lengths of 90 centimeters, the Goliath is the largest known frog. It lives in a small range in western central Africa, where the frog inhabits swiftly-moving mountain streams. Prized by local tribes as food, the survival of the species is under threat. Its habitat is also in danger of disappearing, as rivers are dammed, and rainforests cleared for farms or villages.

Jim Lavrakas
USA, Anchorage Daily News for
Sports Illustrated

2nd Prize Singles

A rainbow trout peers from the gul-
let of a northern pike, in Anchorage,
Alaska. The bigger fish swallowed the
tiny trout alive in an aquarium, in a
demonstration designed to educate
the public about the pike's predatory
nature. Alaska's Fish and Game
Department suspected pike had
been illegally introduced into the
city's popular fishing lakes, far from
its native waters. Once established,
the voracious pike eat trout and sal-
mon stocks sought by local anglers.

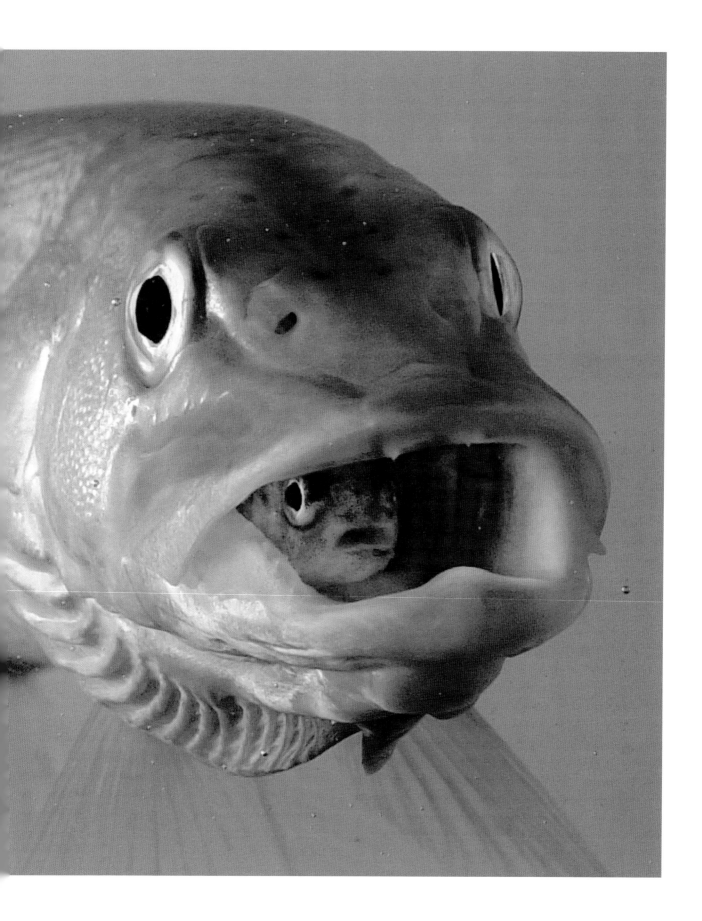

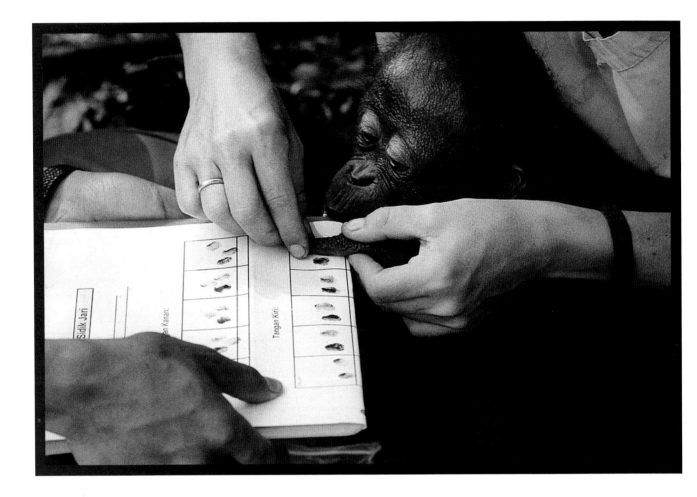

Viviane Moos Holbrooke
USA, Sipa Press

3rd Prize Singles

New arrival Mona gets fingerprinted at an orangutan rehabilitation center in Indonesia. Her vital data is collected, and growth and medical monitoring continue for years, until she is released into the forest. The Nyaru Menteng center in central Kalimantan takes in injured or abandoned orangutans. Through mistreatment by humans, and the deforestation of their habitats, orangutan numbers have fallen.

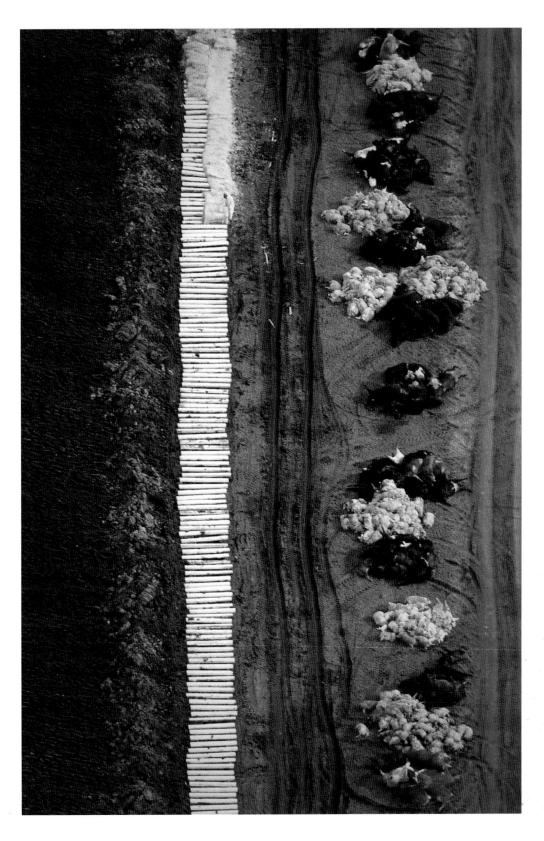

Jeff Mitchell
UK, Reuters

1st Prize Stories

An outbreak of Foot and Mouth Disease in Britain devastated farms across the country. Thousands of animals were slaughtered, bulldozed and buried, to halt the spread of the disease. Cases were also detected in other European countries, prompting widespread debate about modern farming methods. Top: In a field in Cumbria, piles of dead animals await incineration. (story continues)

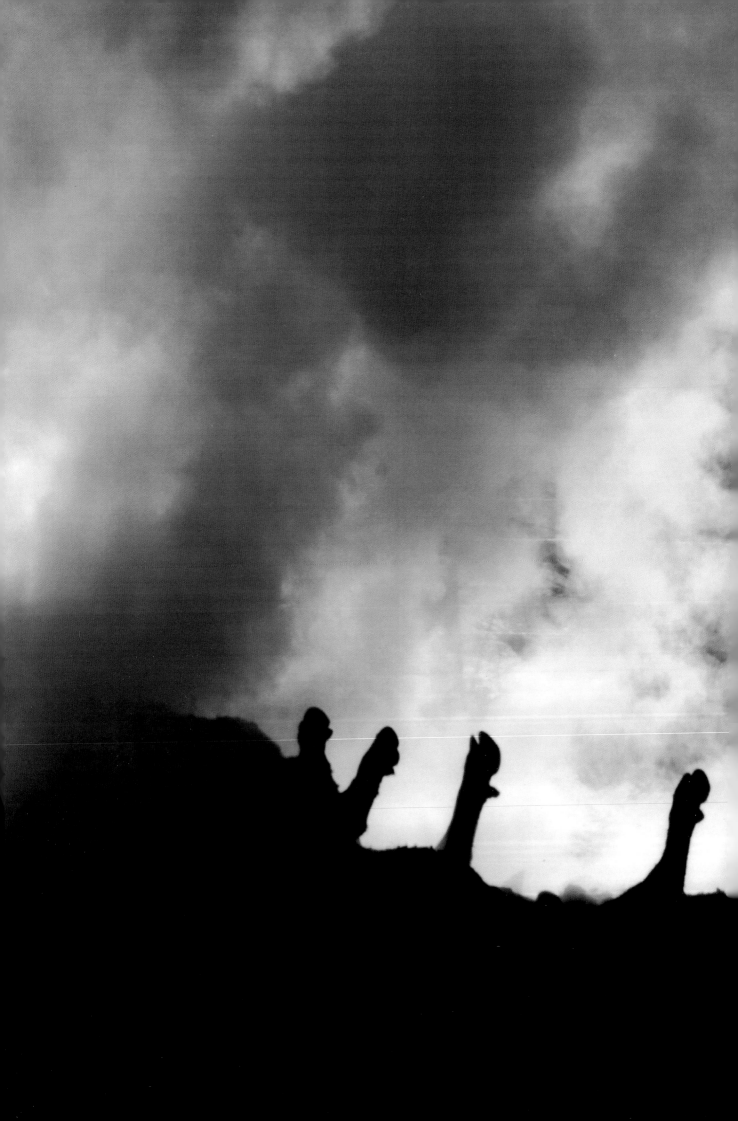

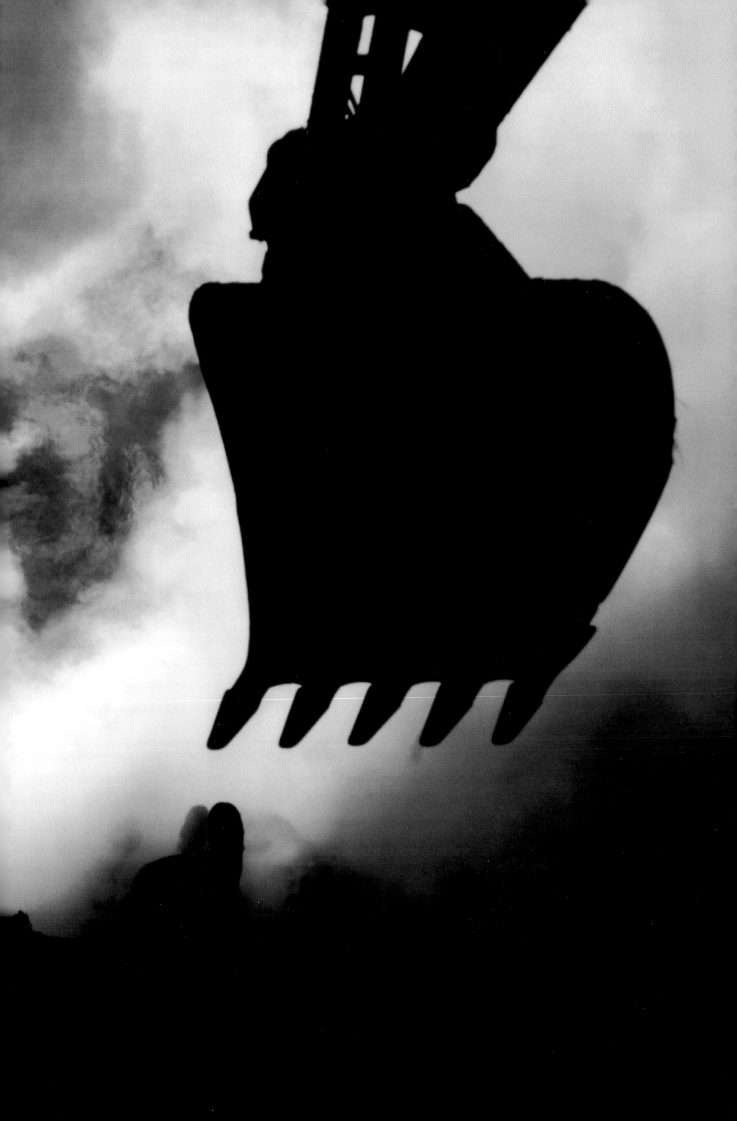

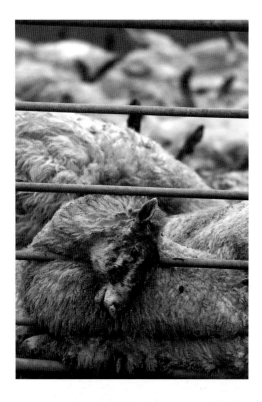

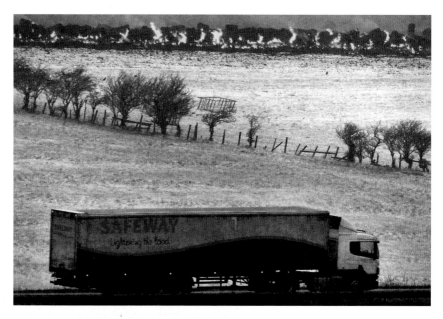

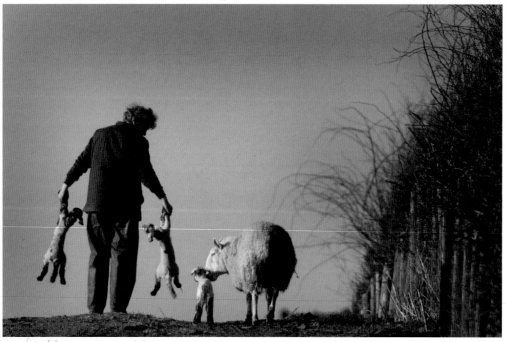

Previous page and this page: Cows, sheep and pigs were destroyed in burning pits on farms from Scotland to England. During the crisis, tensions rose between farmers and agricultural advisers, when apparently healthy animals were also killed, to prevent further outbreaks.

Jozsef L. Szentpeteri
Hungary, Natura-Foto BT

2nd Prize Stories

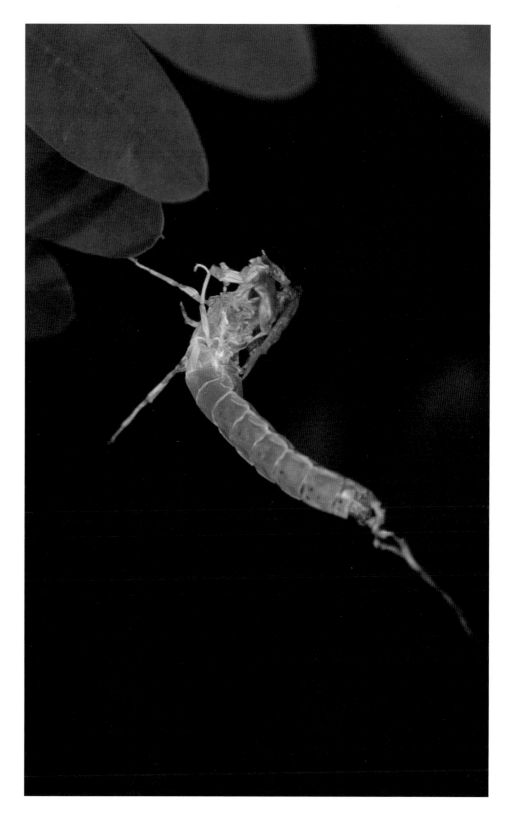

The shed skin of a mayfly larva blows away in the wind. Emerging from Hungary's Tisza river, the hatched Long-tailed Mayfly has just a few hours in which to fly, mate and die. (story continues)

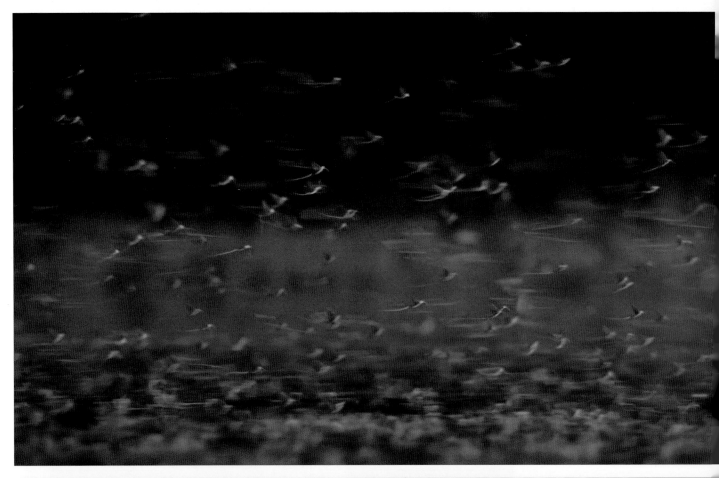
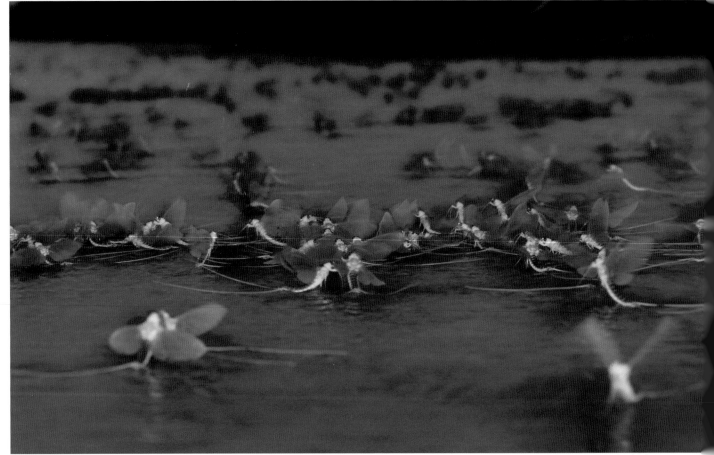

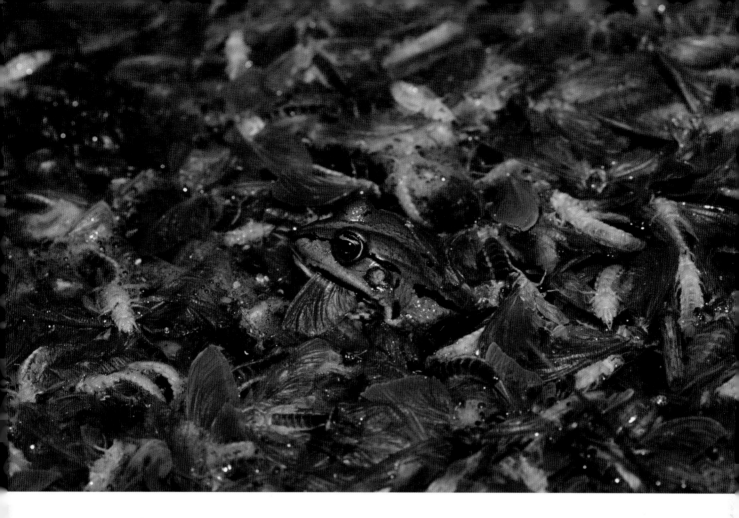

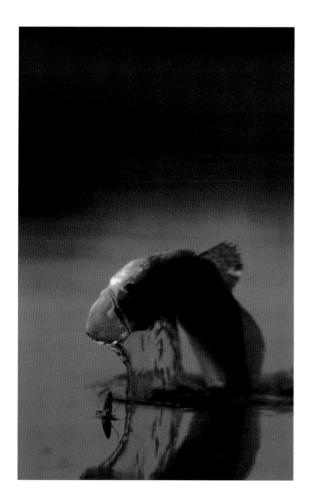

(continued) The swarming of the Long-tailed Mayfly occurs once a year in Hungary's summer. Over a few days, larvae that lay for three years on the bottom of the river rise to the surface within an hour of each other. Millions of larvae cloud the water, before hatching into large winged mayflies. In a brief life cycle, the mayflies mate and lay eggs, but also become food for the river's other creatures. An endangered species, the mayfly is at risk from fishermen seeking bait, and polluted waters.

Facing page: Male mayflies mass in the air searching for females. During courtship, up to 40 males can mate with one female. This page: A frog feeds on a mayfly, surrounded by dead bodies. A fish jumps to catch a mayfly.

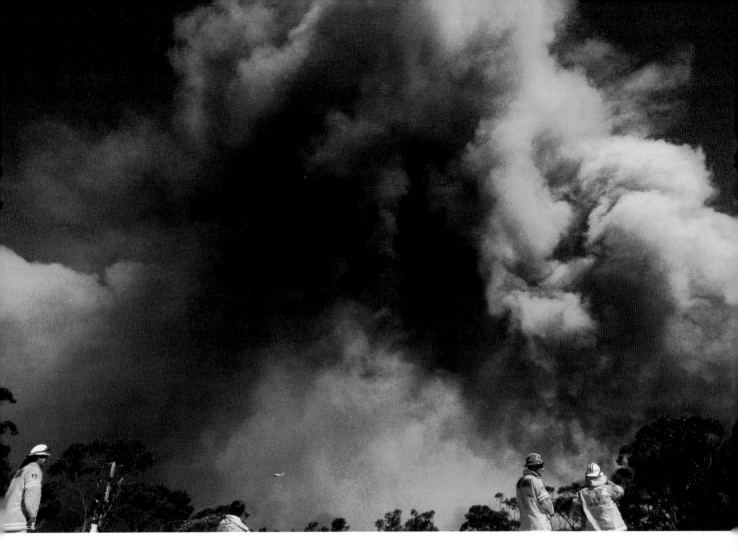

Dean Sewell
Australia, Oculi Photos for Sydney
Morning Herald

3rd Prize Stories

At 4am on Christmas Eve, a single lightning bolt ignited the
most destructive bushfires in Australia's history. Within days,
more than 100 fires were burning out of control near Sydney,
forcing the evacuation of 3000 people. Arson was suspected,
as new fires broke out, testing the efforts of 10,000 firefighters
battling the flames. (story continues)

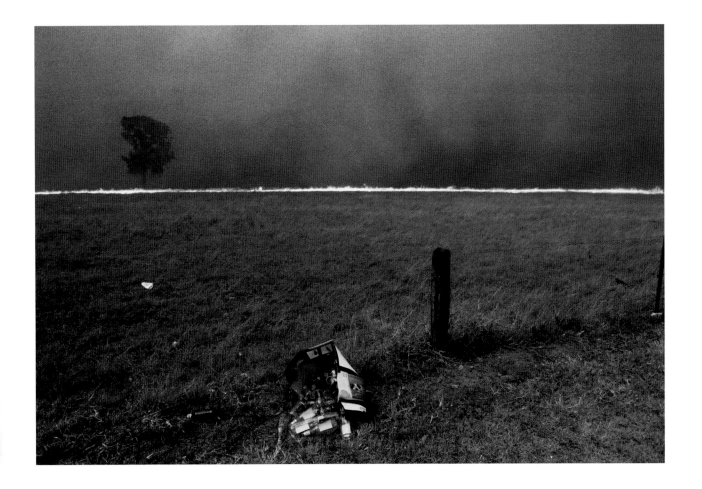

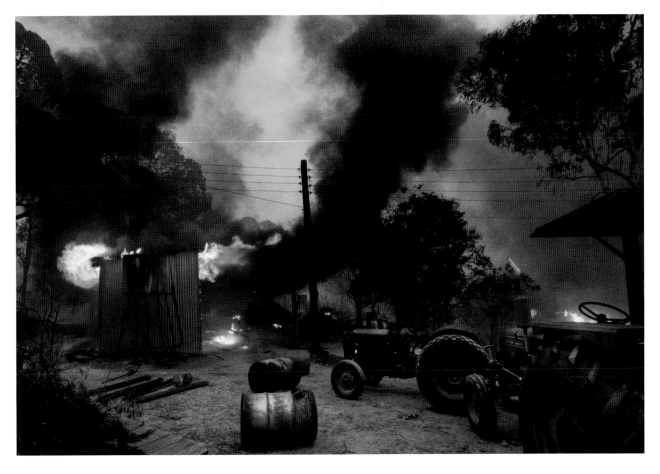

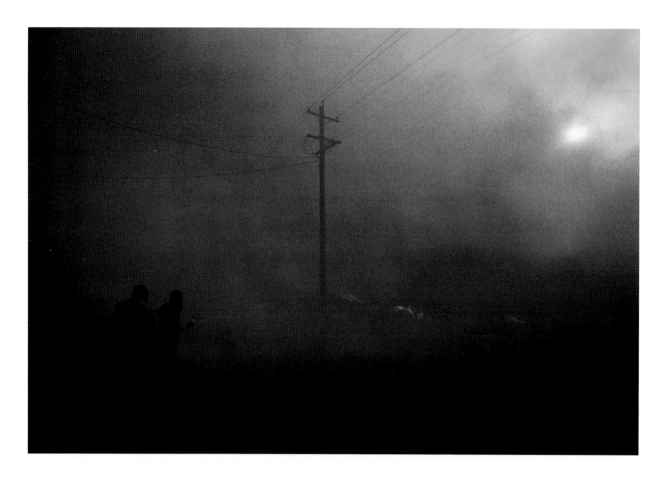

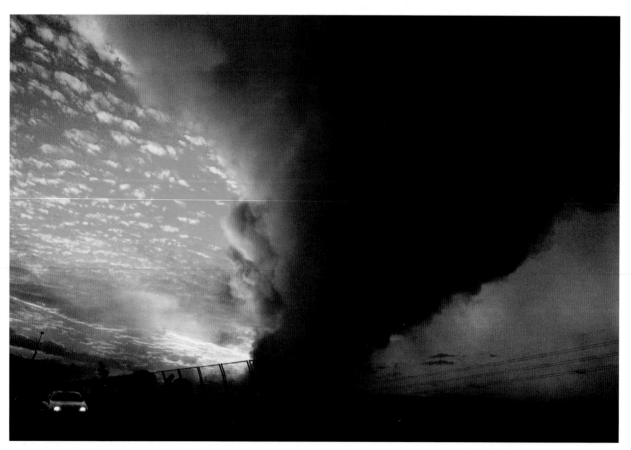

(continued) Hot, dry and windy weather combined to fuel the bushfires, producing the worst conditions possible for firefighters.

Science and Technology

John Costello
USA, The Philadelphia Inquirer

1st Prize Singles

Doctors test the wiring that moves William Kilbride's hand for the first time since his accident. At New Jersey's Cooper Hospital, USA, surgeons used a new muscle stimulation system for quadriplegics called "Freehand". In a seven-hour operation, they first attached eight electrodes to muscles inside his right arm. Then a small Implanted Receiver Stimulator, similar to a pacemaker, was placed in Kilbride's chest. The stimulator, activated by shoulder movements picked up by a sensor, sends electrical signals through thin wiring to the electrodes, causing the muscles to contract. When surgeons turned on the power, his fingers curled. Weeks later, Kilbride could feed himself, with help, and write his own name.

Martin Sasse
Germany, Laif Photos &
Reportagen for Focus

2nd Prize Singles

Women wait for cosmetic eyelid
surgery at Bangkok's Yanhee
Hospital. Many young women in
Thailand strive for a popular
Eurasian look.

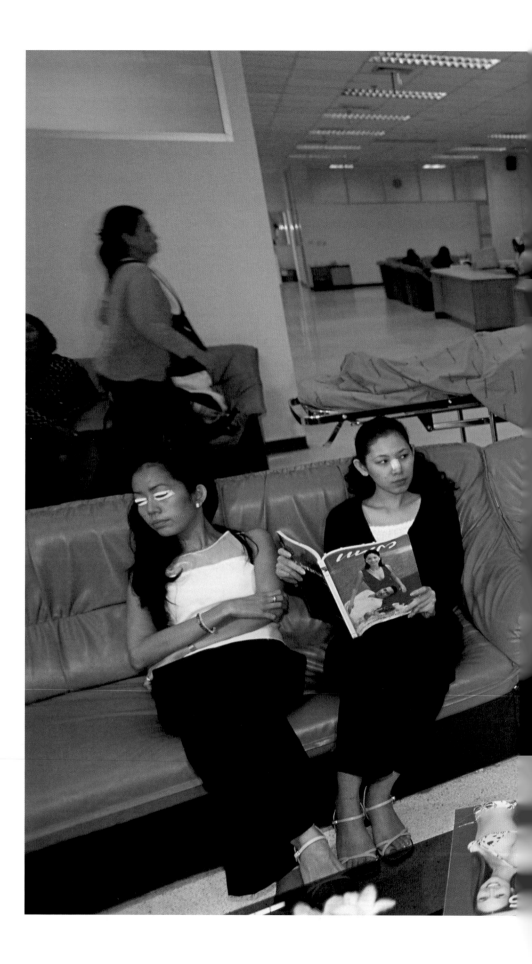

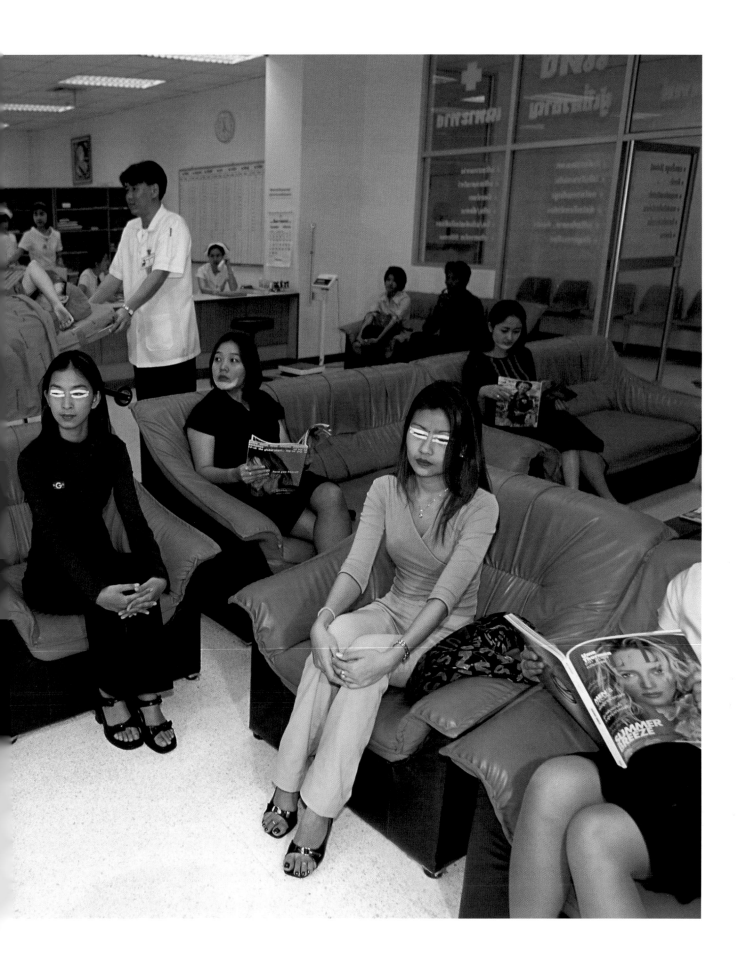

Stefan Boness
Germany, Ipon/Panos Pictures

3rd Prize Singles

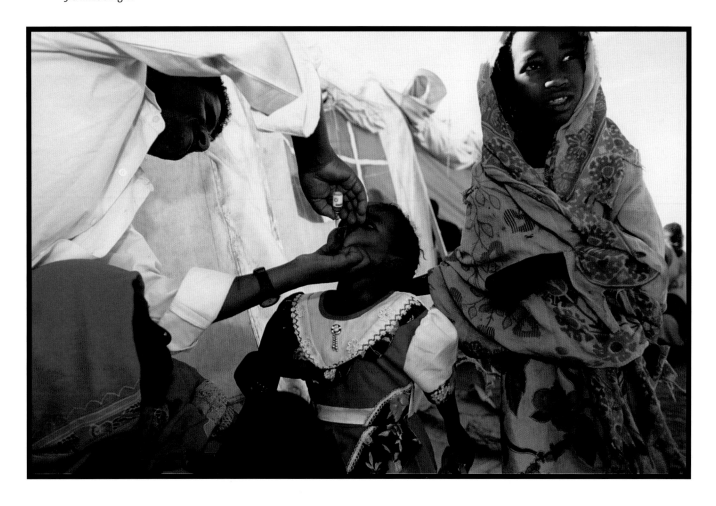

A girl receives a polio vaccination at a health station in Eritrea. Local authorities organized the vaccinations as part of an Africa-wide campaign, to eradicate polio from the continent. Hearing loudspeaker announcements from a mobile clinic, mothers in the village of Dresa took their children to receive the vaccine. While non-existent in many parts of the world, the disease remains a threat, prompting a World Health Organization global initiative to free the world of polio by 2005.

Zijah Gafic
Bosnia-Herzegovina, Agenzia Grazia Neri

1st Prize Stories

Men dig to uncover mass graves in Bosnia-Herzegovina. A number of international organizations are involved in exhuming bodies, in an effort to identify any of the 27,000 people missing after the Bosnian war of 1992-5. (story continues)

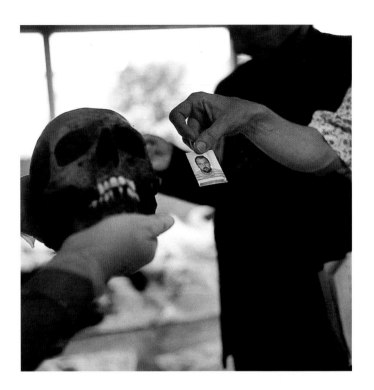
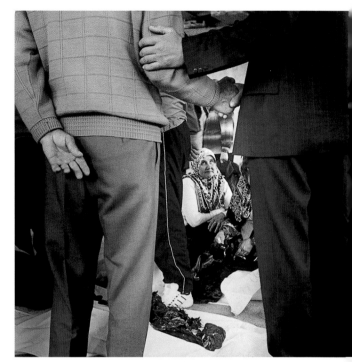
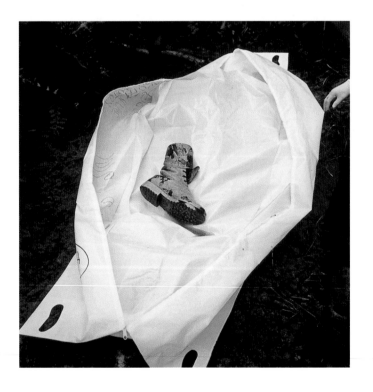
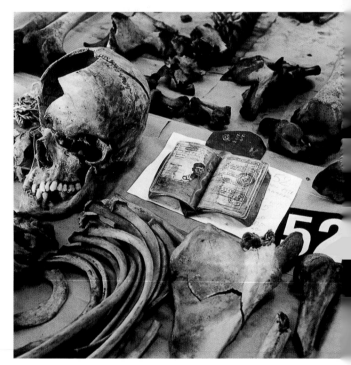

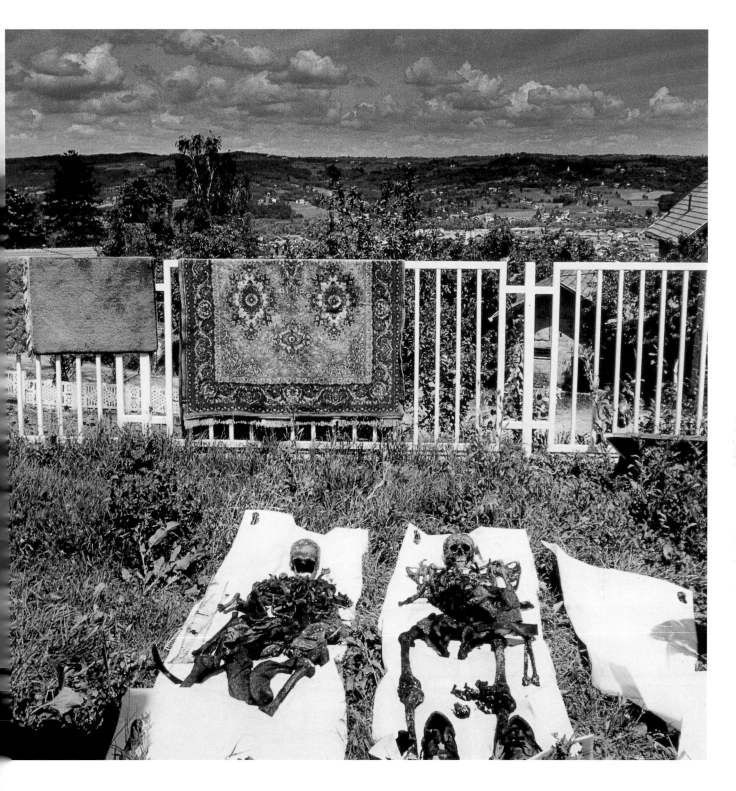

(continued) Investigators use forensic techniques to examine bones and other remains at several locations. Facing page, clockwise from top left: A woman holding a photograph of her brother, is told the skull is his. During the projects, families are interviewed for any information that could link exhumed remains to individuals. Personal effects are often recovered, along with skeletons.

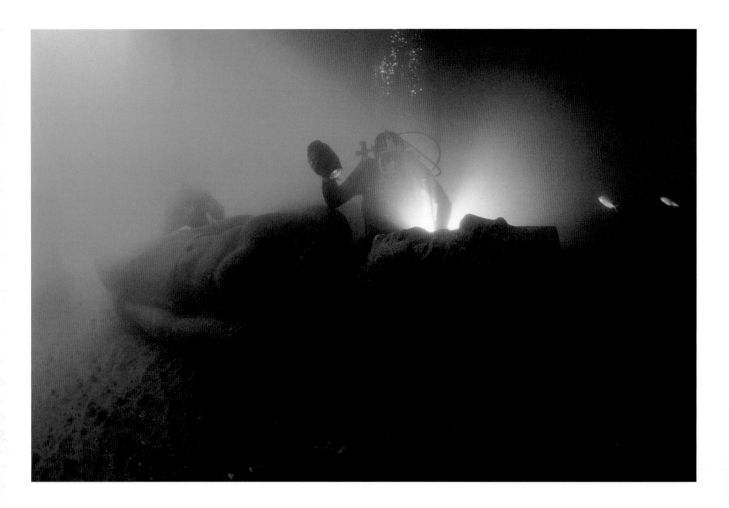

Christoph Gerigk
Germany, for Franck Goddio/Hilti Foundation

2nd Prize Stories

In the Mediterranean Sea, at the site of the ancient city of Herakleion, archeologists search for antiquities preserved in the deep. Top: Divers in Egypt's Abu Qir Bay examine a colossal statue of a Pharaoh dated between 4th and 6th century BC.
Right: Archeologists clean red granite statues of a Ptolemaic queen and Hapi, a divinity of the Nile. Facing page: Fragments are assembled on a platform anchored above the excavation site.

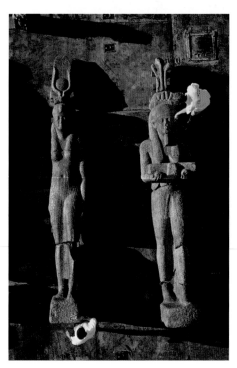

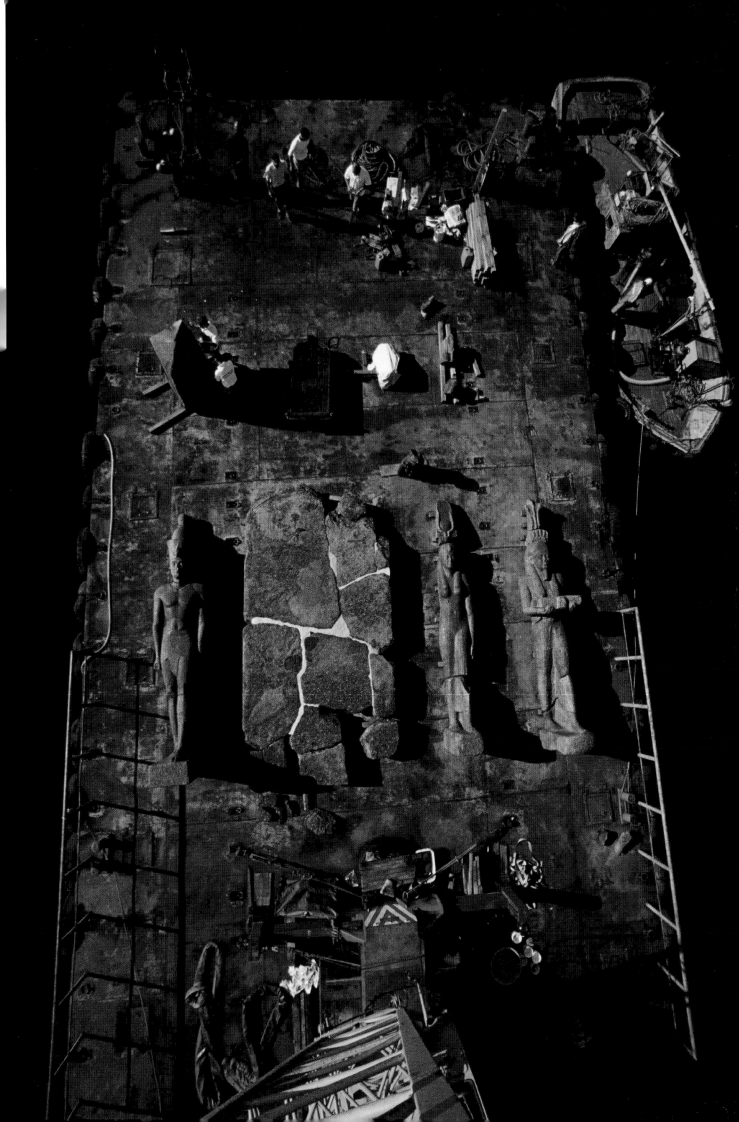

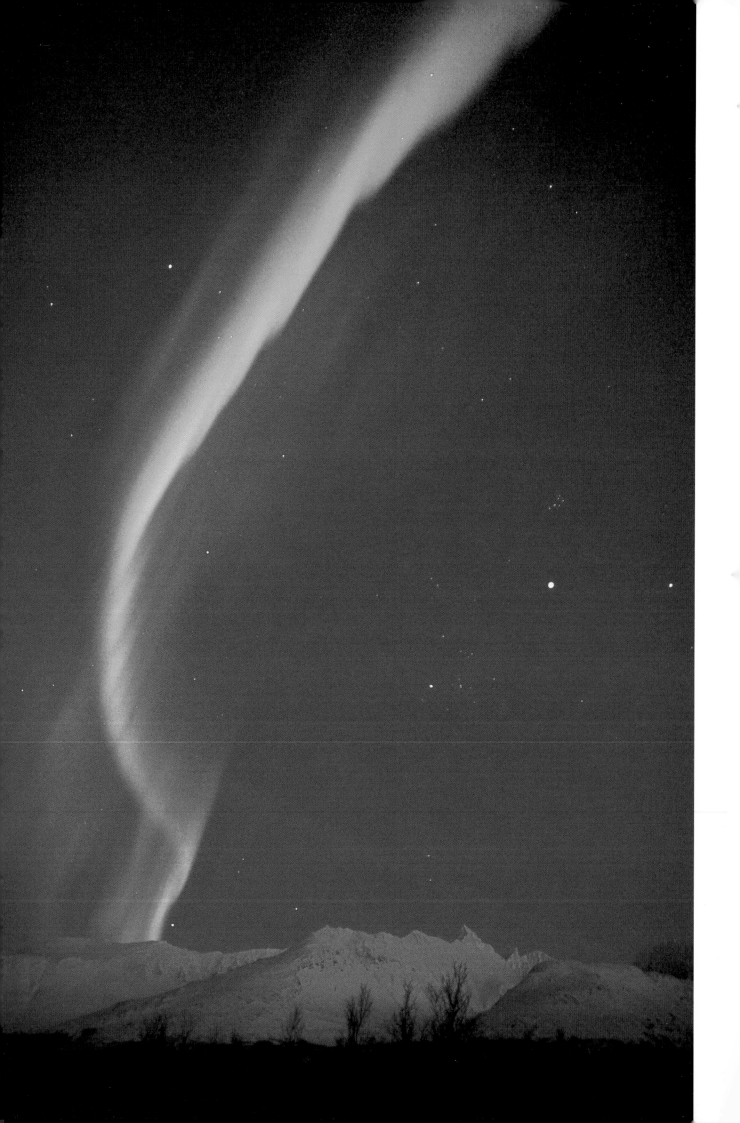

Olivier Grunewald
France

3rd Prize Stories

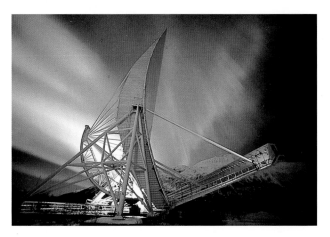

The Northern Lights - or Aurora Borealis - are produced when solar wind, eruptions of electrified particles from the sun, collide with Earth's magnetic field. These magnetic storms can also damage satellites and other telecommunications installations. In a new scientific field, researchers at Norway's EISCAT base are pionee-ring space meteorology, to forecast the weather in space. This page: Using a high frequency dish as large as a football ground, EISCAT's observers record data from space. Top: The University of Tromsø has restored an early experiment from 1913. Using a "ter-rella", or miniature model earth, in a vacuum chamber, physicist Kristian Birkeland created an artificial aurora of color, replicating the effects of solar wind. Facing page: In the period 2000-1, incre-ased solar activity led to particularly intense light displays.

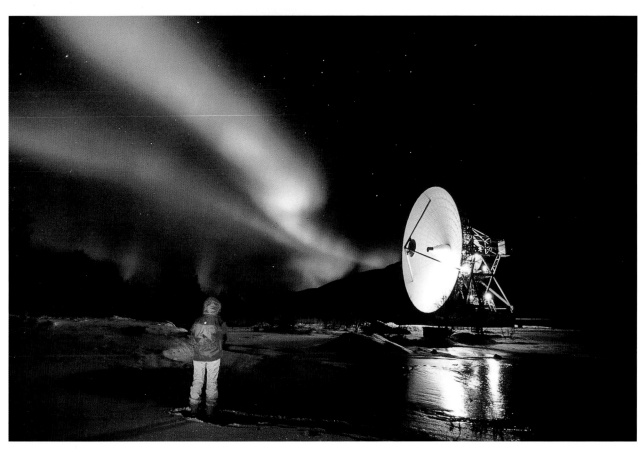

Daily Life

Mike St Maur Sheil
Ireland, Black Star for Anti Slavery International

1st Prize Singles

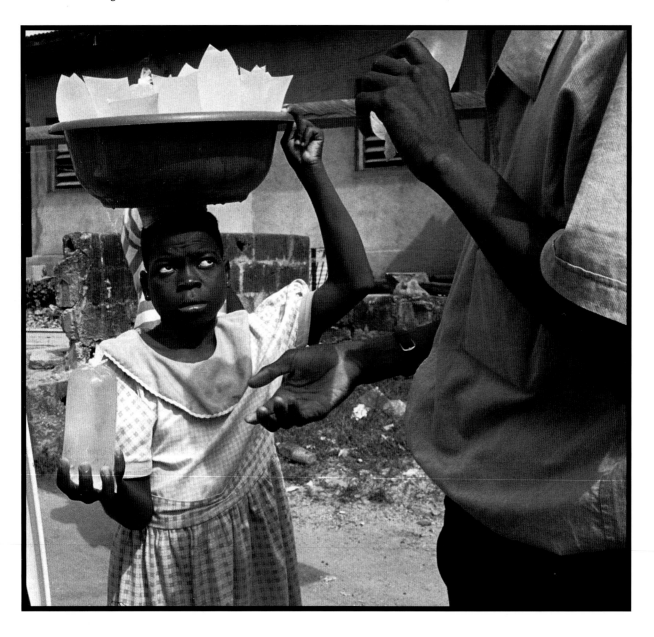

A girl from Togo sells water in Libreville, Gabon. The container is too heavy to lift, so she must sell all the water before she can put it down. Trading in child workers is illegal, but continues to grow in parts of West Africa. The children, many under 12, are often sold in Benin and sent to work in city streets, or on cocoa plantations.

Markus Jokela
Finland, Helsingin Sanomat

2nd Prize Singles

With basketball star Dikembe Mutombo due to arrive, young fans in Kinshasa race to find the best seats. Born in the Democratic Republic of Congo, Mutombo has become one of the USA's most successful sportsmen. He maintained links with his homeland by establishing an aid foundation to improve health and living conditions. On a trip home to open a hospital bearing his mother's name, he received a hero's welcome.

Raul Rubiera
USA, The Miami Herald

3rd Prize Singles

Members of the Revolutionary Armed Forces of Colombia (FARC) search a bus passing through territory they control. The main left-wing rebel group in the country's 38 year-old civil war finances its activities largely by taxing drug trade. Granted a safe haven in 1998 by President Pastrana, the FARC has been engaged in peace negotiations with the government but has maintained its military offensive, taking violence and kidnapping to record levels.

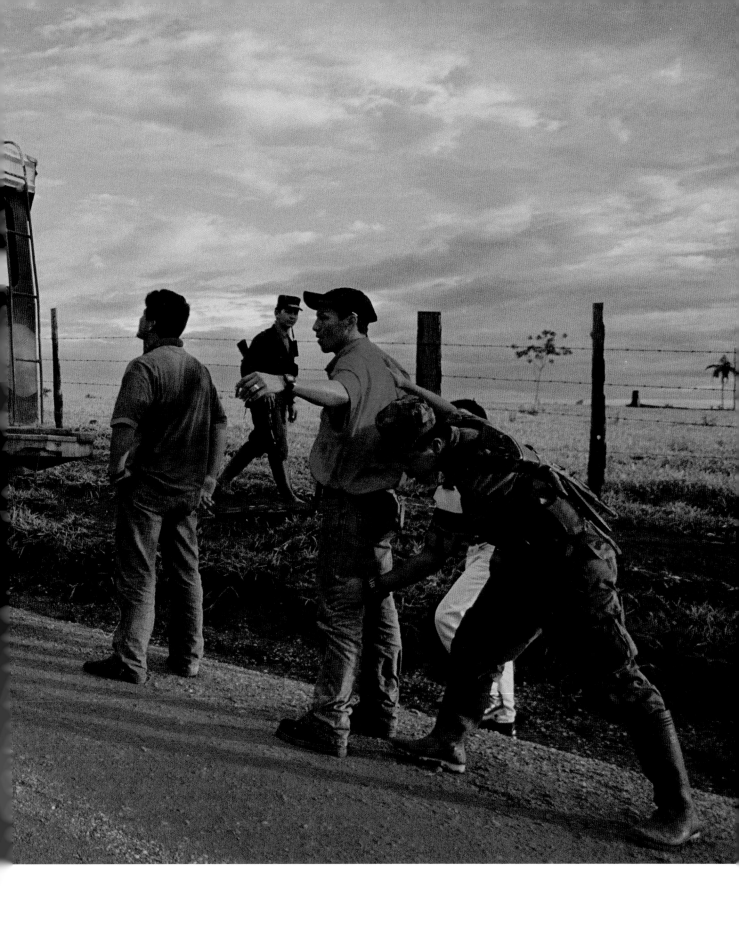

Aleksander Nordahl
Norway, Dagbladet

Honorable Mention Singles

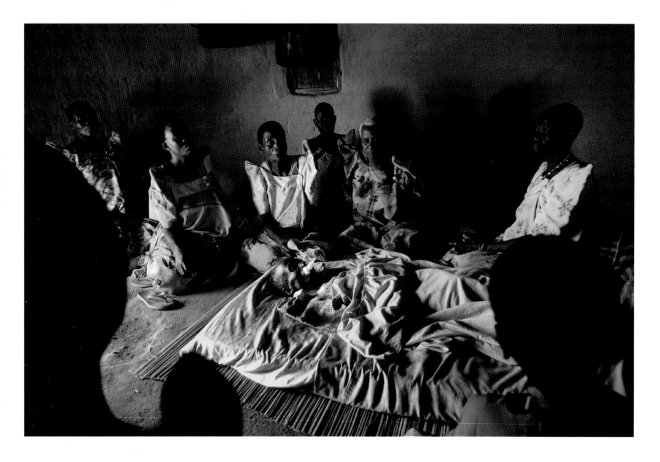

Ester Njaburu died from AIDS, leaving four children. The children had already lost their father,
who died several years ago. Even though Uganda has taken the lead in AIDS prevention efforts
in Africa through education, it still has a high number of orphans.

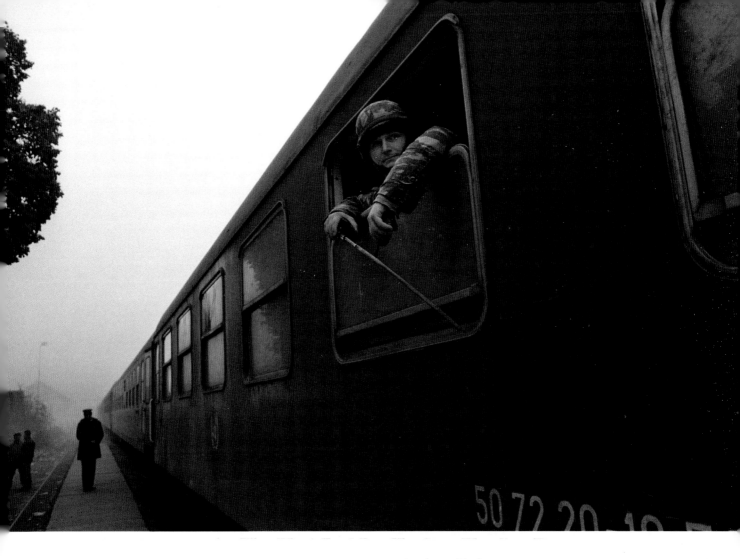

Andrew Testa

UK, Panos Pictures for The New York Times

1st Prize Stories

A heavily-guarded train provides the only safe way for Serbs and Romas to travel through Albanian-dominated parts of Kosovo. Passengers face the risk of revenge attacks, after the massacre of thousands of Kosovar Albanians by Serb forces in the 1999 conflict. Set up by NATO, the train runs from near the capital Pristina through a string of villages until it reaches the Serb strongholds of North Mitrovica and Zvecan in the province's north. International KFOR soldiers guard the passengers, who are split into three sections - Serbs at the front, Romas at the back, the middle reserved for Albanians. Following pages: Serb passengers leave the train at Zvecan station. (story continues)

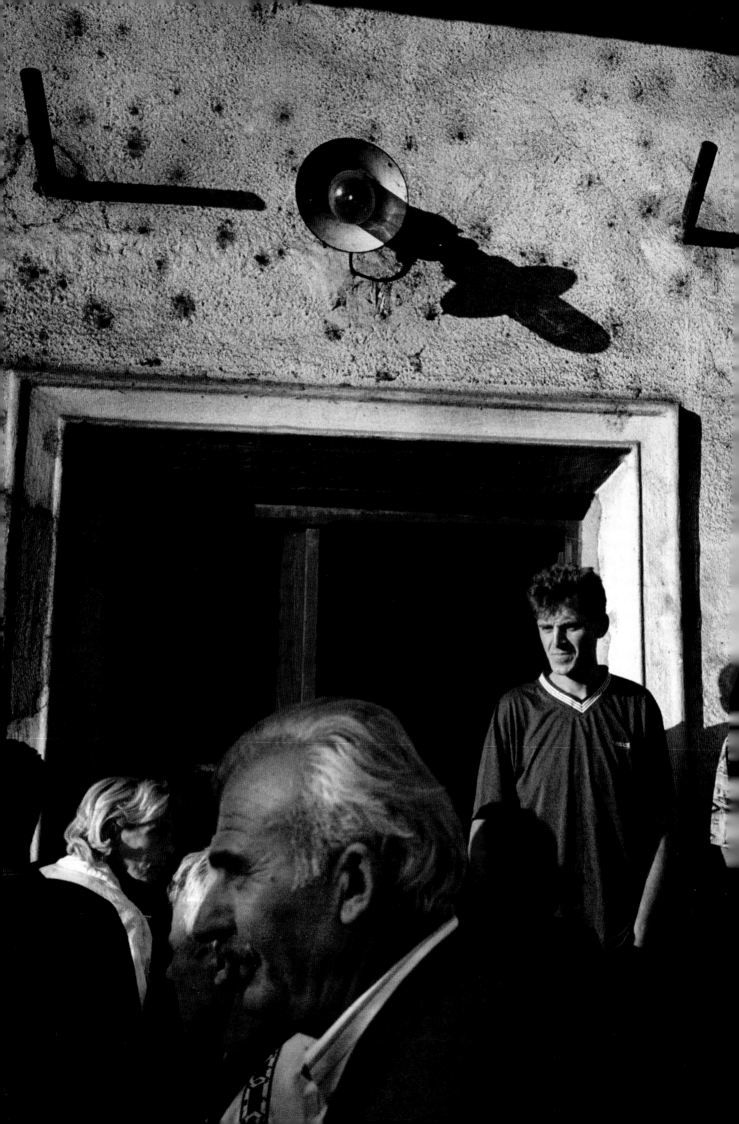

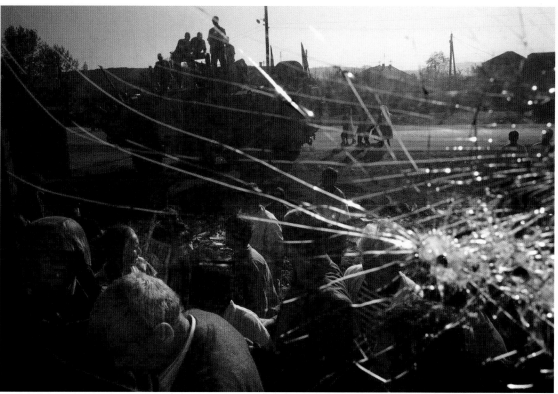

(continued) The train itself has been bombed in Albanian and Serb areas. Carriages and tracks are now patrolled. Above: Windows have repeatedly been smashed by Albanians throwing stones, and by Serbs when KFOR attempted to use Albanian conductors. Top: Finnish troops guard a Serbian Orthodox Church near the train's starting point.

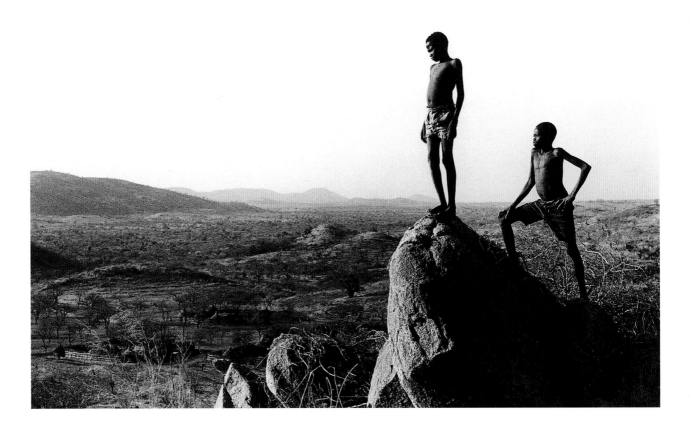

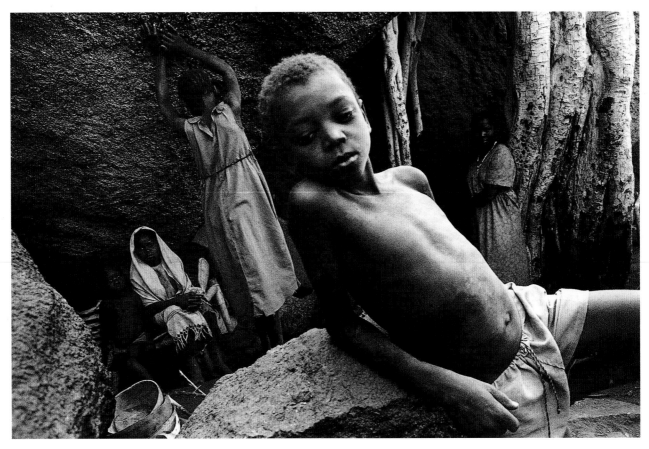

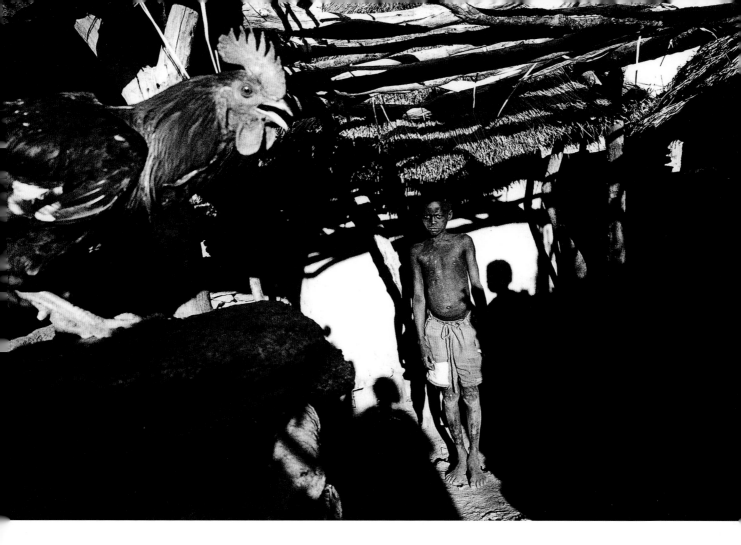

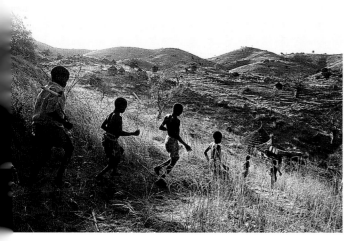 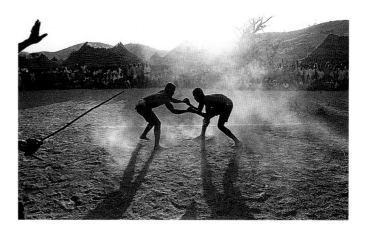

Francesco Zizola
Italy, Agenzia Contrasto for Max

nd Prize Stories

n the mountains of central Sudan, the Nuba people struggle to preserve a culture under threat. The Nuba have lived in the
naccessible and remote region for hundreds of years. However, their numbers are dwindling, as fierce fighting between
overnment troops and the Sudan People's Liberation Army forces thousands to flee, moving to urban centers for food and
helter. Displaced, or forced to hide in caves, they also face hostility from the fundamentalist Muslim government which has
eclared Nuba Mountain Islam to be heretical.

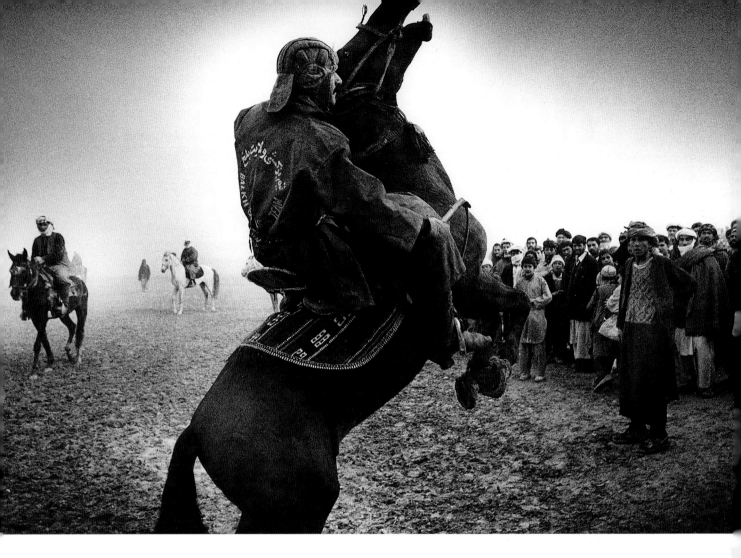

Tim Dirven
Belgium, De Morgen/Panos Pictures

3rd Prize Stories

After years of drought, warfare and a US-led bombing campaign, the people of Afghanistan try to maintain their traditions. The fall of the Taliban regime brought some stability, but widespread malnutrition and harsh living conditions remain. Top: The national sport of buzkashi was banned by the Taliban, but it remained hugely popular. Horsemen who, weeks before, took part in combat, now show their speed and skill on the sports field. Facing page, top: Critically ill after giving birth, a woman is carried to hospital. Her family traveled for several hours through the desert near Meymaneh. Below: The women of Mazar-e Sharif. (story continues)

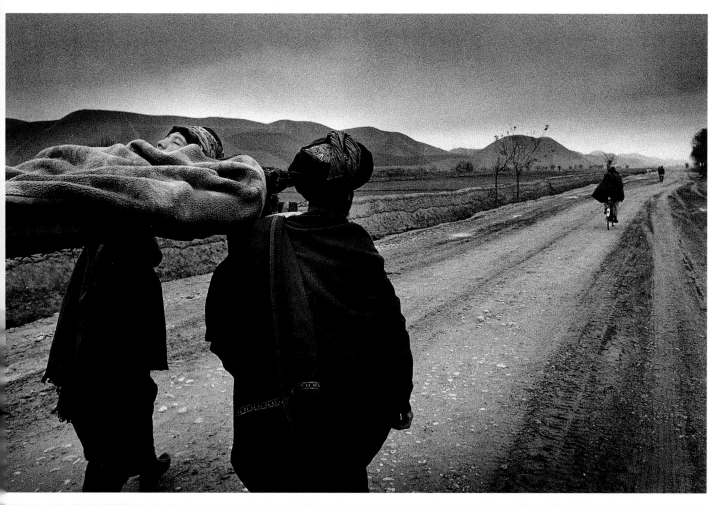

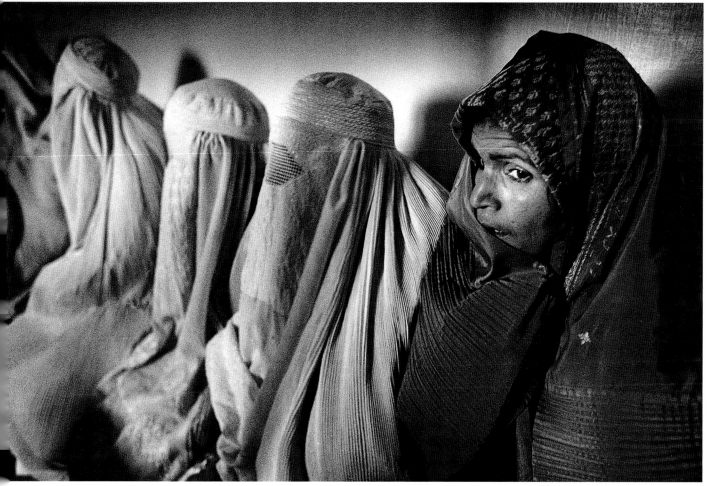

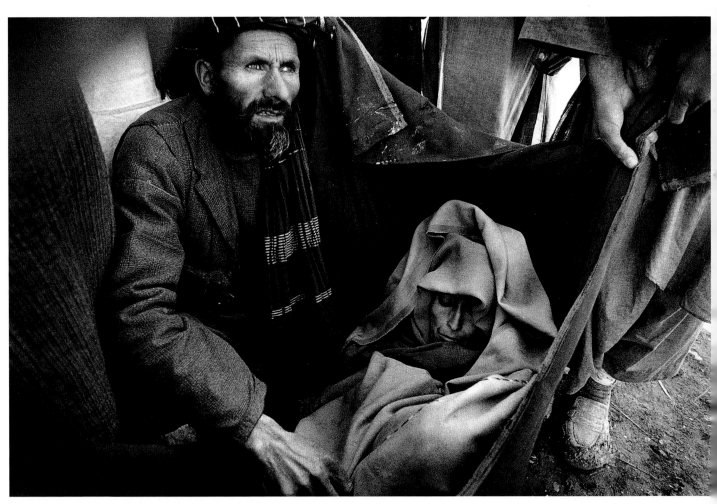

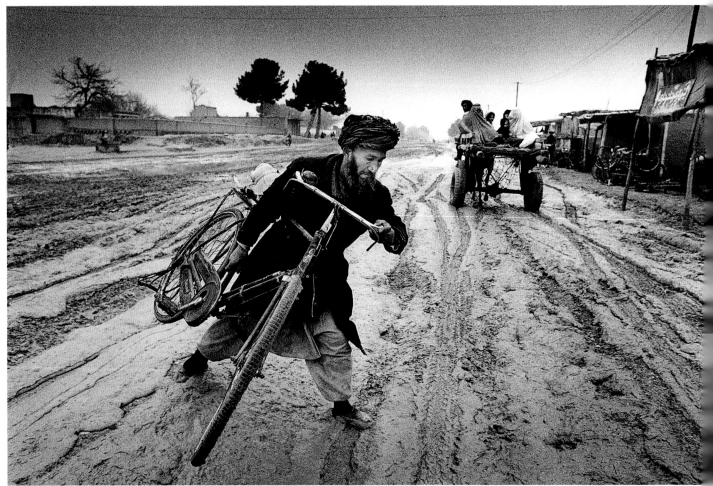

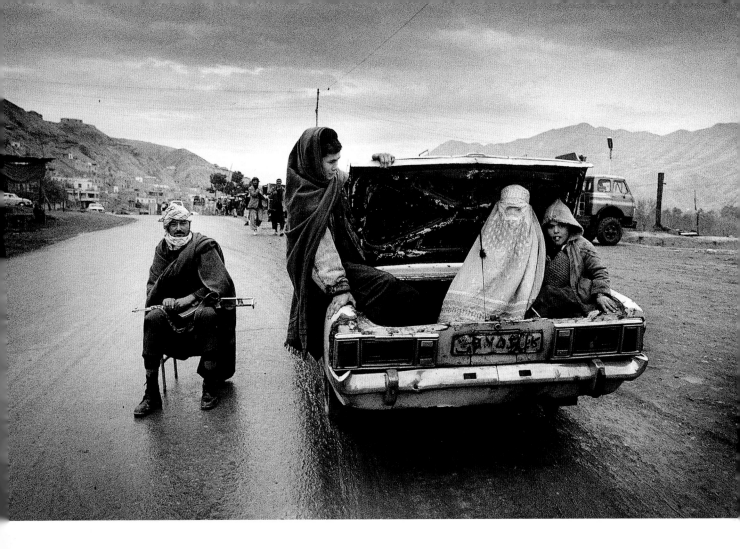

(continued) Facing page, top: A severely malnourished woman is brought to a clinic in Sar-e Pol. Despite the work of international aid agencies, food distribution is still inadequate in many areas. Below: Heavy rain in Andkhvoy turns the streets to mud. This page: An armed man guards a Northern Alliance checkpoint at Pol-e Khomri. The female travelers were not permitted to sit with men inside the car.

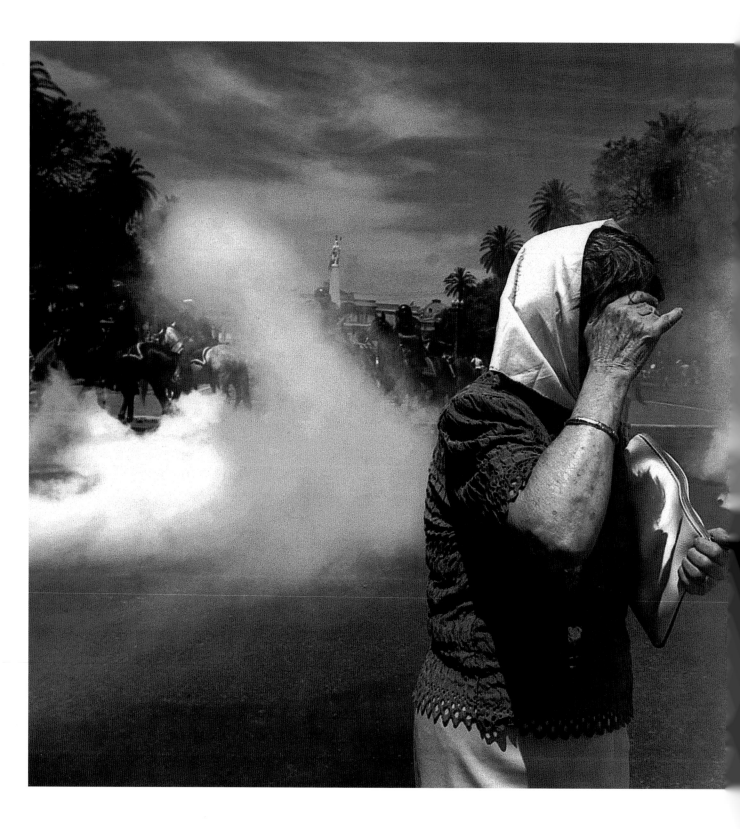

Carlos Barria Moraga
Argentina, Diario La Nación

1st Prize Singles

A Plaza de Mayo mother shields her eyes from tear gas during protests in Buenos Aires. The mothers maintain a vigil in protest at their relatives' disappearance under a military regime. In December, the square was also overrun by Argentines angered by a deepening economic crisis. With the government slashing civil servants' salaries, those who went hungry looted shops for food, and clashed with police. A state of emergency was declared on December 19, and the following day, President Fernando de la Rúa resigned.

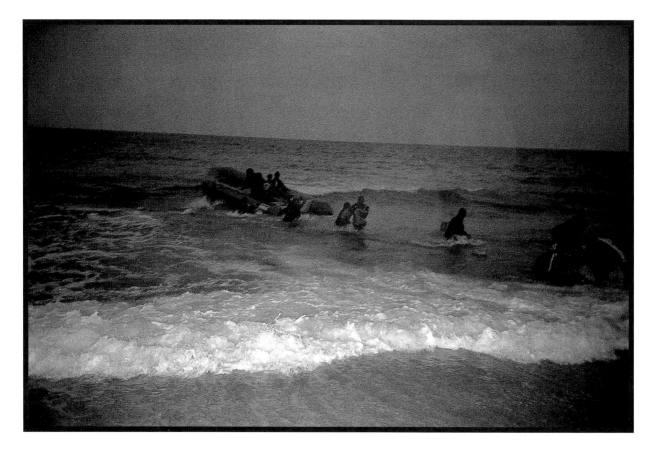

Lorena Ros & Dominic Ridley
Spain/UK, Cosmos/Still Pictures

2nd Prize Singles

A group of sub-Saharan Africans comes ashore in Tarifa, Spain. More than 50 people had crammed into a dangerously overloaded rubber boat to travel the frequently-used route between North Africa and Spain. Each year, hundreds of bodies of those attempting the crossing are washed up on the Spanish coast.

Tiane Doan Na Champassak
France, Agence Vu for Stern

3rd Prize Singles

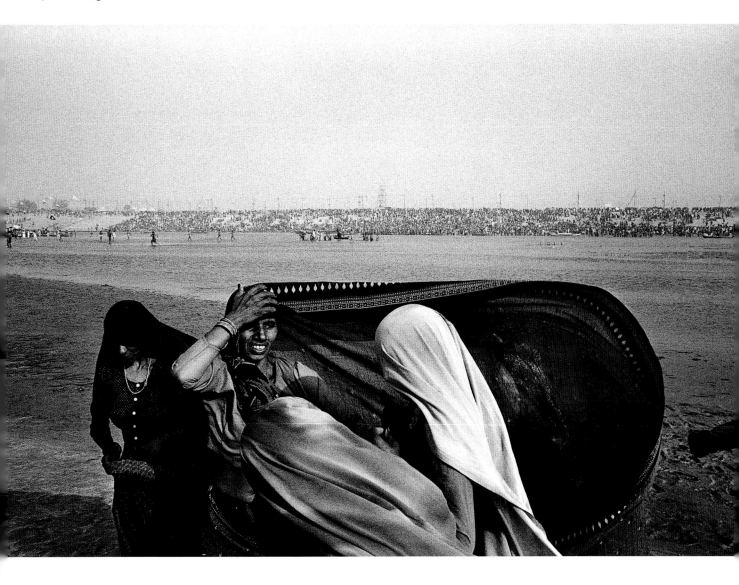

Women dress themselves after bathing at the Kumbh Mela Festival in Uttar Pradesh, northern India. The 2001 festival was the biggest ever, in a cycle which sees it swell in size every twelfth year. Now the largest gathering of humans on earth, it drew 70 million pilgrims, meeting peacefully to celebrate an ancient ritual. Staying in a vast tent city, the Hindu faithful take dips at the confluence of the Ganges and Jamuna rivers, believing that the purifying waters wash away a lifetime's sin.

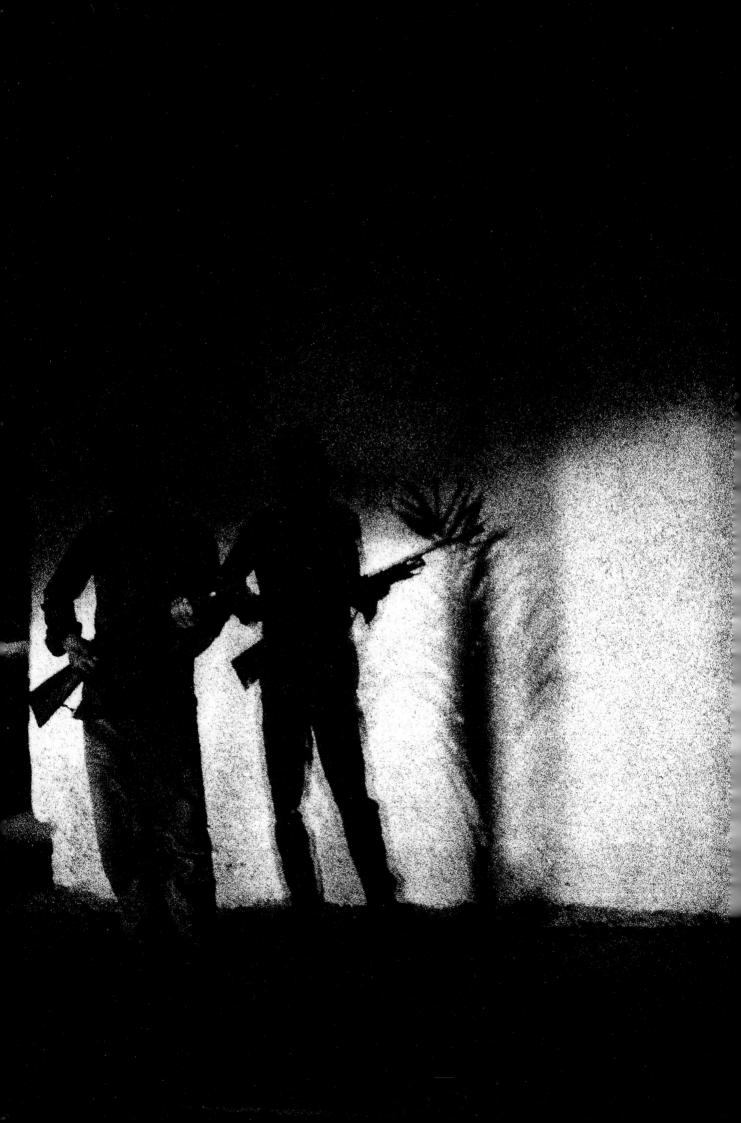

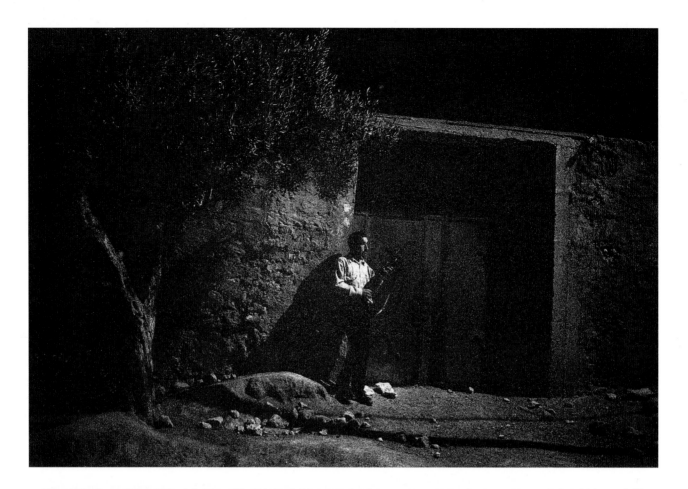

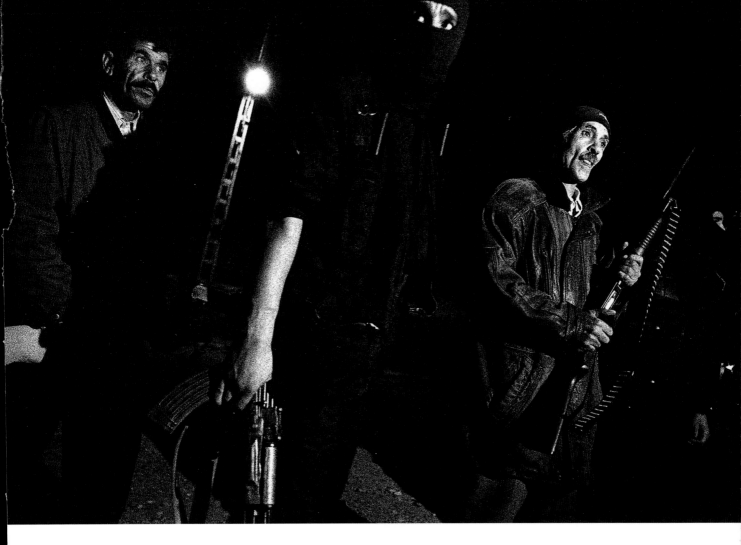

Paolo Pellegrin
Italy, Magnum Photos for Newsweek

1st Prize Stories

Previous spread and these pages: Algeria's bloody guerrilla warfare
has cost 150,000 lives, prompting civilians to take up arms. Amid a
recent history of massacres, local communities seek to protect
themselves from attacks that come at night. In a village near
Mascara, local men patrol alongside the government's elite Special
Intervention Group, or GIS. Created in 1988, the GIS hunts members
of the Armed Islamic Group (GIA), blamed for terrorist attacks
within Algeria. Facing page, below: A GIA suspect is taken away by
car. Right: Documents of highway travelers are examined during
the patrol.

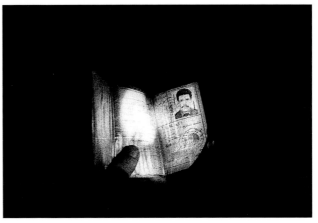

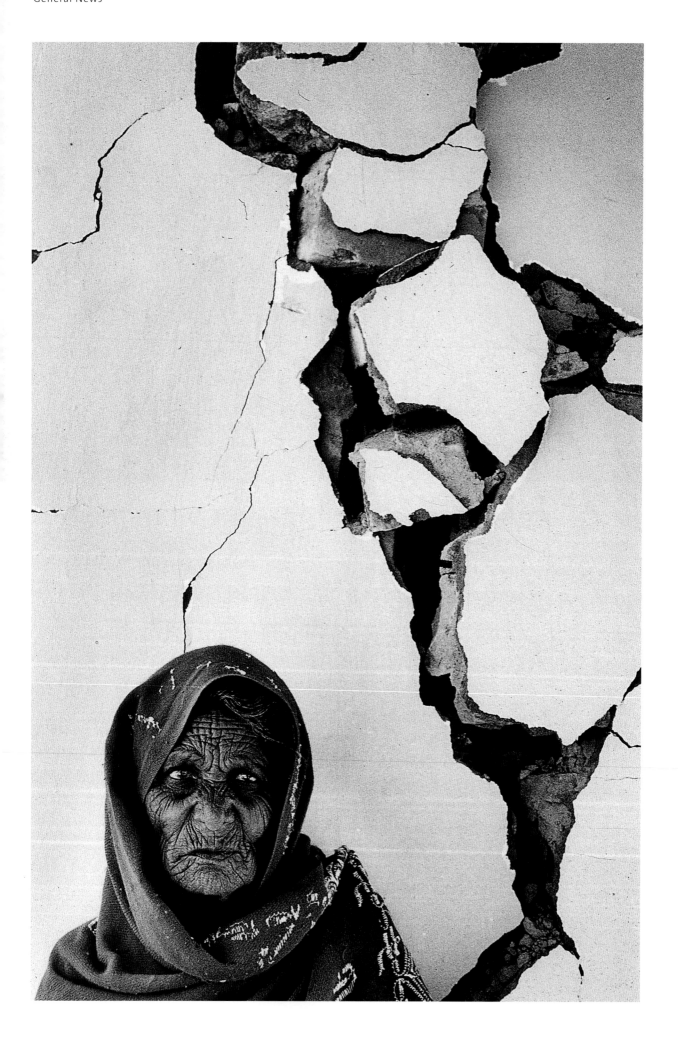

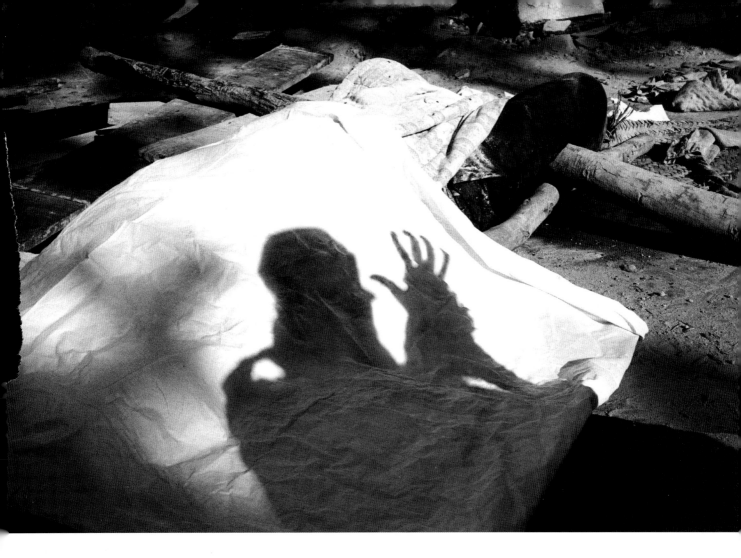

Tom Stoddart
UK, IPG

2nd Prize Stories

One million people were left homeless when an earthquake measuring 7.9 on the Richter scale struck Gujarat, Western India on January 26. It lasted just 30 seconds, but killed 30,000 people. In the following weeks survivors, aided by rescue workers, recovered bodies under the rubble of their homes. The earthquake came during the Indian winter, leaving the homeless cold at night, and at risk of disease. (story continues)

(continued) Densely-populated towns near the earthquake's epicenter were heavily damaged. Left: Beneath collapsed buildings in the village of Bakutra, women carry water cans, in a return to their daily routine. Facing page: In Bhachau, one of the worst hit towns in Gujarat, a child plays with birds.

Mat Jacob
France, Tendance Floue

3rd Prize Stories

In February, the rebel Zapatista movement embarked on a tour of Mexican towns, to deliver its message directly to the people. A hostile relationship remains between Mexico's government and the group, which demands the recognition of indigenous communities' rights. Lacking the resources for a media campaign, masked Zapatista delegates took their march to 36 towns, ending in Mexico City. Along the route, those sympathetic to the movement waved flags, and cheered them on at public rallies.

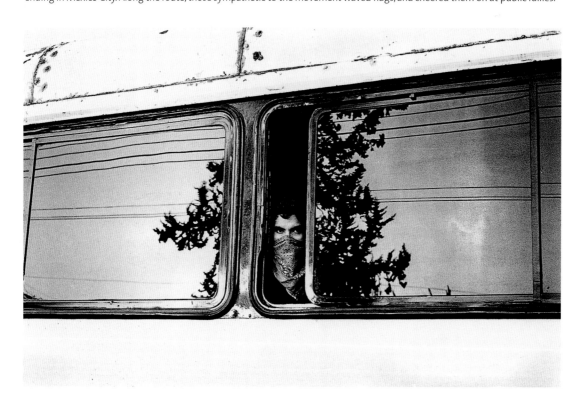

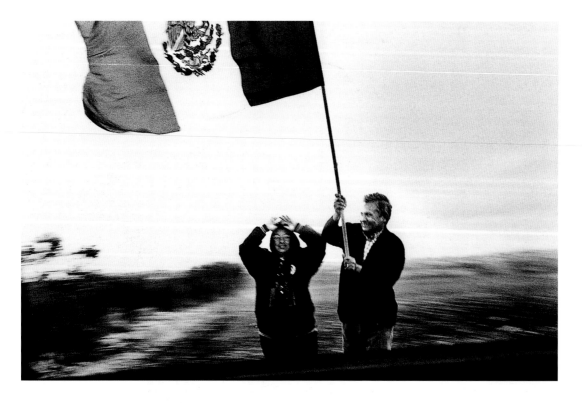

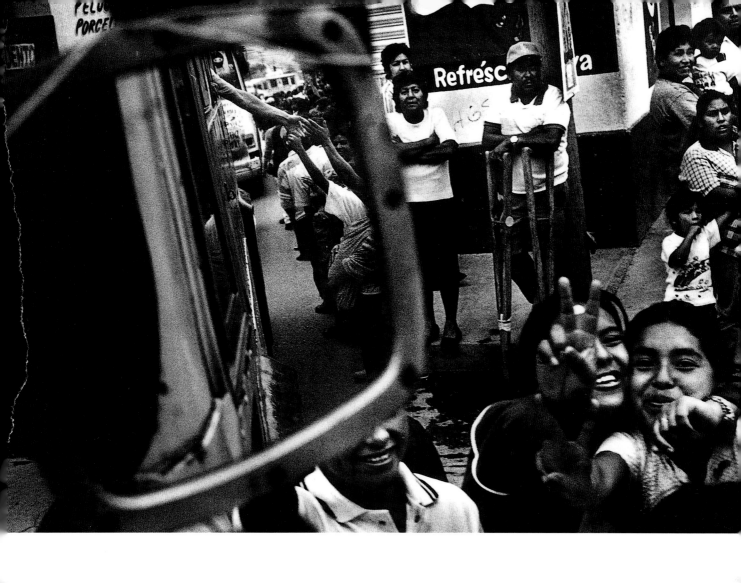
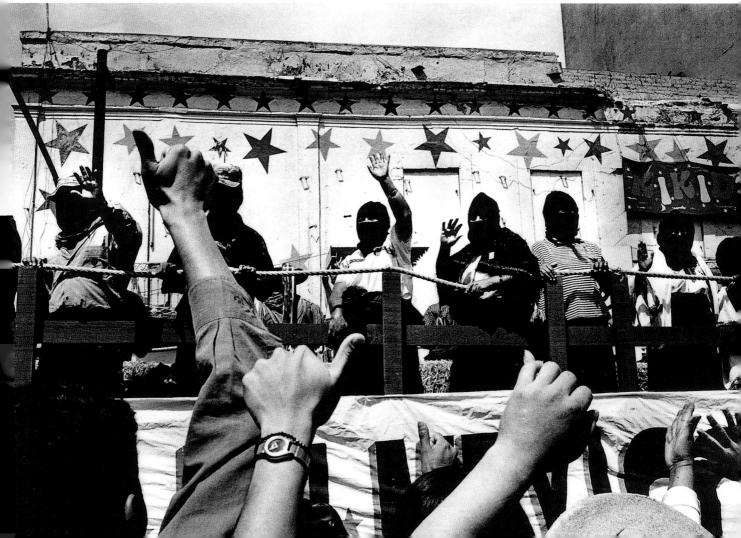

Prizewinners

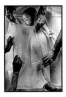

World Press Photo of the Year 2001
Erik Refner, Denmark, for Berlingske Tidende
The Body of an Afghan Refugee Boy is Prepared for Burial, Pakistan, June

Page 5

The World Press Photo of the Year Award honors the photographer whose photograph, selected from all entries, can be rightfully regarded as the photojournalistic encapsulation of the year: a photograph that represents an issue, situation or event of great journalistic importance and which clearly demonstrates an outstanding level of visual perception and creativity.

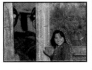

World Press Photo Children's Award
Nordahl, Norway, Dagbladet
Three Sisters, Khwaja Bahawudin, Afghanistan

Page 10

An international children's jury selects the winner of the Children's Award from the entries for the contest. The jury of schoolchildren is composed of winners of national educational contests, organized by leading media in nine countries.

Spot News Singles
1 Luc Delahaye, France, Magnum Photos for Newsweek
Northern Alliance Troops Ambushed by Retreating Taliban Forces, Afghanistan, 12 November

Page 12

2 Antoine Serra, France, Corbis Sygma
Body of an Anti-Globalization Protester Lies on the Street, Genoa, 20 July

Page 14

3 Richard Drew, USA, The Associated Press
A Person Falls from the North Tower of World Trade Center, New York, 11 September

Page 16

Honorable Mention
David Surowiecki, USA, Getty Images
People Fall from the North Tower of World Trade Center, New York, 11 September

Page 17

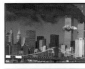
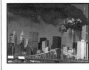

Spot News Stories
1 Robert Clark, USA, Aurora for Time
Flight 175 Crashes into the South Tower of World Trade Center, New York, 11 September

Page 18

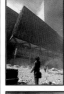

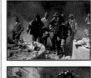
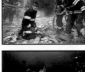

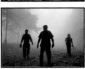
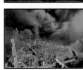
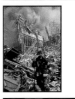

2 James Nachtwey, USA, VII for Time
"Shattered" - World Trade Center, New York, 11 September

Page 20

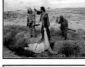
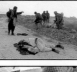
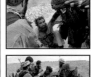
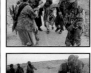
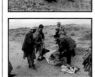
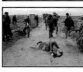

3 Tyler Hicks, USA, The New York Times/Getty Images
A Taliban Soldier Is Executed by Northern Alliance Soldiers, Afghanistan, 12 November

Page 24

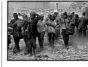

People In The News Singles
1 Gulnara Samoilova, USA, The Associated Press
Survivors of the Collapse of the World Trade Center Towers, New York, 11 September

Page 26

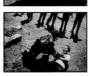

2 David Guttenfelder, USA, The Associated Press
Palestinian Leader Yasser Arafat at a Funeral, Gaza City, 18 January

Page 28

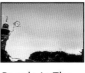

3 Kai Wiedenhöfer, Germany, Lookat Photos
Palestinian Fighter, Bethlehem, October

Page 29

People In The News Stories
1 Jan Grarup, Denmark, Rapho for Stern
The Boys from Ramallah

Page 30

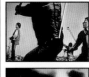
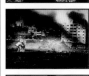
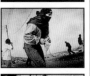
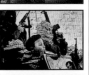
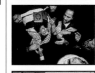
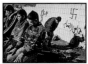
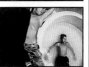

2 Erik Refner, Denmark, for Berlingske Ti[dende]
Afghan Refu[gee] Pakistan, Jun[e]

Page 36

13

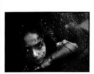
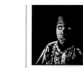

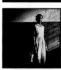

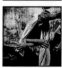
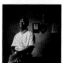
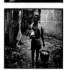

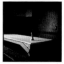
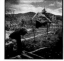
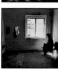
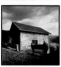
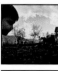
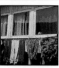
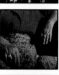
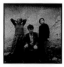

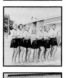

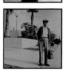
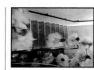
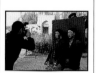
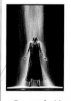
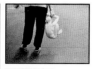

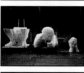
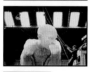

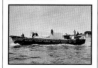
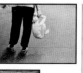
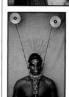
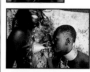
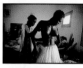
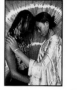
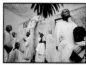
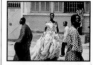
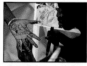
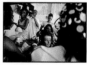
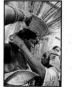
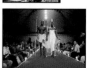
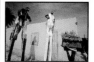

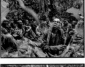

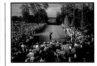

Sports Singles
1 Fred Vuich, USA, Sports Illustrated
Tiger Woods Tees Off at the 18th Hole at The Masters Golf Tournament

Page 66

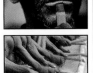

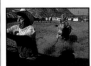

2 Carlos Puma, USA, The Press-Enterprise
At a Jaripeo (Mexican Rodeo), California

Page 68

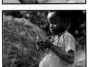

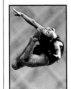

3 Jia Guorong, People's Republic of China
Young Gymnast

Page 69

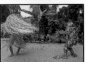

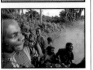

Sports Stories
1 Alex Garcia, USA, Chicago Tribune
Boxing Gym, Havana

Page 70

3 Harald Schmitt, Germany, Stern
Music of the Aka Pygmies

Page 64

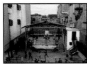

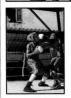
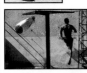

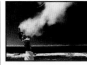
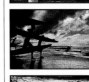
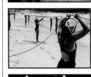
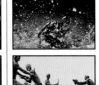
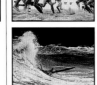
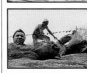
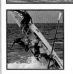
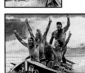
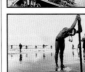

2 Craig Golding, Australia, Sydney Morning Herald
Surf Lifesavers in Competition

Page 74

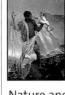

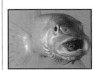

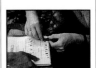

3 Jens Rötzsch, Germany, Ostkreuz
Turbo Golf

Page 78

Nature and the Environment Singles
1 Geneviève Renson, France
Goliath Frog Catch, Cameroon

Page 81

2 Jim Lavrakas, USA, Anchorage Daily News for Sports Illustrated
Pike Swallows Rainbow Trout

Page 82

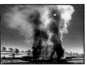
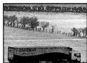
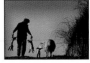

3 Viviane Moos Holbrooke, USA, Sipa Press
Fingerprinting Baby Orangutan, Indonesia

Page 84

Nature and the Environment Stories
1 Jeff Mitchell, UK, Reuters
Foot and Mouth Outbreak

Page 85

2 Jozsef L. Szentpeteri, Hungary, Na Foto BT
The Swarmi the Long-tai Mayfly

Page 89

13

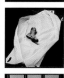

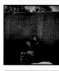

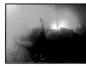
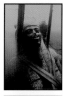
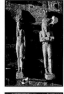

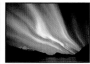

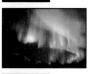

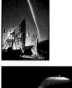

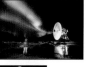

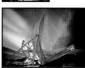

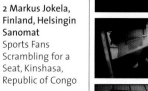
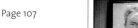
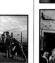

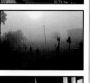
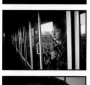

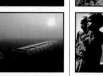

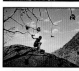
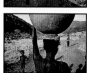
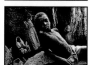
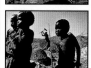
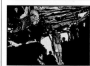
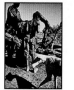

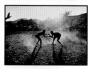

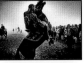

General News Singles
1 Carlos Barria Moraga, Argentina, Diario La Nación
Protest at Plaza de Mayo, Buenos Aires, Argentina, 20 December

Page 122

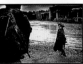

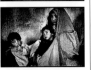

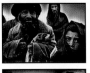

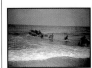

2 Lorena Ros & Dominic Ridley, Spain/UK, Cosmos/ Still Pictures
Immigrants from Africa Come Ashore, Tarifa, Spain

Page 124

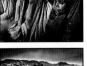

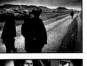

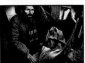

3 Tiane Doan Na Champassak, France, Agence Vu for Stern
Kumbh Mela Festival, Uttar Pradesh, India, January

Page 125

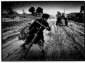

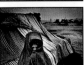

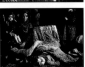

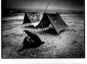

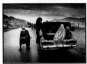

3 Tim Dirven, Belgium, De Morgen/Panos Pictures
People of Afghanistan

Page 118

General News Stories
1 Paolo Pellegrin, Italy, Magnum Photos for Newsweek
Civilians Patrol with Algeria's Anti-Terrorist Elite Troops, Algeria, October

Page 126

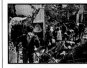
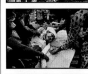

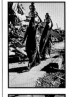

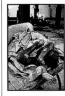

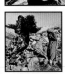
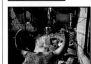

2 Tom Stoddart, UK, IPG
After the Earth-quake of Gujarat, India, February

Page 130

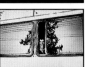
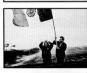

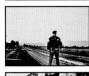
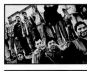
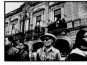
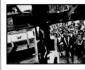

3 Mat Jacob, France, Tendance Floue
Zapatista March, Mexico, February-March

Page 134

14

Participants Contest 2002

In 2002, 4,171 photographers from 123 countries submitted 49,235 entries. The participants are listed according to nationality as stated on the contest entry form. In unclear cases the names are listed under the country of postal address.

AFGHANISTAN
Zalmaï Ahad
Sayed Salahuddin

ALBANIA
Bevis Fusha
Marketin Pici
Kostandin Poga
Namik Selmani

ALGERIA
Hocine
Yanice Idir
Atmane Idjeraoui

ANDORRA
Ramon Villero Castella

ANGOLA
Fernando Lino Guimaraes

ARGENTINA
Marcelo Francisco Aballay
Luis Carlos Abregú
Martin C.E. Acosta
Humberto Lucas Alascio
Pablo Aneli
Martin Arias Feijoo
Jorge Oscar Ariza
Walter Adrian Astrada
Bernardino Alejandro Avila
Daniela Java Balanovsky
Carlos Barria Moraga
Juan Pablo Barrientos
Pablo Bentancourt
Javier Omar Brusco
Ruben Adrian Cabot
Eva Laura Cabrera
Victor R. Caivano
Sandra Mariel Cartasso
Ramon Cavallo
Pablo Enrique Cerolini
Alejandro Chaskielberg
Leandro Walter Coniglio
Ruben Maria Corral
Daniel Dapari
Jorge Dominelli
Milton A. Fernández
Diego Fernandez Otero
Daniel Garcia
Bernardo Giménez
Julio Giustozzi
Pablo Ariel Gomez
Anibal Adrian Greco
Claudio Marcelo Herdener
Nancy Larios
Diego Levy
Alejandro Lipszyc
Eduardo Victor Longoni
Juan Pablo Maldovan
bastian Marjanov
iguel Angel Mendez
aniel Ricardo Merle
ivaldo Walter Moreno
ana Musacchio
fredo Nardini
drigo Néspolo
se Abdala Nuno del Valle
Martin de la Orden
lio C. Pantoja
vier Orlando Pelichotti
ernan Gabriel Pepe
aniel Pessah
ablo Ernesto Piovamo
ian Carlos Piovano
antiago Porter
iime Razuri
éctor A. Rio Hacho
oberto Oscar Salvi
uan Pablo Sánchez Noli
uan Jesus Sandoval

Carlos Sarraf
Antonio Scorza
Pablo Senarega
Jose Maria Seoane
Mariano Federico Solier
Alfredo Santiago Srur
Gustavo Marcelo Suarez
Sebastian Szyd
Luciano Thieberger
Antonio Valdez
Leonardo Adrian la Valle
Juan Domingo Vera
Leonardo Vincenti
Diego Alejandro Vinitzca
Alejandro Miguel Vivanco
Enrique Von Wartenberg
Hernan Zenteno

ARMENIA
Stefan Alekyan
Berge Arabian
Eric Grigorian

AUSTRALIA
Narelle Autio
Mark Baker
Paul Blackmore
Torsten Blackwood
Philip Blenkinsop
Vasil Boglev
Penny Bradfield
Patrick Brown
Chris Budgeon
Glenn Campbell
Steve Christo
Warren Clarke
Tim Clayton
Kevin Clogstoun
Sebastian Costanzo
Paul Crock
Nick Cubbin
Ian Charles Cugley
Sean Davey
Howard J. Davies
Tamara Dean
Michael Dodge
Jennifer Duggan
Stephen Dupont
Nathan Edwards
Robert Elliott
Nicole Clare Emanuel
Darren England
Brendan Esposito
Stephanie Flack
Marc Gafen
Gabrielle Gawne-Kelnar
Timothy Georgeson
Ashley Gilbertson
Luke Glossop
Craig Golding
Steve Gosch
David Gray
Mathias Heng
Phil Hillyard
Adam Hollingworth
Stephane-Arnold L'Hostis
Glenn Hunt
Christopher Hyde
Martin Jacka
David Jenkins
David L. Kelly
Dallas Ashton Kilponen
Alec Kingham
Bronek Kózka
Helen Kudrich
Nicholas Laham
Tanya Lake
Jon Lewis
Jon Lister
Guy Little
Bruce Long
Jesse Marlow
Jean-Dominique Martin
Fiona McDougall
Chris McGrath
Andrew Meares
Andrew Merry
Paul Miller
Palani Mohan
Nick Moir
Fiona Morris
Sandy Nicholson
Renee Nowytarger

Simon William O'Dwyer
Trent Parke
Sonia Payes
Edwina Pickles
Jack Picone
Sean Powe
Mark Ray
Martin Regis
Jon Reid
Simon Renilson
George Salpigtidis
Sean Kennedy Santos
Dean Sewell
Steven Siewert
Matthew Sleeth
Danielle Smith
Troy Snook
Tasso Taraboulsi
Angelo Velardo
Ian Waldie
Greg White
Thomas Wielecki
Lisa Maree Wiliams
Gregory Wood
Andy Zakeli

AUSTRIA
Heimo Aga
Toni Anzenberger
Michael Appelt
Robert Fleischanderl
Sepp Friedhutser
Arno Gasteiger
Peter Granser
Christoph Grill
Kurt Hahofer
Wim van der Kallen
Felicitas Kruse
Wolfgang Mayer
Franz Neumayr
Stefan Pleger
Helmut Ploberger
Klaus Reisinger
Reiner Riedler
Siegfried Wallner

AZERBAIJAN
Talib Asim
Elnur Babayev
Samed-zade Chingiz
Ilgar Djafarov
Gashumov Farkhad
Aliyeva Khadija
Anna Khovshun
Ilham Kishiyev
Hasan Oglu Mirnaib
Safarov Novruz
Kambarov Rafig
Nagiev Rafig
Kambardva Rima
Yulia Rusyayeva
Ibadov Vugar
Zaur Zeylanov
Velieva Zhalyz

BAHAMAS
Andrew Seymour

BANGLADESH
Babul Abdul Malek
Abir Abdullah
Golam Mostafa Akash
G.M.B Akash
Jahangir K.M. Alam
Monirul Alam
Shahidul Alam
Abdul Fazul MD. Ashraf
Md Shahadat Hossain
Fakrul Islam
Rafiqul Islam
Momena Jalil
Shahidullah Kaiser
Kakon
Naymuzzaman Khan
K. Proshanta Buddha
Syed Rafiquer Rahim
Dipu Rahman Mahbubur
Mohammad Safiudden
Jewel Samad
Khaled Sattar
Md Shafayet Hossain
(Apollo)
MD Siraj Miah

Hashi Talukdar
Md. Main Uddin

BARBADOS
Jeffrey Bishop

BELARUS
Vladimir Bazan
Aliaksandr Halkevich
Anatoli Kliashchuk

BELGIUM
Joost De Bock
Michael Chia
Marc de Clercq
Vincent Delbrouck
Tim Dirven
Tomas van Houtryve
Roger Job
Eddy Kellens
Jimmy Kets
Carl De Keyzer
Didier Lebrun
Bart Lenoir
Firmin de Maitre
Frederic Materne
Samer Mohdad
Kris Pannecoucke
Jan van der Perre
Philip Reynaers
Dominique Simon
Bruno Stevens
Dieter Telemans
Gaël Turine
Alex Vanhee
Peter Vanhoof
Louis Verbraeken
Eva Vermandel
Carol Verstraete
Peter de Voecht
Janet Wishnetsky

BOSNIA-HERZEGOVINA
Jasmin Alibegovic
Zijah Gafic
Damir Sagolj
Tarik Samarah

BRAZIL
Vanderlei Almeida
R.R. Almeida de Oliveira
Joedson Alves
Euler Paixão Alves Peixoto
Sergio Amaral
Paulo Amorim
J. de Anchieta X. de Sousa
A. S. Anderson Schneider
Keiny Andrade Silva
Israel Antunes Vieira
Ricardo de Aratanha
W. Souza Camos Araujo
Alberto Cesar Araújo
Elisandro Ascari
Leonardo Aversa
Joao Barbosa Ferreira
Alexandre Battibugli
Alexandre Belem
Mônica Bento de Souza
Marlene Bergamo
Jamil Bittar
Roberto Bonomi
Ricardo Borba
Manoel de Brito
João Luiz Bulcão
R. C.C. Cacalos Garrastazu
F. Canindé C. dos Santos
Rubens Cardia
Weimer de Carvalho Franco
Tatiana Cassia de Deus
Ivaldo Cavalcante Alves
Fernando Rafael Cavalcanti
Antonio R. Cazzali
Adalmir Chixaro
Ciro Coelho
A. Augustus Coelho Cardoso
Jose Luis da Conceição
Julio Cesar Bello Cordeiro
Jose Luiz Cordeiro Lopes
André Correa
Wania Cristina Corredo
Antonio Costa
Antonio José Cury
Everaldo Lima D'Alverga

Fernando Dantas
T.C. Maia Dantas de Góes
A. Claro De Oliveira
Marcos Ramos Esteves
Robson Fernandes
A. Ferreira dos Santos
Orlando Filho
Márcia Foletto
Bárbara Freire Trindade
Juan Galberto Cunha
Paulo Roberto Giandalia
Brito Maia Gil Vicente
Luiz Antonio Giope
Vera Lúcia Godoy de Faria
Ricardo Andrade Gomes
M.A. Gouveia de Oliveira
Patrick Grosner
Caio Garcia Guatelli
Dulce Helfer
André Henriques
Urbano Holanda Erbiste
Peter Ilicciev
Andréa Iseki
Rafael Jacinto
Carlos Latuff
Mauricio Lima
Levis Litz
Moacyr Lopes Junior
Solange Macedo
Benito Maddalena
G. Henrique C. Magnusson
Daniel Mansur de Faria
Mauricio Maranhão
Americo Mariano
Ivo Gonzalez Marinho
Manoel Marques Neto
Eduardo Martino
Eduardo Martins Pinto
Denise Meirelles Cavallini
Márcia Mendes
Gleice Mere
Marco Antonio R. Monteiro
Sandra Maria Silva Moraes
Sebastião Moreira
Nário Barbosa
Marta Nascimento
Marcos Nascimento Porto
J.S. do Nascimento Scofano
Roberto Nemanis Junior
Andreia Mayumi Niiyama
Leopoldo Nunes
Helio Nunes de Oliveira
C. Lima Paixão de Oliveira
M. Christina G.S. Paulinelli
Emilio Carlos Sales Pedroso
Flavio Pereira da Silva
Paulo Martins Pinto
Fernando Pio Figueiroa
Zulmair Porfirio da Rocha
Evzivaldo Quelroz
Marcelo Reis
M.R. de Mendonca e Silva
A. Antonio Ribeiro Gondim
W. Alexandre Ribeiro Soares
Zulmair Porfirio da Rocha
Carla Romero
Teotonio Jose Roque
C. Souto Sant'Anna
Eduardo Santoro
P. Roberto Santos Araújo
J. Santos Santos Conceição
Rogerio Alonso Senaha
Severino Antonio da Silva
Wanderlan P. Silva
Sydney Silva da Motta
Luciola Soares Villela
Fernando Souza
Gilvan De Souza Barbosa
F. Stuckert Do Amaral
M. Antonio Flores Teixeira
André Telles
Otavio Andrade Valle
José Varella
M.L. Vedovatto Scandura
R. Maria Victor de Araujo
J.T. Vidal Cavalcante
Andre Felipe Vieira
Luis Tadeu Vilani
Mônica Zarattini

BULGARIA
Svetlana Bahchevanova
Konstantin Bojanov

Nick Chaldakov
Nellie Doneva
Mishael Geron
Milan Hristev
Hristo Hristov
Ilian Iliev
Nikolay Iliev
Stoyan Iliev
Lyubomir Jelyaskov
Dimitar Kyosemarliev
Georgi Malkovski
Stoyan Nikolov
Anelia Nikolova
Detelin Nikov
Tihomir Penov
Miroslav Simeonov
Sonia Stankova
V. Stoyanov Georgiev
Todor Stefanov Todorov
Ivan Sabev Tzonev
Ivaylo Velev
Vesel Veselinov
Boyan Yurukov

BURKINA
Kabore W. Abdoulaye
Mohamadou Gansore
Yempabou Ahmed Ouoba

CAMBODIA
Chhoy Pisei
Heng Simith
Tang Chkin Sothy

CAMEROON
Dieudonne Abianda
E. Desire Djitouo Ngouagna

CANADA
Suzanne Ahearne
Terry Anthony
Sergey Bachlakov
David Barker Maltby
Bernard Beisinger
Ruth Bonneville
Bernard Brault
Peter Bregg
Joe Bryksa
Shaughn Butts
Phil Carpenter
Dave Chidley
Robert Dall
Barbara Davidson
Ursula Deschamps
Loek Dick
Bruno Dorais
Mike Drew
Frazer Dryden
Bruce Duffy
Bruce Edwards
Candace Elliott
Lisa Fleischmann
Andre Forget
Brian James Gavriloff
Ken Gigliotti
Wayne Glowacki
Christian de Grandmaison
Roxanne Gregory
Leah Hennel
Harry How
Emiliano Joanes
Ladislas Kadyszewski
Marie-Susanne Langille
Julie Langpeter
Richard Lautens
Roger Lemoyne
Derek Lepper
Jean Levac
Motty Levy
Andrew Lindy
John Lucas
Doug MacLellan
Rick Madonik
John Mahoney
Sylvain Mayer
Allen McInnis
Jeff McIntosh
Joshua Meles
Gerry Meyers
John Morstad
Phillip Norton
George Omorean
Lyle Owerko

Peter Parsons
Edward Parsons
Terry Pidsadny
Pierre Paul Poulin
Peter Power
Duane Prentice
Joshua Radu
Mizanur Rahman
Jim Rankin
Erin Riley
Marc Rochette
Steve Russell
Derek Ruttan
Chris Schwarz
Dave Sidaway
Steve Simon
Guillaume Simoneau
David W. Smith
Gregory Southam
Lyle Stafford
Fabrice Strippoli
Robert Tinker
Tannis Toohey
Larry Towell
Marcos Townsend
David Trattles
Kevin Unger
Andrew Vaughan
Andrew Wallace
Chris Wattie
George Webber
Bernard Weil
Simon Wilson
Larry Wong
Iva Zimová

CHILE
Rodrigo Arangua
Orlando Barría Maichil
Christian Byrt Jimenez
K. Romero Goddard Romero
Alejandro Maltés Zarate
Alfredo Méndez Etchepare
Waldo Nilo
Jaime Puebla
Victor Juan Ruiz Caballero
Victor Hugo Toledo Aguilar
Pedro Ugarte
P.A. Valenzuela Hohmann
C. Alejandro Vera Ormeño

COLOMBIA
Maria Cristina Abad Angel
Fabiola Acevedo
Luis Enrique Acosta Rios
Luis Henry Agudelo Cano
G. Eduardo Aponte Salcedo
Iliana Aponte Tovar
Humberto Arango Gomez
F. Andrés Caicedo Chacón
A.E. Cardenas Ortegon
Jose Luis Chavarriaga Ruiz
Gerardo Chaves Alonso
Milton Diaz Guillermo
E.A. Dominguez Catano
C. Hernando Florez Leon
J. Alberto Galeano Naranjo
Jaime Alberto Garcia Rios
Camilo Jose George Jimeno
J. Miguel Gomez Mogollon
M.A. Hernandez Romero
W.F. Martinez Beltrán
C. Julio Martinez Tamara
M. Menéndez Vall Serra
Mauricio Moreno Valdes
Daniel Munoz
Jorge Eliecer Orozco Galvis
B. Alberto Peña Olaya
J. Otoniel Perez Munevar
Filiberto Pinzon Acosta
M. Ingrid Reyes Orjuela
Henry Romero
Robinson Saenz Vargas
J. Antonio Sanchez Ocampo
Carlos A. Sastoque Nestler
Roberto Schmidt
Emiro Silva Ruiz
G. Jaime Vélez Quintero
John Wilson Vizcaino Tobar
Donaldo Zuluaga Velilla

COSTA RICA
Gloria Calderon Bejarano

41

Eduardo Lopez Lizano
Marco Monge Rodriguez
Kattia P. Vargas Araya

CROATIA
Darko Bandic
Angelo Bozac
Vladimir Dugandzic
Marko Gracin
Vlado Kos
Ivan Kovac
Andrea Kulundzic
Dragan Matic
Roberto Orlic
Snjezana Pozar
Damir Rajle
Nikola Solic
Kristina Stedul
Srdan Vrancic

CUBA
Jorge Luis Alvarez Pupo
A. Azcuy Dominguez
Elio Delgado Valdés
Gonzalo Gonzales Borges
C. Herrera Ulashkevich
Quesada Vera Leysis
Jorge Lopez Viera
Nestor Marti Delgado
C. Ignacio Merino Valdes
Eduardo Mojicas Ibanez
Ramon Pacheco Salazar
A. Ernesto Perez Estrada
René Pérez Massola
E.R. Quintas Santiesteban
Ahmed Velázquez Sagués

CYPRUS
Petros Karatzias
Andreas Vassiliou

CZECH REPUBLIC
Tomas Bem
Josef Bradna
Vladimir David
Alena Dvorakova
Eduard Erben
Viktor Fischer
Hana Jakrlová
Antonin Kratochvil
Sidorjak Martin
David Neff
Milan Petrik
Josef Ptáček
Petra Ruzickova
Jan Schejbal
Roman Sejkot
Jan Sibik
Barbora Slapetova
Tomas Svoboda
Jaroslav Tatek
Jiri Urban

DENMARK
Kim Agersten
Lina Ahnoff
Lars Bech
Soren Bidstrup
Nicky Bonne
Thomas Borberg
Anders Brohus
Jakob Carlsen
Thomas Cornelius
Jacob Ehrbahn
Lene Esthave
Morten Fauerby
Jorgen Flemming
Finn Frandsen
Peter Funch
Jan Anders Grarup
Mads Greve
Seren Hald
Tine Harden
Jörgen Hildebrandt
Lars Horn
Carsten Ingemann
Ulrik Jantzen
Christian T. Joergensen
Nils Jorgensen
Lars Hauskov Krabbe
Joachim Ladefoged
Claus Bjorn Larsen
Soren Lauridsen

Bax Lindhardt
Soren Lorenzen
Claus Lunde
Tao Lytzen
Nils Meilvang
Sif Meincke
Morten Mejnecke
Voja Miladinovic
Lars Moeller
Hans Otto
Ulrik Pedersen
Erik Refner
Claus Sjödin
Betina Skovbro
Torben Stroyer
Michael Svenningsen
Ernst Tobisch
Robert Wengler
Kaspar Wenstrup
Steen Wrem
Martin Zakora

ECUADOR
C. Fernando Barros Rivas
Martin Bernetti Vera
Dolores Ochoa Rodriguez
E. Vinicio Teran Urresta
J. Marcelo Vinueza Garcia

EGYPT
Khaled El Figi
Mohamed El-Dakhakhny
Bassam Elzoghby

EL SALVADOR
Diego Barraza Dominguez
Yuri Alberto Cortez Avalos
Amalia Mayita Mendez

ERITREA
Russom Fesahaye
Freminatos Istifanos
Kidane Teklemariam

ESTONIA
Tiit Räis

ETHIOPIA
Abera Dagne
Fasika Ermias Mammo
K. Habtemariam

FINLAND
Jaakko Avikainen
Markus Jokela
Martti Kainulainen
Petteri Kokkonen
Jussi Nukari
Kimmo Räisänen
Erkki Raskinen
Kari Salonen
Heikki Saukkomaa
Eetu Sillanpää
Ilkka Uimonen
Tor Wennström

FRANCE
Lahcène Abib
Bruno Abile
Olivier Adam
Christophe Agou
Antoine Agoudjian
Catherine Alonso Krulik
Julie Ansiau
Patrick Artinian
Patrick Aventurier
Georges Bartoli
Jérôme Bärtschi
Gilles Bassignac
Eric Bauer
Patrick Baz
Eric Beauchemin
Jean Becker
Arnaud Beinat
Remi Benali
Yves Benoit
Valérie Berta
Alain Bétry
Romain Blanquart
Olivier Boëls
Samuel Bollendorff
Guillaume Bonn
Regis Bonnerot

Jerome Bonnet
Thierry Borredon
Bruno Boudjelal
Youssef Boudal
Denis Boulanger
Alexandra Boulat
Denis Bourges
Eric Bouvet
Gabriel Bouys
Alain Buu
Eric Cabanis
Serge Cantó
Richard Carnevali
Sarah Caron
Thierry Chantegret
Denis Chapoullié
Patrick Chapuis
Julien Chatelin
Olivier Chouchana
Bernard Chubilleau
Pierre Ciot
Noémie Coën
Thomas Coex
Guillaume Collanges
Jerome Conquy
Scarpett Coten
Olivier Coulange
Denis Dailleux
Julien Daniel
Beatrice De Gea
Gautier Deblonde
Regis Delacote
Luc Delahaye
Jerome Delay
Magali Delporte
Michel Denis-Huot
Philippe Desmazes
Robert Deyrail
Dominique Dieulot
T. Doan Na Champassak
Marie Dorigny
Claudine Doury
Nicolas Dubreuil
Alexis Duclos
Grégory Ducros
Philippe Dudouit
Emmanuel Dunand
Andre Durand
Guy Durand
Alain Ernoult
Isabelle Eshraghi
Bruno Fablet
Cédric Faimali
Mekdi Fedouach
Eric Feferberg
Franck Fife
Johan Pierre Filatriau
Daniel Foster
Franck Fouquet
Frank Fournier
Eric Franceschi
Sylvie Francoise
Raphaël Gaillarde
Frédéric Girou
Stephan Gladieu
Pierre Gleizes
Georges Gobet
Julien Goldstein
George Gonon-Guillermas
Pascal Grimaud
Diane Grimonet
Olivier Grunewald
Laurent Guerin
Jack Guez
Jean-Paul Guilloteau
Philippe Haÿs
Nils Hardeveld
Daniel Herard
Guillaume Herbaut
Patrick Hertzog
Dominique Issermann
Mat Jacob
Jean-Claude Jaffré
Patrick James
Olivier Jobard
Frédérique Jouval
Nicholas Kamm
France Keyzer
Stephane Klein
Pascal Kober
Gregoire Korganow
Patrick Kovarik
Jean Philippe Ksiazek

Vincent Laforet
Hien Lam-Duc
Dominique Lampla
Patrick Landmann
Georgi Lazarevski
Frederic Le Floch
Christophe Le Petit
Vincent Leloup
Tony Lopez
Philippe Lopparelli
Emile Loreaux
Laurence Louis
Son-Thuy Ma
John Mac Dougall
Robert Margaillan
Georges Merillon
Pierre Mérimée
Bertrand Meunier
Pascal Meunier
Damien Meyer
Gilles Mingasson
Régina Montfort
Philippe Montigny
Olivier Morin
Francois Nascimbeni
Amazone Nativel
Emmanuel Pain
Richard Pak
Joël Palmié
Aleksandra Pawloff
Karine Pelgrims
Gilles Peress
J.-P. Perres Pechmeja
Martine Perret
Yann Perrier
Serge Philippot
Gerard Planchenault
Jean-Pierre Porcher
Vincent Prado
Sylvain Pretto
Arnaud Prudhomme
Noël Quidu
Jean Baptiste Rabovan
Gerard Rancinan
Stephane Remael
Geneviève Renson
Patrick Robert
Michel Roget
Max Rosereau
Lizzie Sadin
Laurent Saez
Joël Saget
Lise Sarfati
Alexandre Sargos
Patrice Saucourt
Frederic Sautereau
David Sauveur
Francois Savigny
Sylvain Savolainen
Benoit Schaeffer
Jean-Pierre Schwartz
Roland Thierry Seitre
Antoine Serra
Serge Sibert
Jean-Michel Sicot
Jean-Manuel Simoes
Christophe Simon
Fabrice Soulié
Françoise Spiekermeier
Laurent Starzynska
Flore-Aël Surun
Patrick Swirc
Dominique Szczepanski
Jean Francois Talivez
Patrick Tourneboeuf
Bernard Tribondeau
Laurent Troude
Gerard Uferas
Eric Vandeville
Véronique Vial
Vo Trung Dung
William West
Laurent Weyl
Stephan Zaubitzer
Sophie Zenon

GEORGIA
Alexandre Kvatashidze

GERMANY
Carola Alge
Michael S. Anacker
David Ausserhofer

Stefan Bau
Michael Bause
Siegfried Becker
Marion Beckhäuser
Fabrizio Bensch
Sibylle Bergemann
Klaus-Dieter Beth
Birgit Betzelt
Antje Beyen
Marina Block
Andreas Bohnenstengel
Stefan Boness
Kai Bornhöft
Michael Braun
Ulrich Brinkhoff
Hans Jürgen Britsch
Martin Brockhoff
Franka Bruns
Siggi Bucher
Hans-Jürgen Burkard
Reinaldo Coddou
Gesche Cordes
Sven Creutzmann
Peter Dammann
Uli Deck
Erwin Doering
Sven Döring
Thomas Duffé
Thomas Dworzak
Winfried Eberhardt
Stephan Elleringmann
Hans-Georg Esch
Stefan Falke
Alexander Fedorenko
Nicolas Felder
Jockel Finck
Ute Fischer
Gerhard Fleischer
Klaus Franke
Jürgen Freund
Helmut Fricke
Stephan Gabriel
Andreas Gefeller
Christoph Gerigk
Peter Ginter
Bodo Goeke
Gosbert Gottmann
Thomas Grabka
Patrick Haar
Gabriel Habermann
Bernd Hafenrichter
Michael Hagedorn
Matthias Hangst
Alfred Harder
Oliver Hardt
Jörn Haufe
Anette Haug
Wim van der Helm
Andreas Herzau
Katharina Hesse
Markus C. Hildebrand
Daniel Hintersteiner
Andreas Hub
Claudia Janke
Matthias Jung
Josef Kaufmann
Oliver Kern
Thomas Kienzle
Michael Kienzler
Ulla Kimmig
Dirk Kirchberg
Gunter Klötzer
Herbert Knosowski
Hans-Jürgen Koch
Heidi Koch
Anja Koehler
Vincent Kohlbecher
Reinhard Krause
Bernhard Kunz
Andrea Künzig
Georg Kürzinger
Jens Küsters
Peter Lammerer
Karl Lang
Paul Langrock
Michael Lebed
Peter Leifels
Lorne Carl Liesenfeld
Dorothea Loftus
Gerd Ludwig
André Lützen
Werner Mahler
Aurelius Maier

Thomas Mangold
Hans von Manteuffel
Oliver Meckes
Guenther Menn
Veit Mette
Marc Meyerbröker
Jan Michalko
Jörg Modrow
Mario Moschel
Christoph Mukherjee
Jörg Müller
Hartmut Müller
Heiner Müller-Elsner
Mark-Oliver Multhaup
Ralf Nachtmann
Anja Niedringhaus
Ralf Nöhmer
Roland Obst
Nicole Ottawa
Christoph Otto
Jens Palme
Laci Perenyi
Sabine Plamper
Stefan Pompetzki
Maik Porsch
Frank Pusch
Armin Rasokat
Hans Rauchensteiner
Andreas Reeg
Sabine Reitmaier
Jiri Rezac
Sascha Rheker
Stefan Richter
Astrid Riecken
Boris Roessler
Daniel Roland
Daniel Rosenthal
Jens Rötzsch
Jan Rozanka
Gerard Saitner
Michael Sakuth
Martin Sasse
Sabine Sauer
Gregor Schläger
Jordis Schlösser
Barbel Schmidt
Bastienne Schmidt
Harald Schmitt
Edgar Schoepal
Lioba Schöneck
Markus Schreiber
Bernd Schuller
Frank Schultze
Bernd Schumacher
Horst Jürgen Schunk
Stephan Schütze-Schulte
Hartmut Schwarzbach
Dieter Schwerdtle
Frank Schwere
Oliver Sehorsch
Stephan Siedler
Hans Silvester
Bertram Solcher
Peter Sondermann
Künibert Söntgerath
Renado Spalthoff
Martin Specht
Berthold Steinhilber
Marc Steinmetz
Thomas Stephan
Patrik Stollarz
Jens Sundheim
Olaf Tamm
Andreas Taubert
Andreas Teichmann
Andreas W. Thelen
Christian Thiel
Karsten Thielker
Murat Türemis
Dieter Tuschen
Markus Ulmer
Friedemann Vetter
Lothar Voeller
Timo Vogt
Heinrich Völkel
Bettina Wachsmann
Uli Weber
Markus Weiss
Maurice Weiss
Bernd Weissbrod

Gordon Welters
Syd Westmoreland
Kai Wiedenhöfer
Arnd Wiegmann
Claudia Yvonne Wiens
Mathias Wild
Lutz Winkler
Manfred Wirtz
Ann-Christine Wöhrl
Michael Wolf
Christian Ziegler
Hubert Ziegler
Dirk Zimmer

GREECE
Yannis Behrakis
Alexander Beltes
Michalis Boliakis
Nikos Chalkiopoulos
Efstratios Chavalezis
Apostolis Domalis
Thalassini Douma
Theodosis Giannakidis
Markos George Hionos
Yannis Kabouris
Yiorgos Karahalis
Charis Katsikatsou
Petros Kipouros
Yiannis Kolesidis
Yiorgos Konstantinidis
Yannis Kontos
Maro Kouri
Thomas Lapdas
Sofia Margariti
Aris Messinis
Yiorgos Nikiteas
Chryssa Panousiadou
P. Papadimitropoulos
Lefteris Pitarakis
Thanasis Stavrakis
Sophie Tsabara
Spyros Tsakiris
Ioannis Yiannakopoulos

GUATEMALA
Jesus Alfonso Castaneda
Andrea Aragon
Erick Estuardo Avila Solis
Moisés Castillo Aragón
Fernando Morales
Walter Miguel Pena Pérez
Ricardo Ramirez Arriola

HAITI
Thony Belizaire
Carl Juste

HONDURAS
Orlando Sierra

HONG KONG, S.A.R. CHINA
David Wong Chi Kin

HUNGARY
Eva Arnold
Attila Balázs
Andras Bankuti
Zsolt Batar
Imre Benkö
Krisztian Bocsi
Bea Bodnar
David Bozsaky
Gyula Czimbal
Végel Dániel
Gabor Degre
Szabolcs Dudás
Andras Fekete
Imre Földi
Viktória Gálos
Balázs Gardi
Túry Gergely
András Hajdu
Róbert Hegedüs
Tibor Illyés
Fazekas Istvan
Edit Kalman
Attila Kisbenedek
Árpád Kiss-Kuntler
Zoltán Knap
Szilárd Koszticsák
Attila Kovács
Petra Kovács
Tamás Kovács

Ladislav Nagy
Gabriella Németh
Zsuzsanna Petö
Márta Pintér
Zoltán Pólya
Balazs Robert Zsolt
Katalin Sándor
Lajos Soós
Sandor H. Szabo
Peter Szalmás
Bela Szandelszky
Zilla Szász
Jozsef L. Szentpeteri
Miklos Teknos
Domaniczky Tivadar
Viktor Veres
Peter Zádor
Pataky Zsolt

ICELAND
Hilmar Thor Gudmundsson
Einar Falur Ingolfsson
Kristinn Ingvarsson
Brynjar Gauti Sveinsson

INDIA
Pradip Adak
Anita Agrawal
Sanjay Ahlawat
Kumar Gupta Amit
Anand
Roy Chowdhury Arunangsu
Aseem P.
Atul
Abul Kalam Azad Munshi
S. Balakrishnan Babu
V. Balaji
Mohan Dattaram Bane
Bivas Banerjee
Dilip Banerjee
Tarapada Banerjee
Pablo Bartholomew
Ranjan Basu
Shyamal Basu
Sandesh Bhandare
Amit Bhargava
Kamana Bhaskar Rao
Vijaya Ch.V.S. Bhaskara Rao
Mukund Bhute
G. Binu Lal
Prasanta Biswas
Gautam Bose
Rana Chakraborty
Rahul Chandawarkar
Bhupesh Chandra Little
Bhaskaran Chandrakumar
Deshakalyan Chowdhury
Sherwin Crasto
Pradip Das
Saurabh Das
Sipra Das
Rajib De
Ranjana Desai Gaur
Pallikunnel Raghavan
Devadas
Minakshi Dey
P. Dileepkumar
K.G. Dilipkumar
Gajanan Dudhalkar
Ezhilmathi
Talaskar Gajendra
rakash Gajjar
njay Ghosh
imitra Ghosh
bhendu Ghosh
lok Bandhu Guha
Anshu K. Gupta
Akhil Hardia
Katragadda Harikrishna
Dipak Hazra
Vyas Himanshu
Sajjad Hussain
Iyer
Arun Jacob Thomas
Arvind Jain
Bijoy Kumar Jain
Jayakrishnan
Jayakumar
N.P. Jayan
Roy Jayanta
Samar S. Jodha
Rajan Kapoor
Rajan Karimoola

James Keivom
Girish Kingar
Ajeeb Komachi
Ashish Kumar Kashyap
Pawan Kumar
Surendra Kumar
Kuttibabu A. Beekayyar
Dilip Lokre
T. Madhuraj
Prahlad Mahato
Shreekant Malushte
Natasha M. Martis
Salim Matramkot
Vivan Mehra
Aloke Mitra
Dakoo Mitra
Kailash Mittal
Mohan
Mohan Das
Moni Sankar Das
Arindam Mukherjee
Bhaskar Mukherjee
Dines Mukherjee
Nupur Mukherjee
Joy Mukhopadhyay
Shailesh Mule
Babu Murali Krishnan
P. Narasimiia Murthy
Tauseef Mustafa
Kunjumohammed Najeeb
Suresh Narayanan
Swapan Nayak
Dev Nayak
Nanu Neware
Dutta Nilayan
Sunoj Ninan Mathew
Dave Nirav
Das Pabitra
Chandrakant Palkar
Josekutty J. Panackal
Bipin Patel
Rajan.T Poduval
Pradeep Kumar
T. Kesavan Pradeep Kumar
Bhagya Prakash
Rajeen Prasad
Chandra K. Prasad
Pramod Pushkarna
Shakeel Qureshy
Aijaz Rahi
Kannekanti Ramesh Babu
Kamal Rana
Shailesh Raval
K. Ravikumar
Ravinder Kumar
D. Ravinder Reddy
Kushal Ray
Abdul Razack
Krishna Roy
Rudrakshan
Jayanta Saha
Rakesh Sahai
P. Sandeep
Alapati Sarath Kumar
Suman Sarkar
Kayyoor Sasi
Satheesh
Dominic Sebastian
Bijoy Sengupta
Hemendra A. Shah
Pandey Shailendra
D.P.S. Shauhan
Jayanta Shaw
V.S. Shine
Basu Shome
Ajoy Sil
Bandeep Singh
Dayanita Singh
Ghanshyam Singh
Nitin Waman Sonawane
Ramesh Soni
Arun Sreedhar
Ellikkal V. Sreekumar
Sreekumar
Tamma Srinivasareddy
Sujith
Manish Swarup
Rajesh Tandon
Pradeep Tewari
Bino Thomas
Rajen M. Thomas
Ghantasala Vasanth Kumar
Vinodan Vinod Pattazhy

Babu Vipinchandran
Keshav Vitla
Ali Zakir

INDONESIA
Abdul Arif KFC
Surya Adi Lesmana
Wisnu Adi Setyo
Nugroho Adiweda
Widagdo
Agung Wiera
Arif Ariadi
Wisnu Aribowo
Arief Sukardono
Fahroni Arifin
Bambang A Fadjar
Oka Barta Daud
Adi Baskoro
Beawiharta
Sinar Goro Belawan
Ali Budiman
Bernard Chaniago
Iwan Darmawan
Achmad Yessa Dimyati
Efendi
Riza Fathoni
Heri Gunawan
Hariyanto
Eddy Hasby
Hendrawan
Arthamiya Hidayana
Afriadi Hikmal
Ika Rahmawati Hilal
Fernandez Hutagalung
Bagus Indahono
Roby Irsyad
Hubert Januar
R. Waluya Jati
Kemal Jufri
Rully Kesuma
Ralph Kholid
Andi Kurniawan Lubis
Aris Liem
Ali Lutfi
Indira S.D.P. Martodihardjo
Audy Mirza Alwi
Pang Hway Sheng
Ivan Nardi Patmadiwiria
Paulus Pamawitana
Erik Prasetya
Andry Prasetyo
Tommy A. Pratomo
Hermanus Prihatna
Astadi Priyanto
Edi Purnomo
Arbain Rambey
Seno Resdianto
Faisal Reza
Elizabeth Rika M.M.
Fadjar Roosdianto
M. Said Hararap
Saptono
Yose Saputra
Yamtono Sardi
Stephanus Setiawan
Hotli Simanjuntak
Edward Sinaga
Ferdy Siregar
Poriaman Sitanggang
Slamet Widodo
Subekti
Sugede S. Sudarto
Cholif Sudjatmiko
Jayadi Sugito
Laksono Sugito
Arief Suhardiman Sutardjo
Sungkono
Setiyo Supratcoyo
Kelik Supriyanto
Agus Susanto
F Fiap Sutrisna Ramli
Maha Eka Swasta
Wibudiwan Tirta Brata
Nuraini Tjitra Widya
Tjitra Winarno
Dadang Trimulyanto
Pandji Vasco da Gama
Donang Wahyu S.W.
Didi Airo Wahyudi Rahardjo
Widjanarko
Effy Wiojono Putro
Woko Wiryono Sriyanto
Wisnu Dani Kusumo

Herman Wongso
A. Damardanto Yudhaputra
Ririt Yuniar
Ujang Zaelani

IRAQ
Hadi Al-Najjar
Thair-Zuhair Al-Sudani
Zuhair Kadhim Al-Sudani
Ibrahim Kadhum Dagher
Kamil Khazal Hassan
Amad J. Kareman
Abed Ali Menahy
Al-Jaff Md Azez Ahmed
Saleh Muhsin Al-Samawi
Ibrahim S. Nadir
Lu'ay Sabah AL-Shekli
Ali Talib

IRELAND
Gary Ashe
Marcus Bleasdale
Laurence Boland
Desmond Boylan
Deirdre Brennan
Séamus Conlan
Kieran Doherty
Christopher Doyle
Colman Doyle
Denis Doyle
Michael Dunlea
Damien Eagers
Noel Gavin
Steve Humphreys
Tony Kelly
Eric Luke
Dara Mac Dónaill
David Maher
Denis Minihane
Seamus Murphy
Jeremy Nicholl
Jack P. Nutan
Bryan O'Brien
Kyran O'Brien
Alan O'Connor
Kenneth O'Halloran
Jim O'Kelly
Joe O'Shaughnessy
Ronan Quinlan
Gavin Quirke
Ray Ryan
Mike St Maur Sheil
Paul Stewart
Dermot Tatlow
Eamon Ward
Neil Wilder

ISLAMIC REPUBLIC OF IRAN
Mehrdad Afsari
Masoud Ahmed Zadeh
Ali Ali
Abedi Alireza
H. Amdjadi-Moghaddam
Amir Aslan Arfa
Kaboodvand
Ali Reza Attariani
Mahmood Badrfar
Ebrahim Bahrami
Taghi Bakhshy Rad
Modaressi Banafsheh
A.B. Farde Moghaddam
A.B. Farde Moghaddam
Mehri Behrouz
Mehdi Dorkhah
Majid Dozdabi Movahed
Javad Erfanian Aalimanesh
Mohammad Eslami-Rad
Mahdi Fathi
Amir Reza Fatorehchi
Gholam Reza Fereidooni
Caren Firouz
Mahmood Ghavampoor
Ardavan Gholami
Mohammad Golchin Kohi
Mehrak Habibi
Seyed Hossien Hadeaghi
Somayeh Hadji
Yousef Lavi Hamid
Persila Hamidi
Seyed Hamid Hashemi
S. Jalil Hosseini Zahraei
Siamak Imanpour
Hashem Javadzadeh

Kamran Jebreili
Ali Karimi Rastegar
Ali Reza Karimi Saremi
Mehdi Keshvari
Ali Khaligh
Majid Khamseh Nia
Reza Khazali
Ahmad Khirabady
Mohammad Khodadadash
Behrad Khodaee
Soleyman Mahmoodi
Karim Malak Madani
Ali Mazarei
Mehdy Monem
Hossein Moslemi Nafini
Mansoreh Motamedi
Nafise Motlagh
Mitra Najmi
Riehaneh Naseh Nsihatgoo
Gholam Reza Nasr Esfahani
H. Neshat Mobini Tehrani
M. Nikoobazl-e Motlagh
Massoud Pourjafari
Morteza Pournejat
Mohammad Ali Qariqi
Zahra Farshami Ranjbar
Mohammad Razdasht
Farzad Refahi
Payam Rouhani
Majid Saeedi
Vahid Salemi
Niloofar Sanandajizadeh
Mohsen Sanei Yarandi
Hasan Sarbakhshian
Ali Seraj Hamadani
Seyyed Ali Seyyedi Abardeh
Ahmad Shabouni
Arash Sharifi
Homeira Soleymani
Arman Stepanian Avroshan
Md Parham Taghioff
Ali Tamaddon
Soheil Teymoori
Behrang Tirgary
H. Vasheghani Farahani

ISRAEL
Tsafrir Abayov
Esteban Alterman
Shahar Azran
Ravid Biran
Rina Castelnuovo
Gil Cohen Magen
Orel Cohen
Tal Cohen
Yori Costa
Nir Elias
Eddie Gerald
Vladimir Godnik
Eitan Hess-Ashkenazi
Nir Kafri
Menahem Kahana
Ziv Koren
Yoav Lemmer
Yadid Levy
Yoray Liberman
Reuben Makover
Lior Yoav Mizrahi
Dan Peled
David Rubinger
Gur Salomon
Ariel Schalit
Nati Schohat
Roni Schützer
Ahikam Seri
Ariel Tagar
Gali Tibbon
Eyal Warshavsky
Inbar Zaafrani
Yossi Zamir
Ronen Zvulun

ITALY
Francesco Acerbis
Alessandro Albert
Marco Albonico
Marco Anelli
Michele Annunziata
Roberto Arcari
Massimo Dall'Argine
Roberto Arobbio
Alfio Aurora
Antonio Baiano

Luca Baldassini
Luigi Baldelli
Nicola Bartolone
Massimo Bassano
Alessandra Benedetti
Rino Bianchi
Giuseppe Bizzarri
Tommaso Bonaventura
Marcello Bonfanti
Giovanni Broccio
Francesco Broli
Antonio Calitri
Maristella Campolunghi
Dino Cappelletti
Davide Casali
Luciano del Castillo
Sergio Cecchini
Giuseppe Chiucchiú
Carlos Guillermo Cicchelli
Lorenzo Cicconi Massi
Francesco Cinque
Angela Cioce
Mario Cipollini
Lauria Ciro
Pier Paolo Cito
Francesco Cocco
Paolo Cocco
Elio Colavolpe
Antonino Condorelli
Gianni Congiu
Matt Corner
Marco Cristofori
Lia Cuccio
Massimo Cutrupi
Vittorio D'Onofri
Daniele Dainelli
Giovanni Diffidenti
Alessandro Digaetano
Dario de Dominicis
Fabio Fiorani
Simona Flamigni
Massimiliano Fornari
Ermanno Foroni
Andrea Francolin
Maurizio Galimberti
Mauro Galligani
William Gemetti
Enrico Genovesi
Moreno Gentili
Vince Paolo Gerace
Pietro Di Giambattista
Angri Gin
Loredana Ginocchio
Gianni Giosue
Catherine di Girolamo
Alberto Giuliani
Kamal Hayouni
Carlo Hermann
Nicola Lamberti
Mario Laporta
Alessandro Lazzarin
Antonino Lombardo
Elio Lombardo
Marco Longari
Fabio Lovino
Stefano de Luigi
Fulvio Magurno
Alessandro Majoli
Ettore Malanca
Alberto Malucchi
Annunziata Manna
Antonio Mannu
Claudio Marcozzi
Matteo Marioli
Carlo Marras
Domenico Marziali
Enrico Mascheroni
Massimo Mastrorillo
Daniele Mattioli
Andrew Medichini
Giovanni Mereghetti
Enrico Minasso
Mauro Minozzi
Giovanni Miserocchi
Mimi Mollica
Luana Monte
Silvia Morara
Alberto Moretti
Gabrio Mucchie
Gianni Muratore
Fabio Muzzi
Luca Nizzoli
Cristina Nunziata

Antonello Nusca
Piero Oliosi
Oliviero Olivieri
Bruna Orlandi
Maurizio Orlanduccio
Agostino Pacciani
Antonio Pagano
Stefano Paltera
Bruno Pantaloni
Eligio Paoni
Maurizio Papucci
Stefano Pavesi
Paolo Pellegrin
Gianluca Perticoni
Maurizio Petrignani
Francesco Pignatelli
Vincenzo Pinto
Alberto Pizzoli
Riccardo Polastro
Piero Pomponi
Daniele Ponteri
Roberto Ponti
Franco Pontiggia
Ciro Quaranta
Mauro Raffini
Sergio Ramazzotti
Alberto Ramella
Giuseppe Rampolla
Stefano Rellandini
Andrea Sabbadini
Ivo Saglietti
Andrea Samaritani
Silva Sangiovanni
Marco Saroldi
Patrizia Savarese
Hannes Schick
Massimo Sciacca
Livio Senigalliesi
Luca Servo
Massimo Sestini
Shobha
Gianluca Simoni
Mauro Sioli
Massimo Siragusa
Attilio Solzi
Mario Spada
Mauro Spanu
Riccardo Squillantini
Marco Stoppato
Alessandro Tosatto
Marco Vacca
Riccardo Venturi
Stefano Veratti
Paolo Verzone
Fabrizio Villa
Francesco Zizola
Aldo Zizzo
Pietro Zucchetti
Vittorio Zunino Celotto

JAMAICA
Mark Bell
Bryan Cummings
Norman Grindley
John Nicholson
Garfield Robinson

JAPAN
Takao Fujita
Masaru Goto
Koji Harada
Takashi Hayasaka
Akiyo Hirose
Itsuo Inouye
Takaaki Iwabu
Toshihiko Kawaguchi
Chiaki Kawajiri
Osamu Kikuchi
Yoshi Kitaoka
Taro Konishi
Kudou Masato
Hiroko Masuike
Eishi Miyasaka
Toru Morimoto
Takuma Nakamura
Yasuhiro Ogawa
Hiroto Ogihara
Akira Ono
Sakamaki
Shimpei Sakamoto
Chitose Suzuki
Ryuzo Suzuki
Ari Takahashi

Kuni Takahashi
Atsushi Taketazu
Kazuhito Yamada
Kiyohumi Yamaguchi
Jun Yasukawa
Mitsu Yasukawa
Yutaka Yonezawa

JORDAN
Hassan Abu-Gallyoun
Iyad Ahmad
Jehad Ahmed Ali Shwayat
Amira Al Homsi
Hayfa Aboul Razaq Al Kady
Nabeel Aref Ahmad Al Koni
Ali Al-Sahouri
Ahmad Ghazi Anis
Samir Atalla
Awad Awad
Isam Bino
Saher Fakher Qaddara
Faeq Rustom Abu Gazaleh
Fouad Hattar
Abdallah Kidess
Salman Madanat
Nidal Tawfic Matahen
Essam Rammaha
Ahmad Taher Saffareni
Mohammed Sawalmeh
Mohamed Shoman R.K.

KAZAKHSTAN
Vitaly Bilkov
Mels Eleusin
Viktor Gorbunov
Olga Korenchuk
Valery Korenchuk
Aziz Mamirov
Kairat Nurkenov
Vladimir M. Shurgayev

KENYA
Kweyu Collins
Antony Kaminju
Noor Khamis
Bernice Macharia
Henry Muriithi Nyage
Steve Okoko
Charles Omondi Onyango
Shadrack Otieno Ochieng
Boniface Walunywa
Peter Waweru

KUWAIT
Ali Nasser Al-Roumi

LATVIA
Valdis Brauns
Aigars Eglite
Kaspars Goba
Andris Kozlovskis
Vilena Makarich
Janis Pipars
Ritvars Skuja
Vadims Straume
Zigismunds Zalmanis

LEBANON
Rabih Moghrabi

LESOTHO
Tiny Sefuthi

LITHUANIA
Giedrius Baranauskas
Joranas Bruzinskas
Aurelija Cepulinskaite
Ramunas Danisevicius
Edis Jurcys
Petras Katauskas
Aleksandr Katkov
Kazimieras Linkevicius
Rolandas Parafinavicius
Sigitas Stasaitis
Jonas Staselis
Georgiy Stoliarov

MACEDONIA
Milan Dzingo
Boris Grdanoski
Zoran Jovanovic

MALAGASY REPUBLIC
J.L. Ravonjiarisoa
Narivololona

MALAWI
Mac Robson Chibowa
Govati Nyirenda

MALAYSIA
Jaafar Abdullah
Sawlihim Bakar
Rohani Binti Ibrahim
Chee Keong Ng
Chen Soon Ling
Steven Cheong Loi Sing
Chin Mui Yoon
Salim Dom
Goh Chai Hin
Jimin Lai
Liang Chow Kong
Liew Wei Kiat
Lim Beng Hui
Jeffery Lim Chee Yong
Liow Chien Ying
David Loh Swee Tatt
Mujahid Mahadi
Bazuki Muhammad
Zainuddin Noor Azizan
Noor Azman Zainudin
Sang Tan
Shum Fook Weng
Tajudin Muhd. Yaacob
Tan Ee Long
Vincent Thian
Andy Wong Sung Jeng
Yau Choon Hiam
Yong Chu Mung

MALTA
Joe P. Smith
Darrin Zammit Lupi

MAURITIUS ISLAND
Georges Michel

MEXICO
Daniel Aguilar Rodriguez
Miguel Alvarez
L. Alonso Anaya Labastida
Armando Arorizo
Evainez Becerra Cárdenas
J.A. Bermúdez González
Dante Busquets Sordo
Ulises Castellanos Herrera
Marco Castro
Ray Chavez
C. Alberto Contreras Durán
Marcos Corona Rodriguez
Erika Cuevas Herrera
Elizabeth Dalziel
Alfredo Estrella Ayala
T. Figueroa Monterde
Ivan Garcia Guzman
J. Carlo Gonzáles Moreno
L. Humberto Gonzalez Silva
C. Guadarrama Guzman
Carla Haselbarth Lopez
J.M. Jiménez Rodríguez
Miguel Juarez Lugo
Angélica Jurado Castillo
J. Agustin Martinez Garcia
Victor Mediola Galván
D.A. Morales Contreras
Humberto Muñiz Ceja
Erick David Muñiz Soto
L. Grace Navarro Gutierrez
Mario Palacios Luna
Ana Isabel Patino Munoz
Carlos Puma
Rafael del Rio Chávez
F. Javier Rios Fernández
José Refugio Ruiz Vargas
Oscar Salas Gómez
V.M. Segura Hernandez
Marcela Taboada Avilés
Rodolfo Valtierra Rubalcava
Marco Aurelio Vargas Lopez
Antonio Zazueta Olmos

MOÇAMBIQUE
Victor Marrao

MOROCCO
Hamid Ben Thami
Ahmed Boussarhane
Mustapha Ennaimi

NEPAL
Ghale Bahadur Dongol
Shree Prakash Bajracharya
Mukunda Kumar Bogati
Shahukhala Ganga Ram
Aroj Gopal Gurubacharya
Chandra Shekhar Karki
Bajracharya Kaushal Ratna
Kiran Kumar Panday
Madan Kumar Panday
Dinesh Maharjan
Sharad Prasad Joshi
Dharama Raj Dongol
Kishor Rajbhandari
K.C. Rajesh
Narenda Shrestha
Naresh Kumar Shrestha
Prasant Shrestha
Sagar Shrestha

THE NETHERLANDS
Rogier Alleblas
Jan Banning
Maurice Bastings
Rob Becker
Frank van den Berg
Reinout van den Bergh
Peter Blok
Chris de Bode
Remco Bohle
Maurice Boyer
Henk Braam
Eric Brinkhorst
Erik Christenhusz
René Clement
Roger Cremers
Peter Dejong
Kees van Dongen
Kjeld Duits
Cornell Evers
Ilse Frech
Brian George
Lukas Göbel
Guus van Goethem
Martijn van der Griendt
Marco de Groote
Christine den Hartogh
Hans Heus
Gerrit de Heus
Wim Hofland
Dick Hogewoning
Laurens van Houten
René van der Hulst
Barbara van Ittersum
Vincent W. Jannink
Anja De Jong
Martijn de Jonge
Jasper Juinen
Karijn Kakebeeke
Martin Kers
Geert van Kesteren
Chris Keulen
Arie Kievit
Robert Knoth
Ton Koene
Ellen Kok
Jorgen Krielen
Jeroen Kroos
Peter Kühl
Jerry Lampen
Gé-Jan van Leeuwen
Jaco van Lith
Judi Lubeek
Alexander de Meester
Ketan Modi
Marcel Molle
Martin Mooij
Reinout Mulder
Robert Mulder
Yvonne Mulder
Alex ten Napel
Benno Neeleman
Eppo Wim Notenboom
John Oud
Henk Pluijm
Frans Poptie
Antonio Quintero
Stijn Rademaker

Annelies Rigter
Guus Rijven
Martin Roemers
Gerhard van Roon
Nadine Salas
Diana Schetters-Scheilen
Ruben Schipper
Erik Schoeber
Peter Schrijnders
Roy Tee
Peter Valckx
Leo van Velzen
George Verberne
Peter Verhoog
Jan Vermeer
Rolf Versteegh
Teun Voeten
Robert Vos
Richard Wareham
Klaas-Jan van der Weij
Eddy van Wessel
Emily Wiessner
Herbert Wiggerman
Matty van Wijnbergen
Paolo Orazio Woods
Herman Wouters
Marco Zeilstra
Rop Zoutberg

NEW ZEALAND
Scott Barbour
Pip Blackwood
Greg Bowker
Jeff Brass
Melanie Burford
Martin De Ruyter
Marion Van Dijk
Janet Durrans
Mark Dwyer
Carolyn Elliott
Andrew Gorrie
Robin Hammond
David Hancock
Jimmy Joe
Robert Marriott
Peter Meecham
Marty John Melville
Bruce Mercer
Brett Phibbs
Peter James Quinn
Kenny Rodger
Craig Simcox
Katiche Monica Tranter
David Leo Ross White

NICARAGUA
A. Sánchez Mendoza

NIGERIA
Ikeanyi Chinyere Adaku
Kingston O. Daniel
George Esiri
Isa Bayoor Ewuoso
Kehinde O.M. Gbadamosi
Olumuyiwa Hassan
Tunde Olaniyi
Augustine I. Ude

NORWAY
Odd Andersen
Lise Aserud
Jonas Bendiksen
Jon-Are Berg-Jacobsen
Tore Bergsaker
Stein Jarle Bjorge
Terje Bringedal
Tomm Wilgaard
Christiansen
Robert Eik
Roger Engvik
Pal Christopher Hansen
Johnny Helgesen
Harald Henden
Pal Hermansen
Vidar Herre
Morten Hvaal
Jan Johannessen
Frode Johansen
Frank Chr. Krisgaard
Mimsy Moller
Otto von Münchow
Aleksander Nordahl
Karin Beate Nosterud

Ken Opprann
Espen Rasmussen
Rune Saevig

PAKISTAN
Zafar Ahmed
Zahid Hussein
Saeed Khan
Farah Mahbub
Arif Mahmood

PALESTINIAN TERRITORIES
Hossam Abu Alan
Luay Abu Haykel
Mahfouz Abu Turk
Jaafar Ashtiyeh
Rula Halawani
Nayef Hashlamoun
Ahmed Jadallah
Suhaib Jadallah Salem
Fayez Nuraldin
Abed Omar Qusini
Mohammed Saber
Nasser Shiyoukhi
Osama Silwadi

PANAMA
Eustacio Humphrey
Alvaro Reyes Nunez
Essdras M. Suarez

PARAGUAY
Hugo Fernández En Ciso

PEOPLE'S REPUBLIC OF CHINA
An Xi
Bai Jianguo
Baowen Hu
Baozhu Yang
Cao Wei Song
Cao Zhi-gang
Chai Jijun
Bowles Chan Kam Fai
Chang Yong
Ke Chen
Chen Da Yao
Chen Genshang
Chen Hangfeng
Chen Zhi Wei
Cheng Binghong
Cheng Gang
Chiang Yung-Nien
Cin Aiping
Cui Bo Qian
Cui Heping
Cui Zhi Shuang
Dahai Yang
Dalang Shao
Deng Bo
Deng Yi
Dong Lianshan
Fan Haibo
Fan Jinying
Fan Ying
Fan Zong Lu
Feng Yaohua
Fu Chun Wai
Gao Hongxun
Gao Ming
Gaohua Zheng
Gu Jia
Gu Xiao Lin
Han Yong Gao
Hang Ling Bing
He DeLiang
He Haiyang
He Jing Chen
Hong Guang Lan
Hu Jin
Hu Qing Ming
Hu Xiao Mang
Hu Xue Bai
Huang Minxiong
Huang Yibing
Huang Yiming
Huang Yue-Hou
Huo Xue Li
Jia Guo-rong
Jian Rong Xu
Jiang Shangbo
Jiang Xiaoming
Jiang Yun Long

Justin Jin
Jin Si Liu
Juan Lu
Juguang Cai
Leng Bai
Li Cheng
Li De
Li Gang
Li Jie Jun
Li Ming
Li Shaoyi
Li Wei
Li Wending
Li Xiaoning
Li Xiaorong
Li Zhenghua
Liang Daming
Lin Jin
Lin Yong Hui
Liu Chang Ming
Liu Gen Tan
Liu Hong Jun
Liu Hongqun
Liu Jie
Liu Jie Min
Liu Liqun
Liu Ping
Liu Shujin
Liu Siyuan
Liu Yadong
Long Hai
Florence Low
Lu Bin
Lu Guang
Lu Ming
Lu Su Yang
Lu Sui Bin
Lu Zhong Bin
Lu Luguangwei
Luo Shurong
Ma Hongjie
Ma Weiwen
Man Huiqiao
Mi Lefeng
Mingang Xie
Mingguo Meng
Mou Jianwei
Nan Qiu Yang
Nuang Jingda
Pak Fung Wong
Pan Enzhan
Peng Cheng Sha
Peng Hui
Pingping Zheng
Qi Jieshang
Qi Shang Min
Qi Xiao Long
Qian Hua
Qin Datang
Qin Wengang
Qiu Yan
Ran Yujie
Ren Xi-hai
Rong Zhang
Shi Jianxue
Song Bujun
Song Jihe
Mok Suet Chi
Jie Sun
Sun Yunhe
Sun Zhijun
Tang Jian
Tian Fei
Tian Fei
Tong Jiang
Oliver Tsang Wai Tak
Wang Chen
Wang Jingchun
Wang Jun
Wang Mianli
Wang Qiu Hang
Wang Shi Jun
Wang Tie Heng
Wang Xi Zeng
Wang Xiao Yan
Wang Xinyi
Wei Yongging
Wen Xiao Han
Roger Wu
Wu Jiuling
Wu Mao Jia
Wuniao
Xiao Huai Yuan

Xiao Lian-cang
Xiao-qun Zheng
Xiaoyun Luo
Xishan Chen
Xu Cheng Ai
Xu Jiashan
Xu Jingxing
Xu Lin
Xu Tiantong
Xu Wu
Xu Xian Xing
Xu Xiyi
Xue Wei Hong
Yan Bailiang
Yang Biwen
Yang Kejia
Yang Lin Tao
Yang Ninghuan
Yang Shen
Yang Xiaogang
Yang Xin Yue
Yang Xingfang
Yang Yankang
Yao Fan
Yie Li Ming
Yong Yao
You Hong Yuan
Yu Haibo
Yu Hui Tong
Yuan Jingzhi
Zeng Nian
Guo Yue Zhang
Zhang Feng
Zhang Feng
Zhang Guowei
Zhang Jing Ming
Zhang Jing Yun
Zhang Liang
Zhang Meng
Zhang Nan Xiu
Zhang Qin
Zhang Shulin
Zhang Si-en
Zhang Wei
Zhang Xiaoyu
Zhang Yan
Zhang Yanhui
Zhang Yi
Zhang You Hua
Zhang Yu
Zhang Yun Long
Zhang Zihong
Zhao Jing Dong
Zhao Jiye
Zhao LiJun
Zhao Wen Sheng
Zhao Xiongtao
Zheng Congli
Zheng Guo-qiang
Zheng Meng Tian
Zheng Niu Guo
Zheng Peigun
Zheng Xun
Zheng Zheng Pang
Zhenhai Zhao
Zhigang Yao
Zhou Changyou
Zhou Guoqiang
Zhou Kun
Zhou Mingxing
Zhou Qing Xian
Zhou Wei
Zhou Yan Ming
Zhou Yuanging
Zhu Jian Xing
Zhu Min Hui
Zhu Xiao Feng
Zhuang Yingchang
Zou Hong
Zou Yi
Zou Zouxian

PERU
Juana Arias
Renzo Babilonia
M. Belaunde Montalván
Pedro Cardenas Muñoz
Nancy Chappell Voysest
F. José Chuoiure Santivañez
Hector Emanuel
Dominique Favre Falconi
Gisella Gutarra
Cecilia Larrabure Simpson

144

G.O. Manrique Robles
Hector Mata
M. Ines V. Menacho Ortega
Mayu Mohanna
Karel Keil Navarro Pando
Verónica Salem Abufom
Daniel Silva Yoshisato
G. Martin Venegas Cabrera

THE PHILIPPINES
Arni Aclao
Alex Badayos
Marcelito "Bong"
Cabagbag
Amper Campaña
Eric de Castro
Claro Fausto Cortes
Ian N. dela Cruz
Ilan Cuizon
Roland Alex P. Dela Pena
Antonio E. Despojo
Pepito Frias
Romeo Gacad
Oliver Y. Garcia
Christopher Garcia
Johnson
Maria Consuelo Gomez
Victor Kintanar
Marvi Sagun Lacar
David jr. Leprozo
Diana Noche
Marcial, Jr Reyes
Ruel Rosillo
Dennis Sabangan
Reena Rose Sibayan
Rafael Taboy

POLAND
Aleksandra Adryanska
Piotr Andrews
Pjotr Babinski
Magdalena Bartkiewicz-Podgorska
Jacek Bednarczyk
Piotr Blalwicki
Grzegorz Celejewski
rzegorz Dabrowski
iotr Dras
Marek Drobiecki
Waclaw Dutkiewicz
Janusz Filipczak
Lukasz Glowala
Andrzej Gojke
Arkadiusz Gola
Waldemar Gorlewski
Andrzej Górski
Andrzej Grygiel
Tomasz Gudzowaty
Rafat Guz
Alexander Holubowicz
Piotr Janowski
Hubert Jasionowski
Maciej Jawornicki
Jarek Jaworski
Maciej Jeziorek
Tomasz Jodlowski
Jaroslaw Jurkiewicz
Jacek Kaminski
Tomasz Kaminski
Aleksander Keplicz
Grzegorz Klatka
Rafal Klimkiewicz
Roman Konzal
Pawel Kopczynski
Pawel Kosinski
Grzegorz Kosmala
Robert Kowalewski
Hilary Kowalski
Damian Kramski
Witold Krassowski
Marek Krzakala
Robert Krzanowski
Andrzej Kubik
Robert Kwiatek
Marek Lapis
Arek Lawrywianiec
Gabor Lörinczy
Grazyna Makara
Andrzej Marczuk
Mieczystaw Michalak
Slawomir Mielnik
Czeskaw Mil
Krzysztof Miller

Wojciech Miloch
Andrzej Nasciszewski
Krystyna Okulewicz
Palusiak Pawel
Mieczystaw Pawlowicz
Cezary Pecold
Leszek J. Pekalski
Jerzy Piasecki
Marek Piekara
Radoslaw Pietruszka
Leszek Pilichowski
Hanna Polak
Jerzy Przybysz
Aleksander Rabij
Ekza Radzikowka
Agnieszka Rayss
Marcin Rutkiewicz
Michal Sadowski
Wieslaw Seidler
Maciej Skawinski
Jacek Smarz
Dorota Smoter
Waldemar Sosnowski
Przemyslaw Stachrya
Maciej Stawinski
Pawel Supernak
Wojtek Szabelski
Michal Szlaga
Marek Szymanski
Adam Tach
Jerzy Tapinski
Tomasz Tomaszewski
Karina Trojok
Lukasz Trzcinski
Jacek Turczyk
Pawet Ulatowski
Adam Warzawa
Matusik Wojciech
Lukasz Wolagiewicz
Bartomiej Zborowski
Jan Zdzarski

PORTUGAL
F. Wis Almeida
A. Mariano Arango Soares
Ricardo Bento
Rita Carmo
Antonio Manuel Carrapato
J. Carlos Almeida Carvalho
Ricardo Augusto Castelo
Leonel De Castro
Pedro Corréa da Silva
Ana Maria Cortesão
Antonio José Cunha
Paulo Cunha
Rui Pedro Duarte Silva
Paulo Manuel Sargo Escoto
Elisabete Farinha
José Manuel Ferreira Mota
Jorge Firmino
Eduardo Gageiro
Helena Cristina Henriques
Mauricio José Chan
Arthur Machado
João Mariano
Paulo Novais
M. de Jesus Cerda Pereira
João Paulo Pereira Pimenta
Luis Ramos
Bruno Rascao
Daniel Marques Rocha
N.A. Rodrigues Garrido
José Carlos Salgueiro
Jorge Simão
Pedro Sottomayor
Fernando Veludo
Miguel Veterano
Sara Maria Baptista Wong

PUERTO RICO
Xavier Araújo Berrios
Jose Rosario

REPUBLIC OF KOREA
Chae Seung-Woo
Hyoung Chang
Cho Sung Joon
Shin Dong Phil
Han Sang Chul
Jae-Ho Ham
Jae-hoon Kwak
Haseon Park
Seogang Park

Mia Song
Soo Hyun Park
Sung Hyun Jun
Sung Nam Hun
Yong I Kim
Young-Jo Kang

ROMANIA
Adrian Ovidiu Armanca
Constantin Daniel Avram
Remus Nicolae Badea
Cristel Bogdan
Petrut Calinescu
Lucian Crisan
Halip Doru
Vadim Ghirda
Radu Ghitulescu
Tasi Ioan
Vlad Lodoaba
Daniel Mihailescu
Emil Moritz
Eugen Negrea
Marius Nemes
Marian Plaino
Radu Pop
Radu Sigheti
Septimiu Slicaru
Mihail Vasile

RUSSIA
George Akhadov
Grigory Aleksikov
Dmitri Astakhov
Eugene Astashenkov
Dmitry Azarov
Tatyana Balashova
Vasily Baranyuk
Dmitry Beliakov
Nikolai Beloborodov
Ivan Belov
Valery Bodrjashkin
Pavel Buchatsky
Sergei Chirikov
Alex M. Degtyaryov
Alexander Demianchuk
Andrey Deyneka
Boris Dolmatovsky
Konstantin Donin
Vladimir Dubrovskiy
Oksana Dzadana
Vladimir Fedorenko
Vladimir Filimonov
Irina Galynina
Vladimir Galynkin
Svetlana Garmash
Igor Gavrilov
Alexei Godunov
Serguei Golovatch
George Gongolevich
Boris Gorev
Anatoliy Haritonov
Alik Hasanov
Nikolai Ignatiev
Sergei Isakov
Vladimir Kakovkin
Kirill Kallinikov
Sergey Kaptilkin
Engin Karderin
Eugeniy Karmaev
Boris Kaulin
Snezhana Kazakova
Sergei Khalzov
Nickolay Kireyev
Victor Kirsanov
Sergei Kivrine
Jury Klekovkin
Mikhail W. Klimentiev
Yuri Kochetkov
Vyacheslav Kochetkov
Alexej Kompaniychenko
Sergei Kompaniychenko
Yevgeni Kondakov
Alexey Kondrashkin
Pavel Korbut
Alexander Korolkov
Serguei Kouznetsov
Sergey Kovalenko
Sergei Kovalev
Denis Kozhevnikov
Igor Kravchenko
Tatyana Kravchenko
Alexandr Kuznetsov
Vladimir Larionov

Oleg Lastochken
Dmitry Leonov
Alexsander Lisafin
Anatoly Maltsev
Olga Mamedova
Alexander Marinitcher
Nick Matrosov
Sergey Maximishin
Semeon Meisterman
Rasul Mesyagutov
Sergei Mikheev
Ilya Mordvinkin
Anatoly Morkovkin
Boris Mukhamedzyanov
Alexei Myakishev
Waleri Nasedkin
Alexander Nemenov
Andrey Nikerichev
Oleg Nikishin
Maxim Novikov
Anton Oparin
Alexander Oreshnikov
Tatiana Parfishina
Jurij Pavlov
Valentina Pavlova
Arturs Pavlovs
Denis Pogostin
Alexander Polyakov
Konstantin Postnikov
Oleg Prasolov
Sergey Prohorov
Vitaliy Reshunov
Koksharov Roman
Andrey Rudakov
Andrej Shapran
Sergey Shekotov
Yuri Shtukin
Ekaterina Shtukina
Nikolay Sidorov
Alexander Skorniakov
Andrei Sladkov
Vladimir Snegirev
Nikolaj Sorokin
Anatoli Sourov
Alexander Stephanenko
Vladimir Stolyarov
Andrey Suchkov
Vladimir Syomin
Grigory Tambulov
Nikolai Tikhomirov
Elena Tikhonova
Sergey Titov
Sergei Vasiliev
Liudmila Velasco
Vladimir Velengurin
Dmytriy Voloshin
Anatoly Vilyahovsky
Yuri Vorontsov
Vladimir Vyatkin
Juri Zaritovsky
Konstantin Zavrazhin
Anatoliy Zhdanov
Igor Zotin
Tatyana Zubkova

SAINT LUCIA
Marius Modeste

SAUDI ARABIA
Fouzy T. Mahjoob
Zaki Ali Sinan
Baker Dawood Sindi

SENEGAL
Idrissa Guiro
Ousmane Dago Ndiaye

SIERRA LEONE
Randolph Dauphin

SINGAPORE
Chua Chin Hon
Dan Loh
Terence Tan
Simon Thong
Teck Hian Wee

SLOVAKIA
Andrej Ban
Jozef Barinka
Roman Benicky
Peter Brenkus
Alan Hyza

Martin Kollar
Ivan Laputka
René Miko
Marek Velcek

SLOVENIA
Edo Einspieler
Dusan Jez
Andrej Kriz
Tomi Lombar
Darije Petkovic
Zvonka Simcic
Bojan Velikonja

SOUTH AFRICA
Peter Bauermeister
Jodi Bieber
Paul Botes
Tracey Derrick
Chippy Devjee
Thys Dullaart
Hein Duplessis
Thembinkosi Dwayisa
Enver Essop
Brenton Geach
Louise Gubb
Anton Hammerl
John Peter Hogg
Rian Horn
Nadine Hutton
Andrew Ingram
Fanie Jason
Jeremy Jowell
Angelo Kalmeyer
Nonhlanhla Eddie Kambule
Christiaan Kotze
Elské Kritzinger
Halden Krog
Alf Kumalo
Juhan Kuus
Anne Laing
Stephen Lawrence
T.J. Lemon
Charlé Lombard
Kim Ludbrook
Denzil Maregele
Leonie Marinovich
Themba Maseko
Kendridge Mathabathe
Simon Mathebula
Gideon Mendel
Katherine Muick
Tinus Muller
Khaya Ngwenya
Mykel Nicolaou
Neo Ntsoma
James Oatway
Siyabulela Obed Zilwa
Andrew October
Jean M.J. du Plessis
Jacoline Prinsloo
Karin Retief
John Robinson
David Sandison
Joe Sefale
David Silverman
Sibeko Siphiwe
Brent Stirton
Guy Stubbs
Caroline Suzman
Guy Tillim
Rogan Ward
Roy Wigley
Graeme Williams
Debbie Yazbek
Schalck Van Zuydam

SPAIN
Tomás Abella Constansó
Carmen Alemán Alvarez
Julen Alonso Laborde
Diego Alquerache
Jose Andres Parrilla
Jesús Antoñanzas Ibañez
Javier Arcenillas
Pedro Armestre
Ariadne Arnés Novau
Pablo Balbontin Arenas
Juan Carlos Barbera Marco
Raúl Belinchón
Enrique Luis Beltran Terol
Clemente Bernad Asiain
Albert Bertran Cipres

Nacho Calonge Minguez
Sergi Camara Loscos
Jordi Cami Caldes
Vicente Cardona Orloff
Xosé Castro Coleiro
Juan Manuel Castro Prieto
Cristobal Castro Veredas
Carma Casulá
Agustín Catalán Martínez
Carlos Cazalis Ramirez
Ignacio Cerezo Otega
Xavier Cervera Vallve
Eduard Comellas Barrau
Matias Costa
Daniel de Culla
Juan Diaz Castromil
Ignacio Doce Villemar
Paco Feria Villegas
Carlos Fernandez Pardellas
Andres Fernandez Pintos
Pere Ferre Caballero
Cristina Garcia Rodero
Ander Gillenea
Paco Gómez García
Toni Gonzalez Santiso
Pasqual Gorriz Marcos
Jordi Gratacòs Caparrós
Bibiana Guarch Llop
Isaac Hernández
Nagore Iraola Gonzalez
Frank Kalero
Alvaro Leiva
Santy López
José A. Lopez Soto
Carlos Lujan
Kim Manresa Mirabet
Fernando Marcos Ibanez
Enric F. Marti
Javier Martinez Llona
Alberto Antonio Martos
Corral
Antonio Mejias Flores
Gemma Miralda Escudé
Fernando Moleres Alava
José Muñoz
Alex Munoz Riera
Dianeris Nieves Santiago
Anna Oliver
Josep Maria Oliveras Puig
Eudald Picas Vinas
Elisenda Pons Oliver
Iñaki Porto Villanueva
Jordi V. Pou Jove
Javier Prieto Cazorla
Ramon Puga Lareo
Joan Puzol Creus
Sergi Reboredo
Manzanares
Begona Rivas
J. Rodriguez Lombardero
Beatriz Romero Herrera
Lorena Ros
Carlos Rubio Pedraza
Marcelli Sáenz Martínez
I. Sainz de Baranda Puig
Moises Saman
Luís Sanchez Davilla
Tino Soriano
Javier Teniente Lago
Maria Torres Solanot
Xavier Torres-Bachetta
Txomin Txueka Isasti
Juan Valbuena Carabana
Luis De Vega

SRI LANKA
Angelo Angelo de Mel
T. Rukshan Bandurathna
Saumyasiri Fernando
Thushara Waruna Perera
Anoma Rajakaruna
Vijayadasa
B. Nalin Wickramage

SUDAN
Issam Ahmed Abdelhafiez
Ahmed Elamin Bakhit
Ismail Ahmed Gaily
Osama Mahdi Hassan
Md Nur El-din Abdalla

SURINAM
Edward Troon

SWEDEN
Martin Adler
Jörgen Ahlström
Torbjörn Andersson
Roland Bengtsson
Lars Dareberg
Joakim Eneroth
Ake Ericson
Per-Olov Emanuel Eriksson
Jan Fleischmann
Jessica Gow
Johan Gunséus
Johnny Gustavsson
Niclas Hammerström
Paul Hansen
Krister Hansson
Tommy Holl
Adam Ihse
Peter Jigerström
Ann Johansson
Jorgen Johansson
Magnus Johansson
Jonas Karlsson
Peter Kjelleras
Mattias Klum
Christian Leo
Larseric Linden
Jonas Lindkvist
Joachim Lundgren
Chris Malusynski
Tommy Mardell
Paul Mattsson
Jack Mikrut
Henrik Montgomery
Thomas Nilsson
Cecilia Olsson
Jan-Christer Persson
Per-Anders Pettersson
Kai Ewert Rehn
Peter Schedwin
Torbjörn Selander
Lisa Selin
Hakan Sjöström
Maria Steen
Göran Stenberg
Per-Olof Stoltz
Roland Stregfelt
Ake Thim
Ola Torkelsson
Roger A. Turesson
Joachim Wall
Jon Wentzel
Henrik Witt
N.K.-G. Zahedi Fougstedt

SWITZERLAND
Iris Andermatt
Veronique Audergon
Manuel Bauer
Nicholas Bonvin
Mathias Braschler
Markus Bühler
Marcel Chassot
Sebastian Derungs
Andreas Frossard
Daniel Fuchs
Mariella Furrer
Enrico Gastaldello
Yvain Genevay
Michael von Graffenried
Michael Greub
Tobias Hitsch
Robert Huber
Thomas Kern
Marc Latzel
Yves Leresche
Claudio Mamin
Marco Paoluzzo
Nicolas Repond
Nicolas Righetti
René Ritler
Germinal Roaux
Didier Ruef
Hannes Schmid
Andreas Schwaiger
Daniel Schwartz
Andreas Seibert
Niklaus Stauss
Stefan Sueess
Hansüli Trachsel

Participants Contest 2002

Valdemar Verissimo
Olivier Vogelsang
Tomas Wüthrich
Luca Zanetti

SYRIA
Ibrahim Abdulmanan
Najem Al-Nayef
Ziad Al-Set
Munzer Bachour
Nouh-Ammar Hammami
Mahdi Jafar
Zukaa Jarrah al Kahlal
Akef Kammoush
Fadi Masri Zada

TAIWAN ROC
Mark Chien
Kuo Yuan-Fu
Kuo-chen Chen
Lin Chung-An
Lin Daw-Ming
Ma Li-Chun
Alan Peng
Peng-Chieh Huang
Shen Chao-Liang
George Tsorng
Wang Yu-Jen
Wu Yi-ping
Yang Hai Kuang
Yang Wen-Chin
Yu Chih-Sheng
Yu Lu Kuang

TANZANIA
Ahmed Abdullah Riyami
Ketan J. Amarshi
Khamis Hamad Said
Mohamed A. Mambo

THAILAND
Pornchai Kittiwongsakul
Sarot Meksophawannakul
Jetjaras Na Ranong

TUNISIA
Karim Ben Khelifa

TURKEY
Yavuz Arslan
Coskun Asar
Bikem Ekberzade
Gunes Kocatepe
Aziz Uzun

TURKMENISTAN
Kakabay Nazarov

UGANDA
Bruno Birakwate
Henry Bongyereirwe

UKRAINE
Igor Bulgarin
Sergei Datsenko
Vladimir Dyachenko
Gleb Garanich
Minchenko Gennady
Andrey Gorb
Alexander Gordievich
Sergey Gukasow
Sergei Ilnitsky
Andrey Kanishchev
Vadim Kozlovsky
Valeriy Levischenko
Ivan Melnik
Oxana Nedilnichenko
Vladimir Osmushko
Sergey Svetlitsky

UNITED KINGDOM
Mike Abrahams
Timothy Allen
Nigel Amies
Chris Anderson
John Angerson
Adrian Arbib
David W. Ashdown
Marc Aspland
Dan Atkin
Stewart Russel Attwood
Jocelyn Bain Hogg
Richard Baker

Roger Bamber
Graham Barclay
Jonathan Bartholomew
Barry Batchelor
Sean Bell
Piers Benatar
Alistair Berg
Suzy Bernstein
Raymond Besant
Vince Bevan
Mark Bickerdike
Susannah Binney
Peter Bolter
Jon Bond
Steve Bould
Stuart Boulton
Russell Boyce
Zana Briski
Nigel Brown
Clive Brunskill
Jonathan Buckmaster
Tessa Bunney
Gary Calton
Mark Campbell
Richard Cannon
Robert Carmichael
Serena Carminati
Angela Catlin
Paul Chappells
David Charnley
Wattie Cheung
Mark Chilvers
Edmund Clark
Garry Michael Clarkson
Paul Clements
Nick Cobbing
Christopher Coekin
Philip Coomes
Ian Cooper
Paul Cooper
Nick Cornish
Brendan Corr
Andy Couldridge
Christopher Cox
Michael Craig
Tom Craig
Eleanor Curtis
Simon Dack
Andrew Davies
Adrian Dennis
Nigel Dickinson
Ann Doherty
John Downing
Mark Earthy
Colin Edwards
Glenn Edwards
Neville Elder
Stuart Mills Emmerson
Sophia Evans
Nick Fairhurst
Malcolm Fearon
Steven Filipovich
Simon Finlay
Andrew Fox
Adam Fradgley
Stuart Freedman
Rob Gallagher
George Georgiou
John Giles
David Graves
Johnny Green
Phil Griffin
Matt Griggs
Paul Hackett
Gary Hampton
Tim Harley-Easthope
Joshua Haruni
Mark Henley
Paul Herrmann
Tim Hetherington
Jack Hill
James Hill
Nigel Hillier
Stephen Hird
James Hodson
Jim Holden
David Hollins
Rip Hopkins
Derek Hudson
John Hulme
Graeme Hunter
Mike Hutchings
Stefan Irvine

Chris Ison
Andrew James
Adrian Judd
Suresh Karadia
Christian Keenan
Findlay Kember
Justin Kernoghan
Mike King
Ross Kinnaird
Glyn Kirk
Gary Knight
Herbie Knott
Nicola Kurtz
Tony Kyriacou
Colin Lane
Kalpesh Lathigra
Stephen Latimer
Karoki Lewis
Andrzej Liguz
Alison Locke
Paul Lowe
Peter MacDiarmid
Alex MacNaughton
Mike Maloney
Stephen Markeson
Paul Marriott
Dale Martin
Keith Martin
Dylan Martinez
Don McCullin
Terence McGourty
Tim McGuinness
Toby Melville
Dod Miller
Sacha William Miller
Jeff Mitchell
David Modell
Brian Moody
Mike Moore
Beth Moseley
Andy Moxon
Eddie Mulholland
Stephen Munday
Barry Myers
Pauline Neild
Joanne Louise Nelson
Zed Nelson
Peter Nicholls
Simon Norfolk
Rob Norman
Jonathan Olley
Kevin Oules
Jeff Overs
Colin Pantall
Teri Pengelley
Gerald Penny
John Perkins
Marcus Perkins
Paul Pickard
Tom Pilston
Olivier Pin-Fat
Nick Potts
Sophie Powell
Gary Prior
David Purdie
Paul Quayle
Tony Quinn
Steve Race
Andy Rain
Scott Ramsey
John Reardon
Peter Reimann
Kiran Ridley
Dominic Ridley
Paul Roberts
Simon Roberts
Ian Robinson
Stuart Robinson
Paul Rogers
Lorena Ros
David Rose
Mark David Runnacles
Ian Rutherford
Peter Sandground
John Schaffer
Christian Schwetz
Mark Seager
Anup Shah
Martin Shields
David Shopland
John Sibley
Ben Smith
Bill Smith

Michael Steele
Christopher Steele-Perkins
Tom Stoddart
Richard Stonehouse
Justin Sutcliffe
Sean Sutton
Jeremy Sutton-Hibbert
Richard Swingler
Martin Sykes
Jonathan Taylor
Edmond Terakopian
Andrew Testa
Siôn Touhig
Nick Treharne
Chris Turvey
Mike Urwin
Asya Verzhbinsky
Joanna Vesten
Howard H. Walker
Michael Walter
Aubrey Washington
Karen Jane Watendewao
Nigel Watmough
Richard Wayman
Felicia Webb
William Webster
Amiran White
David White
Keith Whitmore
Kirsty Wigglesworth
Denis Williams
Greg Williams
James Williamson
Philip Wolmuth
Antony Wood
Steve Wood
James Wright
Matt Writtle

URUGUAY
Leo Barizzoni Martinez
Jarwin Hugo Borelli Galli
G. Alejandro Cusmir Cúneo
Julio Etchart
M. Ines Hiriart Beracochea
F. Daniel Pena Cabrera
Miguel Rojo
Nicolás Scafiezzo Porcelli

USA
Jeffrey Aaronson
Henny Ray Abrams
Michael Adaskaveg
Lynsey Addario
Noah Addis
Michael Ainsworth
Alyson Aliano
Jennifer Altman
Stephen L. Alvarez
Lyn Alweis
Chris Anderson
Jon Anderson
Kathy Anderson
Patrick Andrade
Ryan Anson
Samantha Appleton
J. Scott Applewhite
Charlie Archambault
Glen Asakawa
Marc Asnin
Christopher T. Assaf
Shawn Baldwin
Karen Ballard
Alyssa Banta
Jeffrey W. Barbee
Andy Barron
Jonathan Barth
Don Bartletti
Samantha Bass
Jim Bates
David Bathgate
Stuart Bayer
Liz Baylen
Frank Becerra Jr.
Patricia Beck
Robert Beck
Robyn Beck
Keith Bedford
Vanessa Beecroft
Natalie Behring-Chisholm
H. Darr Beiser
Al Bello
Amy Beth Bennett

P.F. Bentley
Jean-Paul F. Bergeron
Rüdiger Bergmann
Nina Berman
Alan Berner
Susan Biddle
John Biever
Chris Birks
Shannon Bishop
Eileen M. Blass
Gary Bogdon
Diane Bondareff
Harry Borden
Sherrlyn Borkgren
Peter Andrew Bosch
Lawrence E. Boskow
Mark Boster
Bie Bostrom
Jim Bourg
Robin Bowman
Tim Boyle
Heidi Bradner
Brian Brainerd
Alex Brandon
Paula Bronstein
Yoni Brook
Dudley Brooks
Kate Brooks
Frederic J. Brown
Jennifer Brown
Milbert Orlando Brown
Andrea Bruce Woodall
Simon Bruty
Paul Buck
Mark Bugnaski
Jeffrey Bundy
Joe Burbank
Lauren Victoria Burke
David Burnett
David Butow
Alexandra Buxbaum
Renée C. Byer
Billy Calzada
Matt Campbell
Todd Campbell
Jay Capers
Darren Carroll
Paul Carter
Peter Casolino
Chuck Cass
John Castillo
Sean Cayton
Lee Celano
Bryan Chan
Gus Chan
Chang W. Lee
Richard A. Chapman
Tia Chapman
Tim Chapman
Dominic Chavez
Chao Soi Cheong
Chien Min Chung
Jahi Chikwendiu
Barry Chin
Jeff Chiu
Jeff Christensen
Andre F. Chung
Daniel F. Cima
Lorenzo Ciniglio
Mary Circelli
Kevin Clark
Robert Clark
Timothy Clary
Jay Clendenin
Donna Clovis
Victor José Cobo
Gigi Cohen
Marice Cohn Band
Carolyn Cole
James Collins
Cary Conover
Fred Conrad
Jeff Cook
Andrew Copplet
Dean Coppola
Gary Coronado
Anthony Correia
Ronald Cortés
John Costello
Johnny Crawford
Gregory Crewolson
James Cross
Jeff Crow

Stephen Crowley
Annie Cusack
Thomas Dallal
Scott Dalton
Amy Davis
Helen Davis
Jim Davis
Robert A. Davis
Laura De Capua
Grant Delin
Louis DeLuca
Rebecca Denton
Charles Dharapak
Marco Di Lauro
Stephanie Diani
J. Albert Diaz
Cheryl Diaz Meyer
Will Dickey
Brian Diggs
Anthony V. DiGiannurio
Mediha Dimartino
Yvette Marie Dostatni
Larry Downing
Jonathan Drake
Richard Drew
David Duprey
Phelan Ebenhack
Aristide Economopoulos
Debbie Egan-Chin
Don Emmert
Douglas Engle
John Epperson
Fred Ernst
Jason Eskenazi
Frank Espich
Jim Evans
Gary Fabiono
Timothy Fadek
Lennie Falcon
Steven Falk
Melissa Farlow
Patrick Farrell
William Farrington
Christopher Faytok
Todd Feeback
Gina Ferazzi
Gloria Ferniz
Thomas Ferrara
Jonathan Ferrey
Karl Merton Ferron
Stephen Ferry
Brian Finke
Brent Finley
Gail Fisher
Lauren Fleishman
Julie Fletcher
Ricky J. Flores
Marvin Fong
Jacqueline Mia Foster
Tom Fox
Travis Fox
Bill Frakes
Angel Franco
Thomas Franklin
Danny Wilcox Frazier
Luke Frazza
Ruth Fremson
Jen Friedberg
Gary Friedman
Rick Friedman
Jason Frizelle
Susanna Frohmann
Ana E. Fuentes
Hector Gabino
Ingrid Gaither
Thomas Gallagher
Patricia Gallinek
Sean Gallup
Jacek Gancarz
Alex Garcia
Juan Garcia
Mark Garfinkel
Andrew Garn
Ben Garvin
Karl Gehring
Fred George
David P. Gilkey
Lucas Gilman
Ralph Ginzburg
Diego Giudice
Rob G. Goebel
Julian Gonzalez
Carlos Avila Gonzalez

Paul Gonzalez Videla
Leila Gorchev
Russell Gordon
Chet Gordon
Monika Graff
Katy Grannan
M. Spencer Green
Philip Greenberg
Bill Greene
Stanley Greene
Lauren Greenfield
Pat Greenhouse
Michael Greenlar
Susye Greenwood
John Gress
Christopher Griffith
Lori Grinker
Sergei Grits
Daniel Groshong
Deborah A. Grove
Justin Guariglia
Dale Guldan
C.J. Gunther
David Guralnick
Erol Gurian
Hale Gurland
John Gurzinski
Barry Gutierrez
Tony Gutierrez
David Guttenfelder
Carol Guzy
Bob Gwaltney
Thomas Haley
Marsha Halper
Chris Hamilton
Scott Hamrick
David Handschuh
Paul Hanna
Richard Alan Hannon
Deborah Hardt
Alfred Hardy Sullivan
Aaron Harris
Seth Harrison
David Hartung
Nanine Hartzenbusch
David Alan Harvey
Jennifer Hauck
Karl Haupt
Ron Haviv
Jeff Haynes
Sean Hemmerle
Robert Hendricks
Mark Henle
Gerald Herbert
Tiffany Hermon
Tyler Hicks
Jeanne Hilary
Erik Hill
Ethan Hill
Edward J. Hille
Charles Hires
David Hobby
Evelyn Hockstein
Jeremy Hogan
Robin Holland
Jim Hollander
Stan Honda
Chris Hondros
Rose Howerter
Red Huber
Aaron Huebner
Daniel Hulshizer
Micah Intrator
Walter Iooss
Lynn Ischay
Jeff Jacobson
Stephen Jaffe
Terrence Antonio James
Jason Janik
Kenneth Jarecke
Janet Jarman
Ron Jenkins
Angela Jimenez
Jose Jimenez
Lynn Johnson
Frank Johnston
Marvin Joseph
Michael Kamber
Hyungwon Kang
Doug Kanter
Trevor Kapralos
Sylwia Kapuscinski
Ed Kashi

Rebekah Kates
Chris Kaufman
Courtney Kealy
Edward Keating
Beth A. Keiser
David Kennedy
Mike Kepka
Lisa Kereszi
Irfan Khan
Yunghi Kim
John Kimmich
Paul Kitagaki, Jr
Joan Klatchko
Laura Kleinhenz
Heinz Kluetmeier
David E. Klutho
Janet Knott
Richard Koehler
James Korpi
Jeff Kowalsky
Brooks Kraft
Benjamin Krain
Stacy Kranitz
Lisa Krantz
Daniel Krauss
Suzanne Kreiter
Salem Krieger
Amelia Kunhardt
Jack Kurtz
Tom Kurz
Nicholas Kuskin
Teru Kuwayama
Stephanie Kuykendal
John Labriola
Kenneth Lambert
Andre Lambertson
Rodney A. Lamkey, Jr.
Wendy Sue Lamm
Nancy Lane
Bryce Lankard
Jerry Lara
Kirstine Larsen
Eric J. Larson
Craig Lassig
Gillian Laub
Michael Laughlin
m Lavrakas
ared Lazarus
Aarty Lederhandler
Matthew Lee
Tom Leininger
Juli Leonard
Mark Leong
Claude Alan Lessig
Marc Lester
Catherine Leuthold
Mike Levin
Heidi Levine
Wendy Levine
Shlomit Levy Bard
William Wilson Lewis III
John Leyba
Andrew Lichtenstein
Jennifer Lindberg
Brennan Linsley
Steve Liss
Scott Lituchy
Chris Livingston
Michael Llewellyn
Jim Loscalzo
Jeff Loughlin
Dmitry Lovetsky
Jon Lowenstein
Gene Lower
Benjamin Lowy
Robin Loznak
Pauline Lubens
William Luther
Michael Lutzky
Melissa Lyttle
John Mabanglo
Preston Mack
Jim MacMillan
Farrah Maffai
Jim Mahoney
David Maialetti
Todd Maisel
John Makely
Jeff Mankie
Jessica Mann
Sally Mann
John M. Mantel
Elizabeth Margerum

Mary Ellen Mark
Maxim Marmur
Dan Marschka
Bob Martin
Dave Martin
Glen Martin
Steven R. Martine
Raquel Martinez
Pablo Martínez Monsiváis
Diana Matar
Tim Matsui
Tannen Maury
Robert Maxwell
Matt May
Darren McCollester
John McConnico
Cyrus McCrimmon
John McDonnell
Patricia McDonough
Denise McGill
Maryellen McGrath
Clay McLachlan
Joseph McNally
David McNew
Ian McVea
Robert Mecca
Steven Medd
Kent E. Meireis
Susan Meiselas
Steve Mellon
Eric Mencher
Doug Menuez
Peter J. Menzel
Jeff Mermelstein
James Michalowski
Darin Mickey
Jennifer Midberry
Tom Mihalek
Aaron Milestone
Ann Arbor Miller
Cheryl Miller
George W. Miller III
Greg Miller
Peter Read Miller
Robert Miller
Andrew Mills
Doug Mills
Donald Miralle
Mark Mirko
Andrea Modica
Mark W. Moffett
Thomas Monaster
M. Scott Moon
John Moore
Viviane Moos Holbrooke
Ernesto Mora
Cynthia Moran Timms
Daniel Morel
Peter Morgan
Christopher Morris
Graham Morrison
Peter Morrison
John Mottern
Matthew Moyer
Jay Muhlin
Michael Munden
Noah K. Murray
James Nachtwey
Adam Nadel
Jon Naso
Donna Natale-Planas
Mike Nelson
Gregg Newton
Arleen Ng
Michael Nichols
Robert Nickelsberg
Steven Ralph Nickerson
Krista Niles
Landon Nordeman
Jason Nuttle
John O'Boyle
William O'Leary
Annie O'Neill
Susan Ogrocki
Dale Omori
Metin Oner
Dean Orewiler
Edward Ornelas
Francine E. Orr
Jack Orton
Stephen Osman
José M. Osorio
Will van Overbeek

Ilana Ozernoy
Rose Palmisano
Aldo Panzieri
James Parcell
David B. Parker
Gerik Parmele
Helena Pasquarella
Judah Passow
Nancy Pastor
Joseph M. Patronite
Richard Patterson
Tom Pennington
Hilda M. Perez
Lucian Perkins
Algerina Perna
Courtney Perry
Geoffrey Peruier
David Peterson
Mark Peterson
Scott Peterson
Steve Peterson
Keri Pickett
Sylvia Plachy
Spencer Platt
William Benjamin Plowman
Suzanne Plunkett
Jeanine Pohlhaus
Gary Porter
Joshua Prezant
Jake Price
John Prieto
Lisa Quinones
Susana Raab
Joseph Raedle
Lois Raimondo
John Ranard
Tony Ranze
Matthew Ratajczak
Joanne Rathe
Laura A. Rauch
Steven L. Raymer
Eli Reed
Mona Reeder
Tom Reese
Lara Jo Regan
Tim Revell
Corey Rich
Paul Richards
L. Jane Ringe
José A. Rivera
John Rizzo
Michael Robinson-Chávez
John Roca
Manuel Rocca
Dwayne Rodgers
Paul Rodriguez
Joseph Rodriquez
Vivian Ronay
Robert Rosamilio
Ricki Rosen
Amy Rossetti
Raul Rubiera
Steven Rubin
Jeffrey B. Russell
David L. Ryan
Robert Sabo
Ed Sackett
Sadjadpour
Paul Sakuma
Carolina Salguero
Gulnara Samoilova
Amy Sancetta
Wally Santana
Joel Sartore
Tony Savino
Andrew Savulich
Al Schaben
Stephen Schaefer
Howard Schatz
Norbert Schiller
Erich Schlegel
Ken Schles
Kristen Schmid
Stephen Schmitt
Chris Schneider
Jake Schoellkopf
Max Schulte
Rob Schumacher
Aaron Schuman
Michael Schwartz
Andrew P. Scott
Cydney Scott

Paul David Scott
Paula Alyce Scully
Eric Seals
Michael Seamans
Ivan Sekretarev
Bob Self
Zoe Selsky
Andréanna Seymore
Amir Shah
Paras Shah
Stephen Shames
Daniel Shanken
Patrick Shannahan
Gregory Shaver
Stephen Shaver
Ezra Shaw
David Shea
Denny Simmons
Taryn Simon
Michael Simons
Mike Simons
Luis Sinco
Wally Skalij
Tim Sloan
John Smierciak
Danté Smith
Dayna Smith
Hillery Smith Garrison
Brian Snyder
Sage Sohier
Armando Solares
Harley Soltes
Chip Somodevilla
Ted Soqui
Andre Souroujon
Raleigh Souther
Judy Southwind
Pete Souza
Chris Spencer
Victor Spinelli
Sheila Springsteen
Fred Squillante
John Stanmeyer
Shannon Stapleton
Monique Stauder
Susan Stava
Matthew Staver
Larry Steagall
Avi Steinhardt
Sharon Steinmann
Chad Allen Stevens
Mike Stocker
Robert Stolarik
Leslie Stone
Matthew Stone
Nancy L. Stone
Peter Stone
Wendy Stone
Scott Strazzante
Bob Strong
Ray Stubblebine
Pat Sullivan
Robert Sullivan
John Sunderland
David Surowiecki
Lea Suzuki
James C. Svehla
Kevin J. Swank
David Robert Swanson
Mario Tama
Allan Tannenbaum
Jessica Tefft
Patrick Tehan
Sara Terry
Shmuel Thaler
Mike Theiler
Shawn Thew
Scott Thode
George Thompson
Stuart Keith Thurlkill
Al Tielemans
Lonnie Timmons III
Dennis van Tine
Peter Tobia
Jonathan Torgovnik
Christy Townsend
Charles Trainor
Quyen Tran
Robert Trippett
Linda Troellen
David C. Turnley
Peter Turnley
Jane Tyska

Mike Andrew Urban
Gregory Urquiaga
Vicki Valerio
Leonard Vaughn-Lahman
Mark Vergari
Jose Luis Villegas
Kurt Vinion
Ami Vitale
Sarah Voisin
Tamara Voninski
Dino Vournas
Fred Vuich
Bill Wade
Kat Wade
Craig Walker
Diana Walker
Richard Walker
Stephen Wallace
Susan Walsh
Brian Walski
Steve Warmowski
Paul Warner
Jon Warren
Ted S. Warren
Lannis Waters
James Watson
Susan Watts
Bruce Weaver
Spencer Weiner
David H. Wells
Mark Robert Welsh
Matthew West
Warren S. Westura
John H. White
Max Whittaker
Jeff Widener
John Wilcox
Budd Williams
Clarence Williams
Gerald S. Williams
Robert Williams
Michael Williamson
David Wilson
Jonathan Wilson
Mark Wilson
Damon Winter
Patrick Dennis Witty
J. David Wolf
Maurice Wolf
Alex Wong
Tracy Woodward
Mandi Wright
Ron Wurzer
Michael S. Yamashita
Tina Yee
Lloyd Young
Will Yurman
Stefan Zaklin
Mark Zaleski
Barry L. Zecher
Alexander Zelianichenko
Harry Zernike
Tim Zielenbach

VENEZUELA
C. German Balza Casado
F.I. Camacho Rodriquez
H. José Castillo Clemente
F. Anibal Henriquez Salcedo
J. Carlos Hernandez Soria
N. Rafael Jimenez Barrozzi
Jacinto Jose Oliveros Perez
Carlos Enrique Ramirez
Pedro Ruiz Perez
E. Zenon Sanchez Ruiz
Victor Sira

VIETNAM
Do Huu Duc
Doan Duc Minh
Dzung Tran Quoc
Si-So Ho
Hoang Duc Cuong
Le Minh Hoang Kim
Hoang Ngoc Cuong
Khanh Lai
Bui Khánh Toan
Lan Nguyen Duc
Le Dinh Canh
Le Minh Nhut
Luong Chinh Huu
Luu Hong Son
Luu Thuan Thoi

Ly Thi Thu Thuy
My Ngö
Nam Hoang Dinh
Ngoc Dan Huynh
The Tri Nguyen
John Minh Nguyen
Nguyen Anh Tuan
Nguyen Ba Nguyen
Nguyen Duc Chinh
Nguyen Duc Tuong
Nguyen Huu Thanh
Nguyen Luong Hieu
Nguyen Minh Hoang
Nguyen Nhung
Nguyen Thai Phien
Nguyen Thanh Vu
Nguyen The Huyen
Nguyen Van Dung
Nguyen Viet Thao
Pan Tu Long
Pham Ba Thinh
Pham Dinh Quyen
Pham Duc Thang
Phan Van Bau
Quang Huy Vu
Que Nguyen Van
Quoc Tuan Hoang
Thai Nguyen Huynh
Thang Duong Quang
Thuc Nguyen Trung
Tra Thiet
Tran Chinh
Tran Cu
Tran Huu Chien
Tran Huu Cuong
Tran Ngoc Thanh
Tran Thanh Sang
Tran Trung Hoa
Tran Van Chau
Tran Van Luu/Tran Chinh
Nghia
Tran Viet Van
Trinh Dung
Vo Minh Hoan
Vo Quang Ngoc
Vo Quy Hung
Vo Thanh Loan
Vu Viet Dung

YUGOSLAVIA
Zoran Bogic
Jelena Dragutinovic Kalenic
Nikola Fific
Gabi Halász
Sasa Maricic
Mihály Moldvay
Marina Niciforovic
Aleksander Stojanovic
Srdjan Sulejmanovic
Goran Tomasevic
Art Zamur
Milovanovic Zorah

ZAMBIA
Tsvangirayi Mukwazhi
Chatowa Ngambi
John Ngoma
Timothy Nyirenda

ZIMBABWE
Wilson Johwa
Wallace Mawire
Nyaradzo Muchena
Bester Ndoro
William Nyamuchengwa
Lucky Tshuma

Can I stretch my visual limits?

EOS-1 D

▶ There's no point in having unlimited photographic vision if your equipment can't keep up. So if you'd like to expand your capabilities, Canon's superb EOS range of SLR cameras is the first thing to focus on.

The EOS system is designed around the basic concept of maximising both ease of use and image quality – extending the world of photographic enjoyment to everyone from beginners to professionals. With a choice of analogue and digital models and a fantastic array of auto focus or manual options, it gives you the power to express yourself creatively.

Each EOS model is compatible with a large and highly advanced system of accessories and lenses, including more

EOS 300

EOS 30

EOS D60

Canon EF LENS

EOS-1 D

DIGITAL

than 60 extended focus (EF) lenses – enabling you to achieve the photographic results you envision in every situation.

The EOS-1D pictured here will take you way beyond previous technical limits, with a continuous shooting speed of up to 8 frames per second, a 45-point area auto focus system and an extra large 4.15 mega pixel CCD sensor. But even if you're not after a top-of-the-range model, Canon's EOS system gives you the choice you need to take your images to a higher level.

So think how far you'd like to go with photography.

Whatever you can imagine, with Canon you can.

www.canon-europa.com

you can
Canon

The world's finest books on
photography and photographers from

Thames & Hudson

Bailey **Blumenfeld** Bischof

Bill Brandt Brassaï **Cartier-Bresson**

Walker Evans **Lois Greenfield**

Horst **Hoyningen-Huene**

Jacques-Henri Lartigue **Duane Michals**

Lee Miller **Tim Page** Man Ray

Riboud Daniel Schwartz

Cindy Sherman W. Eugene Smith

For details of our new and forthcoming titles, please write to:

(UK) Thames & Hudson Ltd 181A High Holborn London WC1V 7QX **(USA)** Thames & Hudson Inc. 500 Fifth Avenue New York NY 10110

Thames & Hudson